ROBERT KOEHLER'S

The Strike

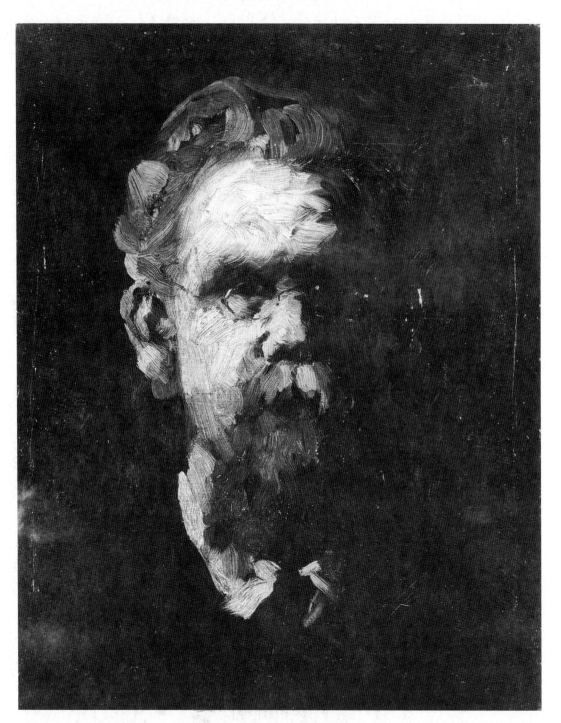

Portrait of Robert Koehler
by Frank Duveneck

ROBERT KOEHLER'S
The Strike

The Improbable Story of an
Iconic 1886 Painting of Labor Protest

JAMES M. DENNIS

The University of Wisconsin Press

Publication of this volume has been made possible, in part, through support from
Dr. Johanna Baxandall, in memory of Lee Baxandall.

The University of Wisconsin Press
1930 Monroe Street, 3rd Floor
Madison, Wisconsin 53711-2059
uwpress.wisc.edu

3 Henrietta Street
London WCE 8LU, England
eurospanbookstore.com

5 4 3 2 1

Printed in the United States of America

Library of Congress Cataloging-in-Publication Data
Dennis, James M.
Robert Koehler's The strike : the improbable story of an iconic 1886 painting of labor protest / James M. Dennis.
p. cm. — (Studies in American thought and culture)
Includes bibliographical references and index.
ISBN 978-0-299-25134-5 (pbk. : alk. paper) — ISBN 978-0-299-25133-8 (e-book)
1. Koehler, Robert, 1850–1917. Strike. 2. Strikes and lockouts in art.
I. Title. II. Series: Studies in American thought and culture.
ND237.K59S16A75 2011
759.13—dc22 2010038903

IN HONOR

of all who fought so long for an eight-hour workday
and a living wage.

Contents

Illustrations

ix

Acknowledgments

THIS BOOK BEGAN WITH THE LATE LEE BAXANDALL. In addition to his rescue, promotion, and ultimate return of *The Strike* to Germany, he interviewed descendents of Robert Koehler and tracked down many other works by the artist, including *The Socialist*. Anticipating a monograph, he entrusted me with his notes, clippings, and correspondence containing valuable research material for the book's final chapters. I am grateful for his faith in my ability to see that his wish came true. For her generous financial support of the book's publication I am also indebted to his widow, Johanna Baxandall. The newspaper and periodical collections of the Staatsbibliothek zu Berlin and the Bayerische Staatsbibliothek in Munich housed significant background references for identifying *The Strike* with the early years of the labor movement. The like collections of the Wisconsin Historical Society and the Minneapolis Public Library held equally useful sources for tracing the painting's fate in Milwaukee and Minneapolis, respectively. The research assistance from all four institutions is greatly appreciated, as is the generosity of the Deutsches Historisches Museum in permitting me a preview of both *The Strike* and *The Socialist* when they were still stored away in Spandau.

In tune with recommendations from the manuscript's two referees, its thorough editing by Paul Boyer, editor of the Studies in American Thought and Culture series, was invaluable. Gwen Walker, acquisitions editor, followed suit by wisely trimming my over-extended Introduction. Managing editor Adam Mehring, in tandem with production

manager Terry Emmrich, saw to the book's final form in a delightfully friendly manner. The combined contributions of them all made for an increasingly improved publication. Its illustrations owe much to the expert scanning and adjustment of their digital files by Tom McInvaille.

I also wish to thank David B. Dennis and John M. Dennis for their assistance with the text and illustrations, respectively. The cover design benefited from their fine-tuning as well. Finally and foremost, liebender Dank to Laurel for her advice and assistance on all aspects of this project from beginning to end, from Berlin to Munich, in Wisconsin and New York, or wherever else our mutual Wanderlust has taken us.

ROBERT KOEHLER'S
The Strike

Introduction

ANY WORK OF ART TAKES ON A LIFE OF ITS OWN from the moment it leaves the artist's studio. This is particularly true for complex, highly populated narrative paintings like *The Strike*, the creation of the Milwaukee-reared artist Robert Koehler. Such works, one may say, begin to speak in multiple first-person-singular voices as they enter the stream of history. Whatever the artist's original intentions, these "voices" address diverse publics who interpret them according to their various needs and interests. As a highly provocative rhetorical painting, *The Strike* at the most basic level conveyed a message of both solidarity and admonition to an unsettled, oppressed working-class public while simultaneously threatening a wealthy elite public.[1]

A few exceptional works in the history of art far outlast the fame of their artists. In American painting, for example, this rare status has been attained by *Washington Crossing the Delaware* and *American Gothic*, while their respective artists, Emanuel Leutze and Grant Wood, are little remembered by the public at large. Leutze's heroic action painting of an early episode in the American Revolutionary War, executed in Düsseldorf during the Revolution of 1848, retains its popularity through its focus on the heroic father figure, viewed in profile, accompanied by an anxious young flag bearer embracing the partially unfurled Stars and Stripes in the winter wind. Wood's half-length rural couple, on the other hand, armed with a pitchfork and penetrating stares, tap into a national sense of humor. The couple's iconic cultural standing results in large part from their being incessantly parodied as ironic signs of domestic insularity.[2] They

3

stand on eternal guard duty, most recently in the form of giant, polychromatic statues on Chicago's North Michigan Avenue, bulwarks against the inevitable inroads of cosmopolitanism and globalism.

While hardly attaining the status of Leutze's patriotic melodrama or Wood's sly lampoon, Robert Koehler's *The Strike* of 1886 (Plate 1), a large-scale narrative painting of unruly industrial workers walking off their jobs and confronting an elderly factory owner, did acquire considerable fame—and notoriety—after its exhibition in New York City just before May Day 1886. Created by an obscure German American artist as a diploma painting at Munich's Royal Academy, *The Strike*'s unprecedented conception and sudden emergence to public view coincided with the final preparations of America's struggling labor movement to launch a nationwide agitation for the eight-hour workday.

Little in Koehler's previous efforts had foretold of the socially engaged intensity of *The Strike* (or of *The Socialist*, a small but extremely spirited intimation of the more famous work that soon followed). Nevertheless, his earlier work does offer intriguing anticipations of *The Strike*'s figural iconography, both male and female.

In contrast to *Washington Crossing the Delaware* and *American Gothic*, with their insularity and rootedness in very specific historical and cultural settings, *The Strike* spoke to issues of urgent concern on both sides of the Atlantic—issues that remain timely even today. From the painting's debut and initial reception against a fevered background of seething ferment among industrial workers, it acquired an increasingly transnational aura as it traveled back and forth between the United States and Europe at a time when activists on both continents, such as August Bebel in Germany and Eugene Debs in America, were energizing socialist politics and the industrial labor movement. Variously contextualized, *The Strike* was introduced to a German public by means of a widely reproduced wood engraving erroneously identified as a depiction of striking Belgian coal miners. But while Koehler traced the inspiration of his painting to the Great Railroad Strike of 1877 in the United States, he clearly intended its action to be universal in meaning, unattached to any specific event.

The Strike's early exhibition record and class-conflicted reception at international expositions in Munich, Paris, Milwaukee, and Chicago from 1889 to 1893 unfolded as labor unrest continued to agitate the public. In 1893, now in his mid-forties and married at last, Koehler, bringing with him *The Strike*, moved to Minneapolis to become director of the city's newly founded school of art. In this rail and industrial center, the painting's fate reflected not only imme-diate contingencies, but larger social and political realities.

Soon after the turn of the century, in appreciation of Koehler's contributions to the city's cultural life as an art instructor and administrator, a group of Minneapolis art patrons, somewhat reluctantly supported by their titular head, the lumber baron and museum owner T. B. Walker, arranged for the purchase of *The Strike* by means of a limited public subscription. However, a potentially inflammatory painting of class conflict and incipient violence, it subsequently sank into obscurity during decades marked by wartime intolerance, political reaction, and renewed bursts of union activism and labor-management strife. Indeed, after Koehler's death in 1917, its inconspicuous display and eventual long-term storage and neglect by the Minneapolis Public Library essentially kept *The Strike* out of public awareness for over four decades.

During this period, only reproductions of the wood engraving offered infrequent reminders of the painting's existence. Nevertheless, one such reproduction, in an obscure local New Left publication in Massachusetts in 1971, led to the painting's rescue. Encountering this publication by chance, Lee Baxandall, a well-to-do native of Oshkosh, Wisconsin, and radicalized graduate of the University of Wisconsin–Madison, tracked down *The Strike*, by now in sadly deteriorated condition in the Minneapolis Institute of Arts art-storage facility. Purchasing it for the low asking price, Baxandall had it beautifully restored in New York City in time for a major show at the Whitney Museum of Art. He then placed it on long-term loan with a labor union whose enterprising cultural director, Moe Foner, displayed it in a gallery at the union's Manhattan headquarters and exhibited it nationally.

As reviews and reproductions proliferated, Baxandall's desire to locate *The Strike* permanently in a major museum finally led to the painting's return to Germany, where it and Koehler's *The Socialist* now face one another in a gallery of the nation's premier historical museum on Berlin's central boulevard, Unter den Linden. This dramatic finale immediately followed the destruction of the infamous Berlin Wall—yet another context in which to interpret Koehler's masterpiece.

As audiences in many venues on both sides of the Atlantic perceived, *The Strike* seemingly sides with its workers in their attempt to voice their grievances to a resistant factory owner—hence its troubled reception in settings marked by class conflict and labor-management tensions. As the art critic Arthur Danto has argued, a painting's rhetorical "ellipsis" requires the viewer's participation. We must interpret its layers of meaning by filling in ambiguities or ambivalences.[3] For instance, *The Strike*'s central figure, a fashionably dressed, ostensibly upper-middle class woman (often too hastily identified as a worker's wife) may have thrust herself into the fray to assist the workers, but not

necessarily in their role as strikers. To understand this figure, and indeed the entire painting comprehensively, one must draw upon the pertinent social, political, and art historical forces acting upon them. One must appreciate *The Strike* as a vital, visible historical document.[4]

In the past decade or so, the subject of socially engaged art in America, much of it related to the post–World War I phase of the labor movement, has attracted widespread, sometimes nostalgic interest. *Images of American Radicalism*, a sumptuous picture book compiled by Paul Buhle and Edmund B. Sullivan (Hanover, Mass.: Christopher Publishing House, 1998) includes more than 1,500 reproductions of paintings, photographs, posters, and cartoons. Its five sweeping chapters range from antebellum utopian movements, especially the Shakers, to the birth of socialism, the growth of the labor movement, and the emergence of the New (now Old) Left in the 1960s and '70s.[5]

Narrower in focus but more analytical and interpretive, *Artists on the Left: American Artists and the Communist Movement, 1926–1956* (New Haven: Yale University Press, 2002), by the British historian Andrew Hemingway, traces the fluctuating influence of the American Communist Party (CPUSA) on "social realist" paintings and graphics from the late 1920s through the heyday of government repression under the House Un-American Activities Committee and the reckless Wisconsin senator Joseph McCarthy. Although *The Strike* and Robert Koehler's career antedate the period of Hemingway's study, he does begin his survey with a pair of illustrations by two of Koehler's favorite Minneapolis art students, Wanda Gág and Adolph Dehn: a 1928 cover and cartoon, respectively, published in the CPUSA-dominated magazine *New Masses*. (Given Senator McCarthy's propensity for finding guilt by association, one is fancifully tempted to imagine him in his prime using this evidence to denounce *The Strike* as communist propaganda, and Koehler as a secret CP sympathizer who indoctrinated his students accordingly!)

Of the considerable outpouring of scholarship on labor-related or "socially engaged" art in recent years, a preponderance tends to be present-minded and often theory-driven.[6] One of my aims in writing this book has been to provide a historic context to this discourse by restoring to contemporary awareness a quintessentially "socially engaged" work of art produced more than 125 years ago—its origins, its admirers and detractors, its maltreatment, rediscovery, and ultimate transnational apotheosis.

In pursuing this project, I have drawn upon a loose assortment of research materials in the United States and Germany. Facts about Koehler's early life and career from Milwaukee to New York to Munich, plus a smattering of information

about *The Strike*'s initial appearances in Europe and America, are to be found in his widow Marie Koehler's brief and unpublished "History of the Koehler Family," edited by Lee Baxandall.

Of much greater value are Lee Baxandall's personally compiled "fact sheets" on Koehler's works filed in two large storage boxes together with a wide variety of miscellaneous articles, photos, rough notes, interviews, clippings, and correspondence that Baxandall, already suffering from Parkinson's disease that caused his death in late 2008, turned over to me after years of contemplating a book. My hope is that they will eventually be preserved in an archive and made accessible to other scholars.

Owing in part to an indifferent son who discarded his parents' and grandparents' papers, almost nothing survives from "the horse's mouth," that is, from Robert Koehler himself, except a few published statements about *The Strike*, a small file of letters he wrote concerning the painting's removal from the Paris Exposition in 1889, a short series of articles on the history of American painting up to 1893, and transcripts of three or four lectures he delivered in Minneapolis. Newspapers, mainly of New York City, Milwaukee, and Minneapolis, yielded some information regarding Koehler's career, his most memorable painting, and the events surrounding its early public reception, especially in the spring of 1886. Munich and Berlin newspaper articles also reported on the latter extensively, and I have made considerable use of these sources, translating the German into English.

Following Lee Baxandall's rescue of *The Strike* in 1971, articles and reviews recorded its whereabouts, as did Baxandall's correspondence concerning its exhibitions and sale. Upon its permanent acquisition by Berlin's Deutsches Historisches Museum in 1992, curator Agnete von Specht organized an exhibition featuring it and Koehler's *The Socialist* (which the museum had acquired slightly earlier). This exhibition consisted of paintings, prints, photographs, posters, cartoons, and even postcards representing European strikes from the beginning of the Industrial Revolution to World War I. The exhibition catalogue, *Streik: Realität und Mythos*, bearing a color reproduction of *The Strike* on its cover, included two essays by von Specht and a colleague, Klaus-D. Pohl, that explored the painting's art historical significance—and to a more limited extent its larger historical significance—more fully than anyone had done before them. In the same spirit, I have written this monograph as a socially rooted biography, as it were, not primarily of an artist, but of the masterpiece for which he deserves to be remembered.

PART I

Robert Koehler's Early Life and Career

Koehler's Art Training

MILWAUKEE, MANHATTAN, AND MUNICH, 1865–79

THE SUBJECT MATTER OF ROBERT KOEHLER'S CENTRAL WORK reflects his immediate family background and to a much larger extent, the profound social changes brought on by massive industrialization during his youth. The second of three children, he was born on November 28, 1850, with a defective right foot—a slight clubfoot—in a tiny flat on Deichstrasse, in a working-class sector of Hamburg, Germany. His father, Theodor Alexander Ernst Koehler, aged thirty-four at the time of his son's birth, a Potsdam-born machinist, was descended from a family of Silesian and Saxon weavers. His mother, Louise, a native of Hamburg, was the daughter of a master mason, Nicolaus Buetor, and his wife Karoline, who was much admired for her fine needlework, a skill she would pass along to her daughter Louise.[1]

In 1854, the family, with a fourth child on the way, immigrated to the United States on a crowded Holland-America Line ship, the *Humboldt*. They stopped in Brooklyn, New York, where the infant girl, Elsbeth, died six weeks after her birth. During this trying time a cousin-in-law, Oskar Graetz, a gunsmith who had settled in Milwaukee, encouraged Ernst to bring his family there.[2] This he did, moving them into a modest dwelling on Fifth Street, two blocks west of the Schlitz Brewery. The neighborhood, not far from the Milwaukee River to the east, was largely German speaking and it was here that Ernst also set up his machine shop.[3] He thereby joined the vast majority of working Americans who throughout the first half of the nineteenth century remained self-employed entrepreneurs

whether on or off the land. At mid-century this tradition of economic independence was on the brink of rapid erosion as a result of unprecedented industrial growth, accelerating during the Civil War. By the time of the economic panic of 1873 nearly two-thirds of an immigration-fed labor force worked for employers. About three-and-a-half million jobs remained in agriculture while approximately five million men, women, and children toiled in factories employing, on average, fewer than a hundred workers each.[4] Clear evidence of this escalating urban labor force could be witnessed by the young Koehler in Milwaukee. Indeed, his older brother Amandus, following in his father's footsteps as an independent machinist, was ultimately forced by business failure to turn wage earner.

When the Koehlers reached Milwaukee, probably by sailing ship from Buffalo, they discovered an urban frontier of less than 30,000 inhabitants that imported supplies and goods essential to a pioneer economy. The few exports of the newly admitted state of Wisconsin included some lumber, but wheat, grown on prairie lands and clearings near the Illinois border, remained its premier cash crop until dairy eventually took over. Production of farm implements had begun along the western shore of Lake Michigan; Jerome I. Case was manufacturing his threshing machines in Racine, for instance. Also vital to wheat cultivation, inland railroads were to supplement the state's inadequate roads and canals, with the first line reaching Waukesha in 1850, followed by Madison and finally the Mississippi River at Prairie du Chien and La Crosse in 1857. Three-quarters of the freight rumbling over these tracks was agricultural. Lumber, increasingly river-rafted, lagged behind. In addition to rail traffic, water power for Milwaukee's first grain mills, breweries, and wood and leather goods factories originated inland as the otherwise deficient Milwaukee–Rock River canal ended with a dam. Industry grew: 7.5 percent of the city's residents held manufacturing jobs in 1860, increasing to a still modest 18.1 percent twenty years later when the population reached well over one hundred thousand.[5]

Of crucial value to an independent machinist like Ernst Koehler, the Milwaukee foundry, metalworking, and machinery industry had started up by the time he opened his small job shop. Custom parts made to order defined his trade, sustained by subcontracts from principal suppliers of flour and sawmill equipment and perhaps from manufacturers of steam engines as well. All three of these product areas were among those successfully exploited by Edward P. Allis, one of many New York transplants in early Wisconsin history and the owner of Milwaukee's largest company when he died in 1889.[6] Meat-packing, malting and beer brewing, plus the manufacture of leather goods and clothing

became major components of Milwaukee's economy as well, generating subsidiary industries in need of additional labor and perhaps an occasional specialty part from Ernst.

While neither he nor his son Robert were active in trade unionism, they could observe its erratic rise around them. Local and national trade unions had originated in the 1830s as demand for a ten-hour workday spread from a combination of seventeen trades in Baltimore throughout the East. The Panic of 1837 slowed the movement, and not until the late 1840s were renewed attempts at economic betterment instigated by a limited number of locals. National organizations, better led than any in the 1830s, subsequently appeared, including the National Typographical Union, the Iron Molders' International Union, and the Machinists and Blacksmiths' National Union in 1857, a year that saw still another panic.[7] Strikes increased, many of them prompted by skilled workers pleading for a shorter workday and higher wages. An audacious call for an eight-hour day was written into a broad reformist platform of the National Labor Union (NLU), the earliest national federation of labor in the United States. It originated at a congress of unions convening in Baltimore in August 1866, when Robert Koehler was fifteen, and was fostered by the most prominent labor leader of the time, William H. Sylvis, president of the Iron Molders' International Union, and William Harding, president of the Coach Makers International Union. Besides urging state legislatures to pass eight-hour workday laws, they proposed consumer and producer cooperatives, currency and banking reforms, restriction of immigration, abolition of convict labor, and full rights for women and black laborers. The last item was doomed from the beginning, and all the rest faded with the collapse of the National Labor Union three years after Sylvis's sudden death at the age of forty in 1869. Only a legislative eight-hour day campaign gained strength under the dynamic guidance of Ira Steward, a Boston machinist who originated a network of "eight-hour leagues" during the Civil War that subsequently extended to Chicago, Milwaukee, and as far west as San Francisco.[8]

The Milwaukee Eight-Hour League enlisted an admirer of Steward, Saxon-born Robert Schilling, a Cleveland-based Greenbacker and former president of the Coopers' International. Upon his arrival in 1880 he edited the German-language newspapers *Der Reformer* and *Das Volksblatt* and organized a populist assembly of the Knights of Labor that eventually swept Milwaukee County's elected offices with its candidates and sent another to Congress. Neither the printing press nor political action, however, met the challenge of unionizing industrial labor, especially as long as Milwaukee's largest firms could turn its plentiful, often part-time labor force over at a rapid, job-by-job pace.

Also defying trade unions, its foundries and major machine shops farmed out piece-by-piece bids among highly skilled machinists like Ernst who in turn hired semi-skilled helpers in order to meet deadlines.[9]

Persistent attempts at unionization in Milwaukee fueled a local socialist movement as early as the mid-1870s, even though the current depression had reduced the city's thirty labor unions to nine. A Social Democrat candidate, one Colin Campbell, entered the gubernatorial election in 1877 on a platform that included a women's suffrage plank. He received more votes in Milwaukee County than the single-issue Greenback candidate, Edward P. Allis, in the face of a statewide Republican victory.[10] Less than a decade later, at the peak of the disastrous eight-hour-day upheaval, socialism returned as a potential alternative only to be diverted by anarchist extremism and suppressed by state-sponsored violence. Once again rendered dormant, it then was revived, if in name only, when a pragmatic young Austrian immigrant, Victor Berger, turned it into a moderate party of gradualist reform ultimately able to nominate victorious candidates for city, state, and federal office alike.[11] It continued to base its power on organized labor and to ally politically with the progressivism of Senator Robert M. La Follette and three-term Governor John Blaine into the 1920s.

Though alert to the politics of his hometown, Koehler understandably focused on his own prospects. By the early 1870s he had completed a five-year apprenticeship in commercial engraving and lithography at the Milwaukee Lithographing and Engraving Company, founded and operated by Henry Seifert, a native of Saxony, and his partner James Lawton. Seifert and Lawton would have gladly kept the young man in their employ had he chosen to follow his initial purpose of becoming a master lithographer. This youthful aim, which brought him as close as he ever came to working in a factory, was to be sidetracked by a growing ambition to be an artist. Aspirations for a more creative way of life were probably encouraged at Milwaukee's West Side German and English High School, or Academy, as it was sometimes called, which Robert and his brother attended. It had been established in 1855 by members of the Freie Gemeinde, or Free Thinkers, to which Ernst Koehler belonged.[12]

Koehler took lessons, albeit sporadically, from a German-born, Munich-trained landscape and portrait painter, Heinrich Vianden, the most accomplished artist in Milwaukee at the time. He also benefited from another Milwaukee artist, Heinrich Roese, who had studied in Berlin and painted Shakespearean subjects in addition to portraiture. Both advised their best students to attend an art academy in Europe, preferably in Germany.[13] This was Koehler's goal when in 1871, soon after his election as president of Westside Milwaukee's German Young Men's Association,[14] he suddenly left home to take a job as a lithographer in Pittsburgh. Within a few months, seeking treatment for an eye problem,

he moved on to New York City. There he remained for two years, earning a modest living as an employee of the Arthur Brown lithography shop on Thames Street near the Old Trinity Church and attending evening life-drawing classes under the instruction of Lemuel Wilmarth at the National Academy of Design.[15]

By 1873 he had saved enough for passage to Germany. On October 15, on the strength of the drawings from casts and from life that he had brought with him, he entered Munich's Royal Academy of Art. That night he bought a twenty-pfennig standing-room ticket to attend what was to become his favorite opera, Beethoven's drama of true love triumphing over political imprisonment, *Fidelio*.[16]

Although the panic of that year plunged Germany into a prolonged depression, disciplined frugality, presumably supplemented by freelance lithography jobs, saw Koehler through two years of drawing classes: "Antique" under Alexander Straehuber, a graphic artist as well as a painter, and "Life" under Ferdinand Barth. He also attended a beginning figure-painting class before financial pressures forced him to return to America.

Two brief notices in the *Milwaukee Sentinel* in August and September 1875 announced that Robert Koehler had completed a course of study at Munich's Royal Academy and had won a medal at an exhibition there. With greater specificity, the July 25, 1876, *Sentinel* reported that Ernst Koehler had received "two faithful and well executed portraits" from the New York City studio of his son. One was of the New York poet and newspaper editor William Cullen Bryant and the other of Matthias Stein, Milwaukee's first gunsmith and leader of the city's earliest German immigrant community. Both portraits, according to the anonymous reporter, "give proof of fine talent on the part of the young Milwaukeean and will add to his reputation as an artist."[17]

In reality, for a twenty-six-year-old art student, these were comparatively modest accomplishments. His fellow American students at the Munich Academy, William Merritt Chase, Frank Duveneck, and Walter Shirlaw, had come under the influence of Wilhelm Leibl, Munich's premiere anti-academic realist. Returning to New York, they had helped found the breakaway Society of American Artists and the Art Students League and by the mid-1870s were well established. Koehler, by contrast, was still only gradually learning his craft. He therefore must have been delighted to have two still-life paintings accepted into the annual spring exhibitions of the National Academy of Design in 1878 and 1879. These gave little hint of the social engagement that would mark his work of the 1880s. The 1879 still life is essentially a study of heavy-hanging, warm-colored drapery and a crumpled carpet (Fig. 1). A dark, high-backed armless chair upholstered in black leather emerges from the drapery. An arrangement of seemingly unrelated accessories

features a tall sword and brass pitcher perched on top of what appears to be a stack of manuscripts and portfolios. A large, disintegrating leather-bound book leans against the floor stand of a dark, stained globe while a dried-out laurel wreath encircles the hilt of the sword. This hints at a theme of past glory in keeping with the worn appearance of all that surrounds it.

Picturesque decay prevails in another modest painting of 1879, entitled *Ninth Avenue*, wherein Koehler experimented with a loosely painted but densely opaque landscape of several ramshackle dwellings on the edge of Manhattan (Fig. 2). *Ninth Avenue* does suggest at least an incipient social consciousness, with its implication of precarious poverty on the outskirts of America's emerging commercial and financial capital.

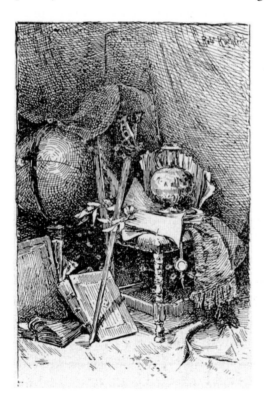

FIGURE I
Robert Koehler, *Still Life with Sword,*
etching, 1879

In search of direction, and dependent on routine lithography to make ends meet, Koehler needed a sponsor, as does any young, underprivileged artist. Through a close friend from Milwaukee working in New York, he finally acquired one. Edwin Henes, who had landed a good office job at the Hell Gate Brewery, introduced him to its German immigrant owner, George Ehret, who, impressed by Koehler's work and work ethic, provided him a stipend to complete his studies abroad.[18] This break allowed him to return to Munich in the fall of 1879 and enter the painting class of Ludwig Loefftz, a recognized landscape and genre painter who had already approved him as qualified for the class four years earlier.[19] Toward the end of the term, perhaps as the final class assignment, Koehler painted a portrait of an old peasant that remained unsigned and undated until early 1881 (Fig. 3).

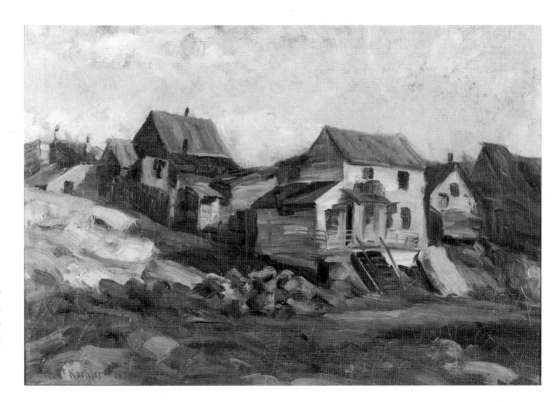

FIGURE 2
Robert Koehler,
Ninth Avenue, o/p, 1879
(private collection)

This work marked the beginning of Koehler's most creative period, during which he proved adept at depictions of anonymous working-class people, both urban and rural, industrial and agricultural. He would demonstrate an affinity for portraying particularly individuated women, not merely as passive portrait subjects, but as vital, assertive beings alertly engaged in a variety of activities.

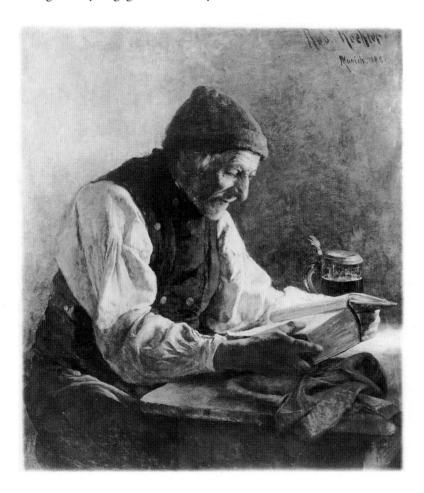

FIGURE 3
Robert Koehler, *Holy Day Occupation*, o/c, 1880–81 (Pennsylvania Academy of the Fine Arts, Philadelphia, Pennsylvania)

Images of Women

MUNICH, 1879–92

ROBERT KOEHLER'S SECOND STAY IN MUNICH, from 1879 to 1892, opened with the genre painting described in chapter 1: a precisely rendered elderly peasant seated at a rustic table. It closed with two paintings of atmospherically rendered peasant women, one sowing seed and another returning at dusk from the fields, and two other nearly contemporaneous depictions of young, leisure-class women. Koehler's turn to such nonthreatening subject matter so soon after his crisis-ridden representation of the urban working class, *The Strike*, was likely related to major developments in his personal and professional life that gradually distanced him from his family origins. His depictions of fashionable individuals in cosmopolitan café scenes may likewise be read as reflecting potential changes in his social status.

Perhaps the most revealing statement of this aspiration, created in the midst of Koehler's most class-conscious period, is a painting of polite bohemianism: a young artist sitting with friends in a Munich beer garden. It was through his art studies, after all, that this slightly disabled son of the working class sought access to the upper middle class. He would seal this quest by marrying a woman of higher social rank and by counterbalancing his powerful representation of revolutionary protest by organizing and leading artists' groups, curating museum exhibitions, and administering an art school. In fact, it was these executive accomplishments, mainly forgotten today, that would be eulogized in obituary tributes, while the works for which he is remembered today went largely unmentioned.

The first significant painting of Koehler's thirteen-year Munich sojourn belongs to a popular Bavarian genre that Koehler chose or was assigned as an exercise by his teacher, Loefftz. Entitled *Holy Day Occupation* (Fig. 3) at its permanent abode, the Pennsylvania Academy of the Fine Arts in Philadelphia, it depicts a gnarled, white-whiskered old man sitting at a coarse wooden table. He wears a knit cap, full-sleeved heavy linen shirt, and buttoned-up vest. Light shines from the upper right in a traditional Caravaggesque manner, indicating a nearby lamp or window. He holds a thick book he has started to read, his slightly parted mouth perhaps pronouncing each word. The painting's alternative title, *A Holiday Occupation*, explains the man's tankard of beer, his clean white shirt, and what is most likely his best vest, trimmed with silver buttons. Since he appears to be a peasant, even if he skips field labor for a day or for a weekend, he would perhaps still have animals to tend. If the book is a Bible, as has been assumed, it could indeed be a Sunday, which accords with the title given the work by a venerable German art encyclopedia, *Eine Sonntagsbeschäftigung* (A Sunday Occupation).

The rustic figure resembles the country folk favored by Wilhelm Leibl, who specialized in painting Bavarian peasant life: for example, the five similarly attired elders of his 1876 *Village Politicians* (Fig. 4). Possibly following its strand of Leibl's work, Koehler's brushwork became relatively tight and deliberate, an approach he continued throughout his career. In contrast, Leibl's alternative style, inspired by Frans Hals, captivated a generation of American artists, including Robert Henri, and was demonstrated to Koehler when he visited the young Frank Duveneck's studio-school in Venice in the summer of 1880. Duveneck, in fact, employed that style's impasto techniques in his single-brush oil portrait of Koehler painted on this visit (frontispiece). Viewed from a distance, its thick strokes fuse into a tenebrist contrast of illuminated surfaces that stand out against the deep shading of the face as it sinks into total darkness.

Koehler experimented with a similar technique in a few minor studies like *Head of an Old Woman* (Fig. 5), probably done in the early 1880s. While the black bonnet, white hair, fur collar, and the lower planes of the aged face appear to have been deliberately abstracted into a relatively undescriptive surface of orderly brushstrokes, the deeply set eyes, distinctive nose, and thin-lipped mouth unmistakably define an individual.

These early experiments make clear that Koehler's stylistic development ranged from precisely finished figures to out-of-focus, sparsely detailed figures that occasionally even lack clearly recognizable facial features. His more conventional figural style is evident in a Leibl-like half-length portrait of a dark-eyed young woman with two blossoms attached beneath the small lace collar of her black dress (Fig. 6).

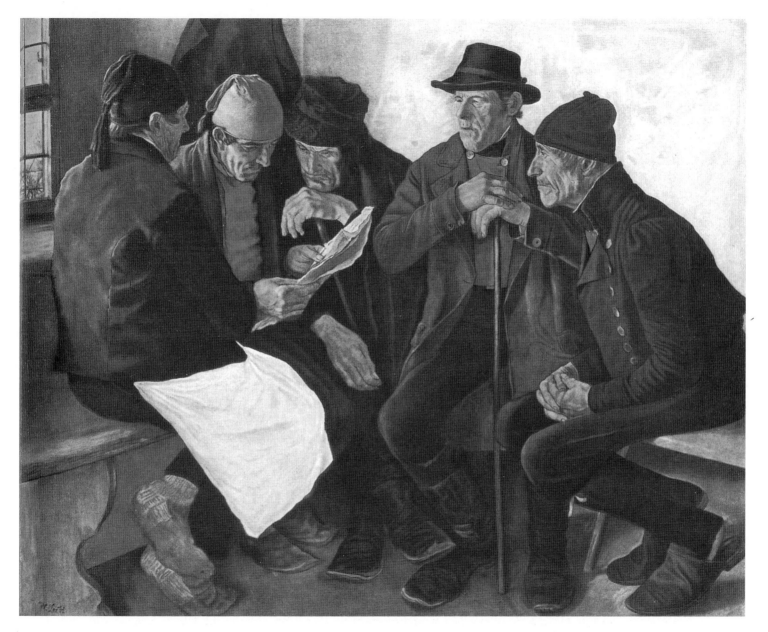

FIGURE 4 Wilhelm Leibl, *Village Politicians*, o/c, 1876 (Oskar Reinhart Foundation, Winterthur, Switzerland)

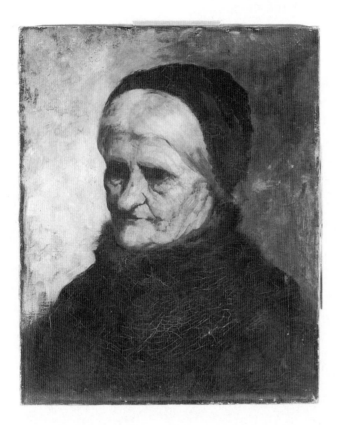

FIGURE 5
Robert Koehler, *Head of an Old Woman*,
o/c, c. 1881 (The Minneapolis Institute of Arts,
Minneapolis, Minnesota)

In *Portrait of Woman with a Book* (Fig. 7), the mature, seated woman also wears black, enlivened with late Biedermeier accessories. Fur-trimmed cuffs, a V-neck lace collar, and dangling earrings compete for attention with a white headpiece. Illuminated from her right, the woman's contemplative expression matches the stillness of her hands resting on her lap. She marks a page in her book with her forefinger, perhaps daydreaming or pondering what she has been reading. Koehler portrays an intelligent, literate woman, an image that would recur in other paintings of this period.

Another seated but more actively engaged woman figures in *Prosit!*, an etching for which Koehler did several preparatory studies. She clinks her small, lidded beer mug against a larger one held by her male counterpart (Fig. 8).

Seated at the end of a coarse wooden table on a stool, the woman's drinking companion wears a mixture of peasant and industrial worker clothing. While his visored cap is of a type often worn by urban workers, the loose-sleeved jacket hangs over long cloth pants, commonly worn in the country, that tighten around his ankles above high-top field shoes.

The woman's chair and attire are, in contrast, quite fancy. The heart-form back support and spindle legs of the *Brettstuhl* identify it as southern German or Austrian. Her straw hat has the crown, velvet band, and broad brim of workaday *Tracht* worn in the fields of East Tirol. Koehler likely saw such details of dress, including the neck scarf, full

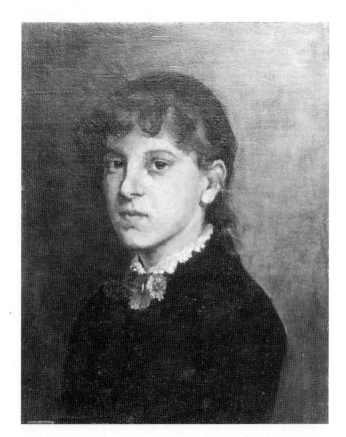

FIGURE 6
Robert Koehler, *Portrait of a Young Woman*,
o/c, early 1880s (private collection)

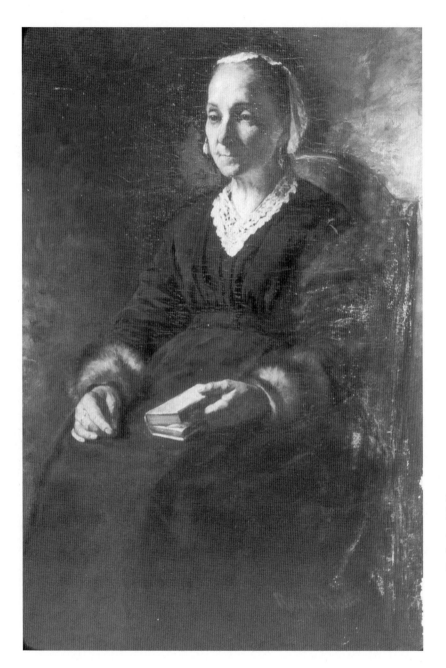

FIGURE 7
Robert Koehler,
Portrait of Woman with a Book,
o/c, early 1880s
(private collection)

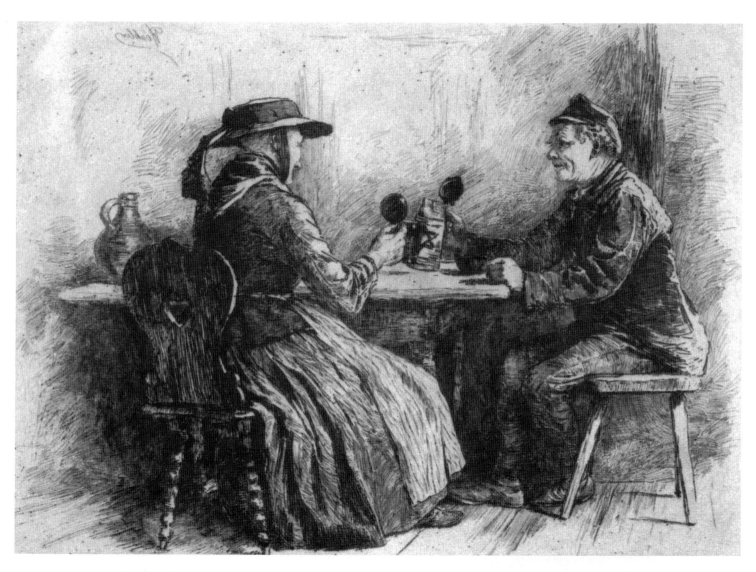

FIGURE 8 Robert Koehler, *Prosit!,* etching, mid-1880s (The Minneapolis Institute of Arts, Minneapolis, Minnesota)

skirt, and apron, during an excursion into southeastern Austria, a region he commemorated in a quiet, souvenir pic-
ture, void of figures, entitled *A Courtyard in Brixen, Tirol.*

A possible commentary on the rapidly changing economy, the man in *Prosit!* may be a worker who has returned
from the city to visit his native rural area, where he enjoys a visit with a relative, perhaps a sister, who has decorated
her hatband with a bow and trailing ribbon for the occasion. By the late nineteenth century, many uprooted workers
were forced to go wherever industry provided employment. That this could cause personal estrangement is further
suggested in Koehler's roughly executed *The Smoker* (Fig. 9). Wearing the ubiquitous workers cap, black vest, and

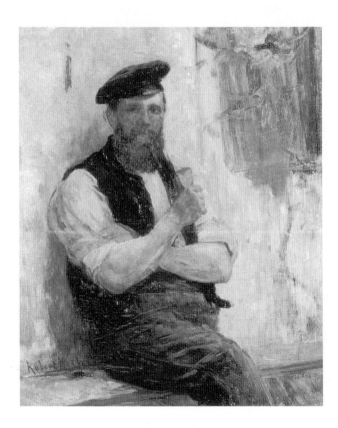

FIGURE 9
Robert Koehler, *The Smoker*, o/c, early 1880s
(private collection)

white shirt with rolled-up sleeves, this younger man, sporting a full dark beard, stares at us blankly. In keeping with this lack of affect, the nondescript setting is limited to a makeshift bench, a crumbling stucco wall, and a blurred window, obscured further by the tips of an out-of-focus tree branch. Such ambiguity, and the figure's relative inactivity, contrast sharply with the more elaborate, highly detailed paintings Koehler made during these years.

Drawing upon a traditional beer-drinking genre popularized in the seventeenth century, Koehler's *The First Guests* (Plate 2) dates from 1887, one year after *The Strike*. Doubtless basking in the latter painting's success, he here portrays two art students enjoying a leisurely springtime moment in a Munich beer garden, perhaps that of the Englischer Garten next to the Chinese Pagoda. Its fairytale trees, to which a good half of the composition is dedicated, barely sprout their new leaves. A cleaning woman wipes off tables, a background anecdote to which attention is drawn by a line of three chickens and the diagonal of a portable easel. The latter accompanies an umbrella, several rolled-up canvases, and a paintbox belonging to the centrally located young man dressed as a dandy. Like his working-class counterpart in *Prosit!*, this good-natured artist, ready for another sip of beer with his companion across the table, smiles at a lively young woman facing him on the bench. She holds a small open book, and appears to be referring to it, lips slightly parted in a smile, as she looks the artist steadily in the eye. She could be a waitress with an account book, but it seems unlikely that a waitress would sit down in such a familiar manner to accept payment. Her patterned blouse, full apron, and unbraided hair pulled back in a bun were altogether proper daytime wear for middle-class young women in Bavaria at the time. While she could not have been a student at the male-only Royal Art Academy, she does appear to be obviously intelligent and a good friend of the two art students, perhaps the daughter of the beer garden proprietor.

Koehler's *Afternoon in a Café* (Fig. 10) was exhibited in the First Annual Munich Exhibition in 1889. In this work, a seated, apparently patrician lady, wearing a brightly patterned lace-trimmed dress and feathered hat, looks down at her little blonde daughter, equally elegant in a short beribboned frock and a plumed hat much larger than her mother's. Together they stand out among more than two dozen figures divided into three clusters—essentially a trio of group portraits.

Although this painting followed *The Strike* by only three years, the subject matter could hardly be further removed from the earlier work's portrayal of a swarm of disgruntled industrial workers in a smoke-infested wasteland. Now, a palatial *Gründerzeit* interior buzzes with smartly dressed male customers enjoying a leisurely hour or so, seated around marble-topped tables on up-to-date bentwood Thonet chairs. Their conversing, chess playing, and newspaper reading

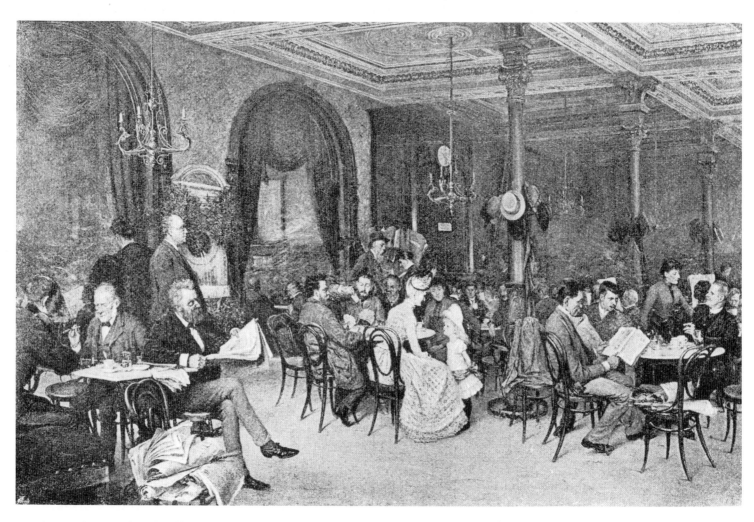

FIGURE 10 Robert Koehler, *Afternoon in a Café*, o/c, 1889 (whereabouts unknown)

are too affectionately portrayed to be considered targets of social criticism. The two or three barely visible waitresses are in no way presented as underpaid victims of exploitation. *Afternoon in a Café* clearly speaks to Koehler's increasing desire to move out of the working class into which he was born, and to whose betterment he had so recently dedicated his supreme efforts as a mature art student.

The quest for upward mobility in the face of all obstacles, that quintessential American motivation, seemed to have intensified for Koehler during the summer of 1886, since it was then that he met his future wife, Marie Fischer, the daughter of a prosperous engineer. Beginning at her family's vacation home in the picturesque town of Überlingen overlooking the Bodensee (Lake Constance) in southwestern Germany, the courtship lasted nine years before the couple finally married.[1] During this extended period, paintings of women, mostly of the middle class but a few of peasant stock, figured very prominently in Koehler's work.

At the Café (Fig. 11), either a forerunner or successor of *Afternoon in a Café*, places a finely dressed young woman on vulnerable display. She sits alone at a marble-topped table, fidgeting with her hands as she looks toward a chair upon which her absent male companion has left his top hat and umbrella. If the newspaper rolls are any indication, he has apparently been spending much of their time together reading, contributing to her uneasiness. Her edginess may also relate to her awareness of the army officer in the background. Seated before a large window through which a city street and buildings are visible, he interrupts his conversation with his fellow officer and—taking advantage of the absence of the woman's companion—adjusts his monocle for a better look.

Male neglect and exposure to the intrusive male gaze are clearly the point of the painting—themes possibly related to Koehler's own lengthy absences from Marie. Although she confessed in her reminiscences she had secretly yearned to marry him, other "more practical and advisable" suitors had appeared as well, including "a pensioned major" who disliked the attention she was receiving from the American artist.[2] This may explain why Koehler portrayed the brash interloper in military uniform. Whatever its personal sources, the painting offered a pointed critical commentary on late-nineteenth century social conventions and gender relations which Koehler knew well from his life in Munich, and which writers like Edith Wharton, Kate Chopin, and Charlotte Perkins Gilman would soon explore in an American context.

Koehler's *Love's Secret* (Fig. 12), exhibited along with *The Smoker* (Fig. 9) at New York's National Academy of Design in 1890, explores gender themes from a different perspective. A young woman, aglow in the sunlight, shares a

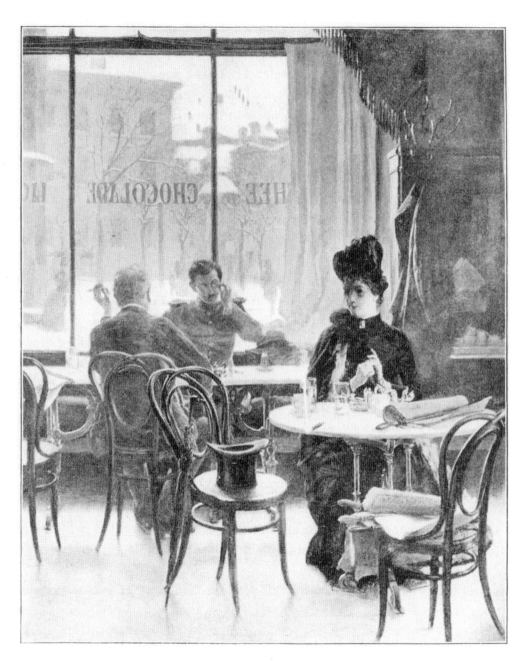

FIGURE 11
Robert Koehler,
At the Café, o/c, 1889
(private collection)

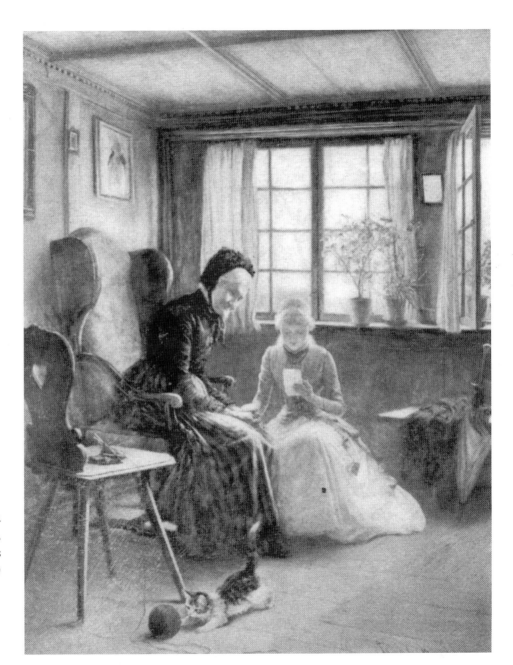

note, perhaps a marriage proposal, with a much older woman, possibly her grandmother. Koehler's choice of this traditional sentimental theme may refer to his romantic condition at the time, revealing his hope that his own letters to Marie would have the same weighty significance. The twitching tail of the cat stalking a ball of yarn points to the all-important message. The heart-backed *Brettstuhl* appropriately reappears, this time as a *repoussoir*, leading the eye to the primary figure, who leans forward from her high-backed armchair to hear the relayed message. Looming large in a confined space, her monumentality dwarfs the young woman who is apparently sitting on a footstool; this underscores the role of a respected advisor who has come by to offer counsel.

It may be more than coincidence that Koehler clothed this wise elder in a dark striped walking dress and small black bonnet. Except for the apron, this attire is almost identical to that of the advice-giving or appeal-making woman at the center of *The Strike*. His major shift, however, from a theme of large-scale economic crisis and class conflict to one of intense domesticity, from social turmoil to romantic complications, reflects the transformation Koehler was undergoing. The Sturm und Drang of an extended student period was at last modestly paying off at age forty, and a permanent position of teaching and art administration in America, plus a comfortable marriage, lay just over the horizon.

Any inclination Koehler might have had to pursue the political tendentiousness and radical implications of *The Strike* quickly gave way to less fraught topics of social criticism and eventually to complacent, uncontroversial portraits, watercolor landscapes, and sporadic etchings. From here on out, *The Strike* was on its own as a radical social critique of the new industrial order.

Koehler's interest in exploring the situation of women continued throughout these Munich years, however, and indeed to the end of his career. A pair of garden paintings from the early 1890s (Figs. 13 and 14), in which he came closest to Impressionism, identify contemplative women with nature. Both likely portray his fiancée Marie. In the first, the woman turns her back on a shadowy grove to relate more intimately to the flowers immediately in front of her. Isolated, she is absorbed in her book.

The two paintings share common elements—a leafy background, a white tablecloth, a peculiar, green-painted wooden chair with a two-part back—but they are otherwise quite different. In the first, the white-clad woman reads alone after finishing her tea. In the other, portraying a social encounter, the woman in white is the visitor, sitting stiffly upright on the chair. She sports a plumed summer bonnet and sniffs a rose blossom as she shares a steady gaze with

the little blonde girl opposite her, presumably the daughter of one of the two women. The lack of a hat identifies the dark-attired woman facing us as the hostess. She is attentive to what the other woman is saying, her facial expression and stiff-armed body language registering a hint of tension.

In contrast to mothers and grandmothers teaching children to read, as in Chardin's *La Bonne Education* (1753) and Franz Defregger's *The First Lesson* (1885); women reading a Bible at worship, as in Leibl's *Three Women in Church* (1878–82); or, for that matter, women sharing love letters, as in Koehler's *Love's Secret*, a woman reading in solitude proved an increasingly popular motif among progressive painters of the later nineteenth century. Well-known examples include James McNeill Whistler's etching *Reading by Lamplight* (1858); Winslow Homer's watercolor of a young woman lying on her side at the edge of a woods reading a book, *The New Novel* (1877); and Mary Cassatt's portrait of her mother reading *Le Figaro* (1878). Koehler's placement of his young female reader in a sylvan outdoor setting puts his work in company with Frank Dicey's *The Novel* (1880), Peter Kroyer's *Rose Garden* (1893), and Walter Palmer's more loosely Impressionist *Afternoon in the Hammock* (1882). Such works may be interpreted variously as suggestive of educated intelligence, self-sought independence, or involuntary isolation and social estrangement. In any case, they challenged the more typical objectification of women in relation to male subjects.

In the same year that Koehler portrayed his white-clad fiancée in a wooded garden setting (1892) he exhibited *Judgment of Paris*, an updated interpretation of an ancient Greek myth, typically depicting three female nudes, as in Peter Paul Rubens's 1636 painting. In Koehler's whimsical peasant variation, now surviving only as an etching (Fig. 15),[3] Hera, Athena, and Aphrodite, minus their guide Hermes, sit chastely clothed in a newly harvested grainfield. The most pronounced figure is not Paris, as one would expect, assigned to judge the beauty of the three, but Aphrodite, who forcefully addresses the smiling young man sprawling in the back of the circle with the golden Apple of Discord in his hand. Attired in a full, pleated dark skirt, white apron, and headscarf tied in back, she opens her left hand toward him, seemingly offering the winning bribe as the other two women listen attentively. In place of a male-dominated encounter, Koehler illustrates a dialogue that, for the moment, at least, is led by the woman. Once again, as in *The Strike*, the central figure is an assertive woman.

Peasant women take to the field in the final pair of genre paintings marking the close of Koehler's Munich period. As if the foremost figure from the rest period depicted in *Judgment of Paris* had returned to work, the female figure in *Sower* (Plate 3) shoulders a sheet of heavy white cloth loaded with seed and sows a freshly plowed field. The fading

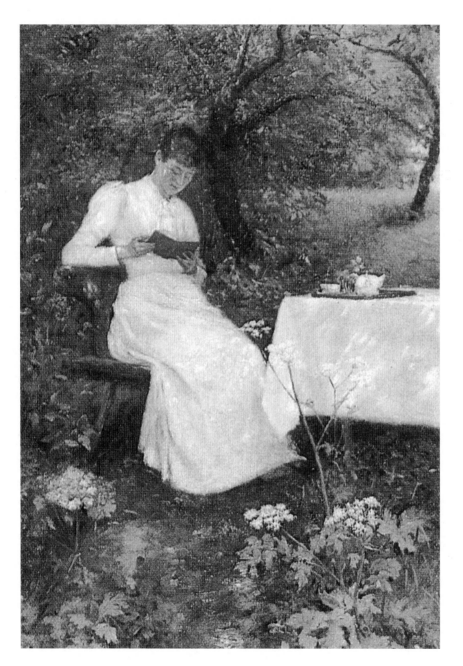

FIGURE 13
Robert Koehler, *Woman Reading in a Garden*, o/c, early 1890s (private collection)

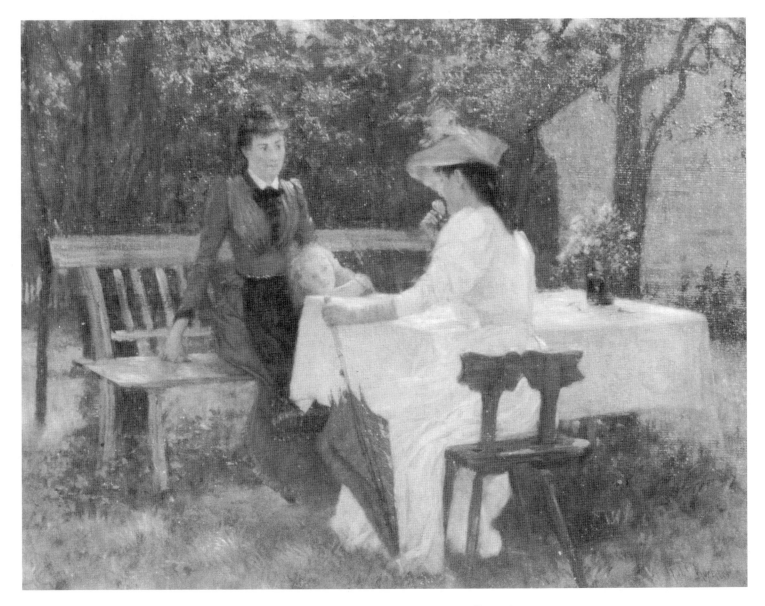

FIGURE 14 Robert Koehler, *Conversation in a Garden*, o/c, early 1890s (private collection)

FIGURE 15 Robert Koehler, *Judgment of Paris*, etching, 1892

light of sundown blurs her upper body and outstretched arm and casts her solemn face in deep shadows while softly highlighting the outline of her determined chin.

A similar low-lying light source helps to define the right arm and water bottle of the smaller-scaled woman in *Homeward Bound* (Fig. 16). Rake over shoulder, she looks back toward a plowman and his horse still working a field.

FIGURE 16
Robert Koehler,
Homeward Bound, o/c,
early 1890s (on loan to
West Bend Art Museum,
West Bend, Wisconsin)

Along with the distant tower-topped barn, the figures rise slightly above the horizon as the painting's attention-holding focal points. In both paintings, the fading light and picturesque treatment soften the exhausting reality of farm labor, a reality that Koehler also tended to downplay in his depictions of nonagricultural work a decade before. At the same time, the two paintings for which he is best remembered, *The Strike* (Plate 1) and *The Socialist* (Plate 4), abandoned the sentimentality of genre conventions by forcefully portraying the gritty reality of exploited labor in revolt, marked by incipient violence among the angry workers walking off their jobs.

3

Koehler's First Worker Images
and *The Socialist*

MUNICH 1879–85

ALONGSIDE REPRESENTATIONS OF BOURGEOIS WOMEN, middle-class café scenes, socializing art students, and romanticized peasants, Koehler in these Munich years also portrayed urban workers and craftspeople followed by a memorable image of a socialist agitator. These bring us closer to his masterpiece, *The Strike*, to which we turn in Part II.

In *The Carpenter's Family* (Fig. 17), dating from the early 1880s and exhibited in Munich in 1891, the carpenter himself is absent, although his presence is invoked by his precisely rendered workbench and tools. Vermeerlike light streaming through a window illumines the young wife as she breastfeeds her baby. The couple's poverty is indicated by her simple clothing and by the cradle's location, suggesting that the workroom also serves as the family's dwelling. The cradle's mangerlike appearance links the painting to the Renaissance *Madonna dei Latte* tradition. Koehler's avoidance of an overly academic finish, particularly in the treatment of the wall surfaces and the broken floorboards, resembles Franz von Defregger's many interior studies of impoverished Tyrolean cottages dating from this same period.

The central figure in *Her Only Support* (Fig. 18), painted, etched, and exhibited in 1883, is another poor woman who stands before the workbench of a machinist to whom she has brought a broken sewing machine part. Dressed for cold weather in an old-fashioned Biedermeier dress, apron, shawl, and headscarf, she is accompanied by her little

FIGURE 17 Robert Koehler, *The Carpenter's Family*, o/c, early 1880s (private collection)

FIGURE 18
Robert Koehler,
Her Only Support,
etching, 1883

daughter, who looks up at the object of concern. The machinist, holding the broken part in his hands, listens attentively as the woman explains the problem. Their human interaction is one of trust and compassion. Whether the title refers to the mother or the machine, it expresses a critical dilemma of cottage industry: dependence on fragile mechanical equipment for one's meager livelihood. The hoped-for aid in this case must come from the seemingly capable and confident machinist, possibly an allusion to Koehler's father Ernst back in Milwaukee. The major diagonals of the composition converge on him, even though the dark forms of the woman and her large wicker basket stand out more prominently, establishing the flow of the narrative from the lower right corner to the overhead lamp and the arched window opening.

In *Twenty Minutes for Refreshments* (Fig. 19), a woman sits on a partially enclosed heavy-duty wheelbarrow, built to carry heavy stones for use in constructing the scaffolded building in the background. No visitor, she is dressed for labor and drinks from the same type of tin canteen as the smiling male co-worker who stands beside her. The black form of her skirt anchors the composition, counterbalancing his dark hair and hat silhouetted against the sky. As in *Her Only Support,* the spatial relationship between the two workers is determined diagonally by the figure of the woman. In this case, however, her bright white headscarf and lively striped blouse are in keeping with their relaxed interchange and easy camaraderie. Although both are momentarily at rest, their hard work is indicated by the smudges on her leather apron and on his hat, pants, and shoe. In contrast to Koehler's slightly later depictions of leisurely ladies, this painting acknowledges without monumentalizing or allegorizing Germany's multitude of laboring women. It simply documents the presence of one of them on site, as if photographed off guard.

Koehler's only factorylike interior, *Smithy in Bavarian Highlands* (Fig. 20), was exhibited at the National Academy of Design's spring annual in 1885. Amid a hearth, anvils, and a massive steam-driven forge, three men are hard at work under the solidly beamed roof. Standing stock still, hands behind her back, thumbs hooked together beneath her long braids and apron bow, a little blonde girl—the first of several in Koehler's work—silently observes the scene. A blacksmith in wooden shoes labors at stage center. A heavy chain and hook hang against his bent back as he concentrates on forging a red-hot metal rod grasped in tongs he has selected from the assortment hanging on the wall. His skills demonstrate the persistence of time-honored craftsmanship, but changes in factory labor caused by new machinery intrude upon him.

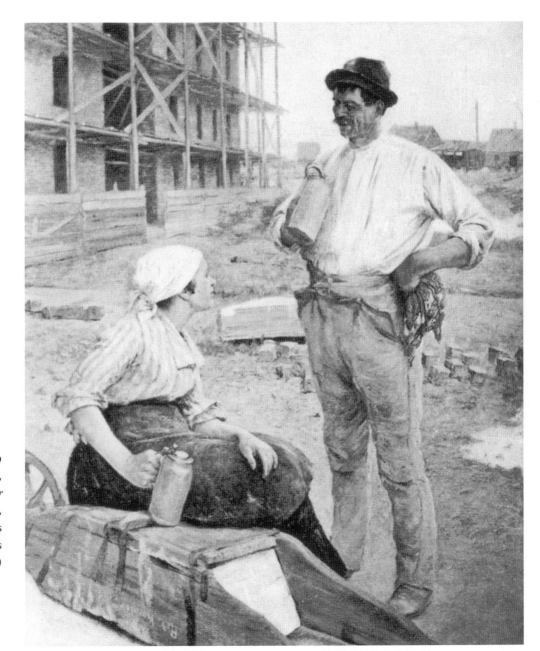

FIGURE 19
Robert Koehler,
*Twenty Minutes for
Refreshments*, o/c,
early 1880s
(whereabouts
unknown)

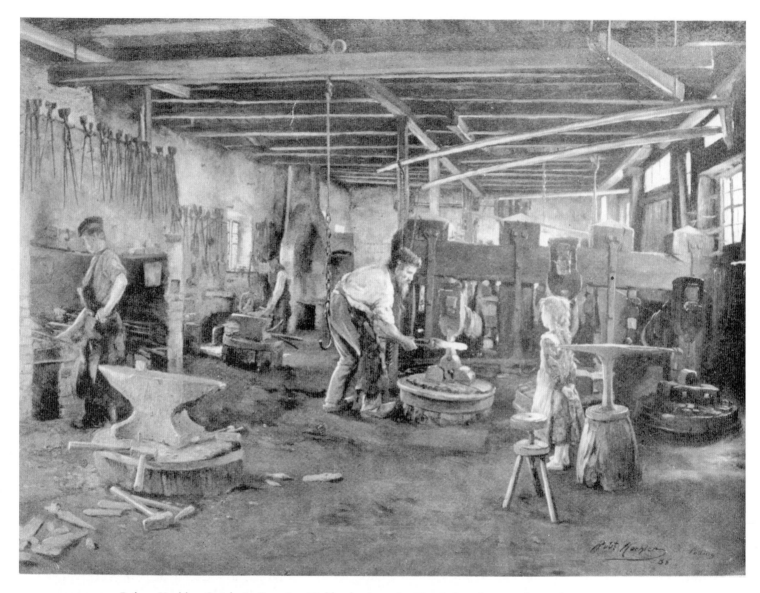

FIGURE 20 Robert Koehler, *Smithy in Bavarian Highlands*, o/c, early 1880s (whereabouts unknown)

The Socialist: Koehler's Ambivalent Response to Working-Class Radicalism

Even as Koehler chose to depict this traditional scene, labor unrest and ideological ferment were roiling the urban-industrial world in Europe and America. With machines rendering handicraft rapidly obsolete, factory owners, intent on cutting labor costs, demanded long hours at the lowest possible wages from a modestly skilled workforce. Industrial unrest increased and many labor leaders responded to the appeal of Socialism, whether the internationalist revolutionary version of Karl Marx and Friedrich Engels or the gradualist, politically based version advocated by Ferdinand Lassalle and others. To the dismay of conservatives, Lassalle founded Germany's first workers' party in 1863 and Marx and Engels launched the International Workingmen's Party a year later. In 1878, as Socialists gained political strength, the German Reichstag under Chancellor Otto von Bismarck passed a stringent anti-socialist law, the *Sozialistengesetz*, "against the socially dangerous aspirations of the Social Democrats" ("gegen die gemeingefährlichen Bestrebungen der Sozial-demokratie"). This draconian measure, however, only intensified support for Socialism among industrial workers, whose parliamentary representation increased in the later 1870s and early 1880s.

It was in this volatile political climate that Koehler followed up his smithy painting with a small but provocative work, *The Socialist* or *Social Democrat* (Plate 4). This dramatically close-up figure was painted in Munich during 1884–85 in the heavily impastoed, realist style currently popular among the most progressive Munich artists. The firebrand speaker, a red ribbon hanging from his breast pocket, stands out against a murky, scarcely defined background. A note-taking scribe, perhaps a reporter, calmly sits below and behind the speaker's raised arm. Audience members' hats and coats hang on the wall opposite. Light from above illuminates the speaker's upper body, his clenched fists, and the well-thumbed newspapers, including one called the *Sozialist*, spread out on the red-draped table that he appears to be pounding. The face thrusts forward and glares out at us, coarsely complexioned, wrinkled and narrow, framed by thick and disheveled reddish hair and moustache. Koehler's enraged socialist outperforms the central figure in Daumier's 1848 *The Uprising* and anticipates John Steuart Curry's fanatic John Brown of some fifty years later.

A more immediate comparison may be made with the best-remembered painting of the prolific Berlin-based genre painter Ludwig Knaus. Painted in 1877, it is known as *Der Unzufriedene* (The Discontented One), but was originally entitled *Der Sozialdemokrat* (Fig. 21). Koehler's orator, in fact, might be identified as the same man, matured into a highly energized political activist. Knaus's figure appears in workers' clothing slouched in a pub with a cigar and a

small mug of dark beer that his melancholy prevents him from enjoying. A red cloth sticking out of his jacket pocket hints at his political affiliation and a possible reason for his state of mind. The leaflet attached to the wall in the upper left corner summons all citizens, craftsmen, and workers to vote in the upcoming Reichstag election—an election in which the Social Democrats did, in fact, gain twelve seats. The nearest of the newspapers hanging on the wall and the one on the table are issues of the city's first Socialist daily paper, the *Berliner Freie Presse*.

Despite these promising signs, an urban-based socialist worker of 1877 would have had cause for glum discontent. In both Germany and the United States, an anti-labor, anti-radical backlash was on the rise. In America that year, a national strike by railroad workers protesting wage cuts was put down by government troops dispatched by President Rutherford B. Hayes. In Germany, intensifying anti-radical sentiment would reach near-hysterical levels in early 1878 following two assassination attempts against the aging Kaiser Wilhelm I as he rode in an open carriage on Berlin's Unter den Linden. On May 11, a politically unaffiliated young apprentice fired three revolver shots at the Kaiser without hitting him. On June 2, a mentally disturbed academic, Karl Nobiling, seriously wounded the Kaiser with a shotgun blast and then turned the gun on himself.[1]

In response, an alarmed Reichstag in October 1878 enacted Bismarck's legislation banning socialist publications and authorizing the police to break up socialist meetings. Such, then, was the explosive political climate that gave rise to Ludwig Knaus's painting of a demoralized socialist. As art historian Agnete von Specht has noted, the muzzled dog lying next to the silenced worker may be interpreted as a symbol of the gathering forces of political suppression.[2]

In this context, whether Koehler's painting of a fiery orator at a forbidden assembly, with what under the Socialist Law would have been illegal newspapers prominently in view, was created in fear or in support (or some ambivalent mix of sentiments) is open to debate. If fear were the impetus, as von Specht speculates, Koehler would have been ostensibly alarmed by the rapid growth of radical socialism, including the increasing number of German socialists-turned-anarchists advocating violent action.

A good number of these radicals were in the United States by the mid-1880s, having fled Bismarck's crackdown. Among these exiled revolutionaries, who would certainly have delighted in Koehler's dynamic image of revolutionary rage, was Johann Most (1846–1906), an Augsburg-born bookbinder turned Marxian socialist and radical street orator in Vienna. Imprisoned and then deported to Germany, Most edited socialist publications, including Berlin's *Freie Presse*, and in the 1870s was twice elected to the Reichstag. Expelled from the Lassallean Socialist Workers Party for

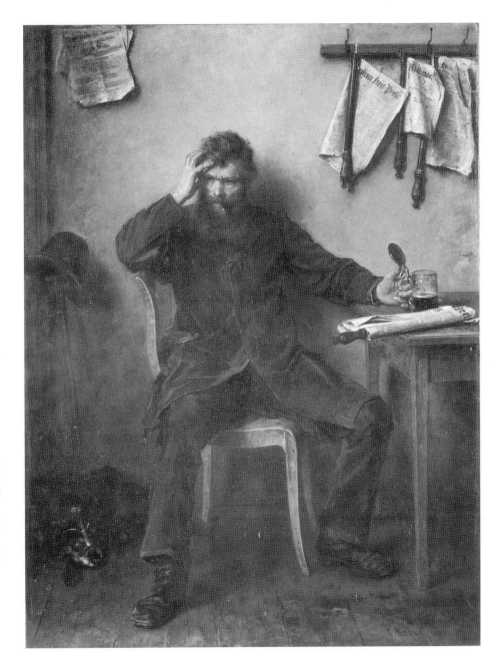

FIGURE 21
Ludwig Knaus,
Der Sozialdemokrat
(The Social Democrat),
o/c, 1877 (Deutsches
Historisches Museum,
Berlin, Germany)

advocating terrorism and the anarchist doctrines of the Russian Mikhail Bakunin, he was imprisoned under the 1878 Socialist Law. After his release he settled in London where he founded a newspaper, *Die Freiheit*. Moving on to New York in 1883, he led the Marxist International Working People's Association, commonly known as the "Black International," advocating "the propaganda of the deed" (a phrase borrowed from Peter Kropotkin) and calling for the destruction of "the existing class rule" by any means necessary.[3] One newly invented means was Alfred Nobel's dynamite, with which Most became obsessed, publishing instructions for producing it in *Die Freiheit* and in an 1885 pamphlet entitled "The Science of Revolutionary Warfare."

At precisely this moment, Robert Koehler's *The Socialist* went on display at New York's National Academy of Design annual spring exhibition in 1885. The terror inspired by Most's "propaganda of the deed" may well have underlain the description that accompanied a woodcut interpretation of the painting in the edition of *National Academy Notes* published in conjunction with the exhibition (Fig. 22). Addressing patrons wary of labor unrest and foreign-born agitators, it reads: "A German Socialist propounding His Bloodthirsty Ideas." Despite this proviso, the mere presence of a realist painting of rabid radicalism, potentially a Black Internationalist, in the midst of innocuous portraits, landscapes, still-lifes, and classical allegories must have shocked many exhibition visitors. That the "blood-thirsty" agitator could possibly portray a fugitive German revolutionary recently arrived in New York City would have intensified their anxiety. Indeed, the poorly executed engraving in the exhibition catalogue makes the orator with his exaggerated staring eyes appear even more frightening than in the original painting.

The painting's American reception took a new turn that November when a better engraving (Fig. 23) appeared in the recently established *Century Magazine* to illustrate an article entitled "Danger Ahead" by Lyman Abbott, a Brooklyn Congregationalist pastor and reform-minded editor of a liberal religious periodical, *The Christian Union*. The creative engraver, identified only as "T. Johnson," introduced teeth to the orator's mouth and demonic swirls of smoke around the upraised arm and clenched fist, making his already inflammatory appearance even more sinister. In the accompanying article, Abbott warned of growing hostility between powerful and greedy capitalists with vast influence over all levels of government and "honest workmen" lured into trade unions led by "clan-like chiefs" who provoke them to doomed and counterproductive strikes. But even more dangerous to workers' interests, he declared, were the anarchists armed with dynamite and intent on destroying private property and society itself. The editors' selection of Koehler's *The Socialist* was presumably intended to illustrate this terrifying menace. (Abbott's own

idealistic solution to the "danger ahead" was a mildly socialistic "industrial democracy" in which enlightened workers would pool their resources and collaborate with management in a system of "cooperative production" while the government operated the railroad and telegraph systems.)

In response to *Century*'s reproduction of *The Socialist*, the *Milwaukee Sentinel*, the city's oldest newspaper, published an unsigned article entitled "Robert Koehler's Success." The appearance of Koehler's work in "a journal like *The Century*," the article declared, was "flattering recognition" and highly gratifying to "the Milwaukee friends of this promising artist." In evaluating Abbott's article, the *Sentinel* misrepresented it as a mere diatribe against socialism, and while stopping short of labeling Koehler's socialist orator "bloodthirsty," the author declared that he "represents a typical member of that incendiary fraternity earnestly and rather demonstratively expounding his favorite doctrine."[4] The hostility to socialism woven through this "local boy makes good" article doubtless reflects the *Sentinel*'s uneasiness over increasing socialist influence in Milwaukee's own journalism, municipal politics, and cultural life, including the Freie Gemeinde (Freethinkers) and the Southside Turnverein, the initial base of Milwaukee's most successful socialist-politician, Victor Berger, and a succession of radical newspapers starting with the *Sozialist* (1875–78), edited by a young Lassallean immigrant from Austria, Joseph Brucker. (The *Sozialist* newspaper in the foreground of Koehler's painting may represent the Milwaukee paper of that name, though by the mid-1880s it had long since ceased publication.) Other Milwaukee socialist papers included the *Social Democrat*, *Die Arbeiter Zeitung*, *The Emancipator*, *Arminia*, and *Die Volkszeitung*, purchased by Berger in 1893 and renamed the *Wisconsin Vorwärts*.[5]

Later references to *The Socialist* became increasingly infrequent (and decreasingly political) as the painting passed to private owners and disappeared from public view. It was first purchased, together with Koehler's *Her Only Support*, by George Ingraham Seney, a New York banker, railroad investor, philanthropist, and art collector.[6] Seney died in 1893 and the painting was included in the 1894 estate sale conducted by New York's American Art Gallery. In describing *The Socialist*, the catalogue noted the speaker's "violent gesticulations and fiery energy," but, perhaps in deference to its late owner's banking career and philanthropic inclinations, called the painting "a powerful character study of a radical social reformer" rather than hinting at any revolutionary intent. "The type is German," the catalogue added.[7]

Three years later, the socialist newspaper *New Yorker Volks-Zeitung* went even further in discreetly distancing itself from Koehler's depiction of passionate radicalism. While reproducing the painting in its 1897 calendar, the *Volks-Zeitung* simply captioned it "Einer, der seine Meinung Sagt" (One Who Speaks His Mind). This bland characterization

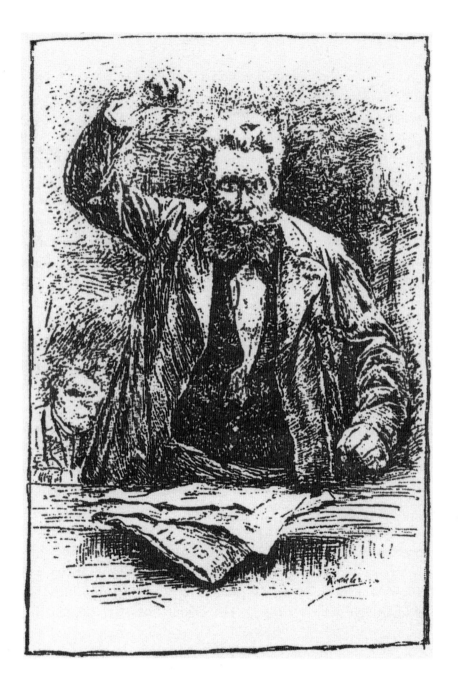

FIGURE 22
Robert Koehler,
The Socialist,
woodcut reproduction
by unknown artist,
*National Academy of
Design Notes*, 1885

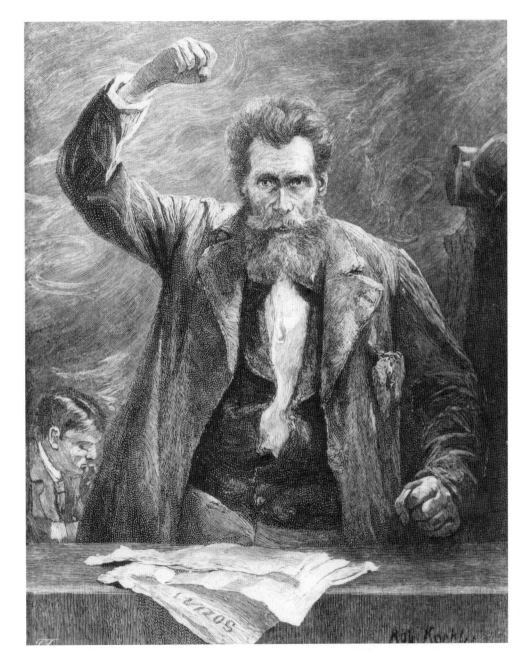

of Koehler's potentially inflammatory painting was echoed in an anecdotal survey of his career published in a 1901 issue of the Chicago monthly *Brush and Pencil*. In a few sentences, the author, Charlotte Whitcomb, praised Koehler's workingmen as "full of strength and vitality." The impassioned orator of *The Socialist*, she noted with studied neutrality, had been "commented on for its quality of crude vigor."[8]

The Socialist would not appear again in print for seventy-four years, and then in a highly unlikely venue. In its summer 1975 issue, *Montana: The Magazine of Western History*, while providing no information about the painting or the artist, reproduced the 1885 T. Johnson engraving to illustrate an article titled "1876 on the Hustings: Centennial Politics in Montana."[9] Responding to an inquiry, *Montana*'s assistant editor explained that, "The choice was simply one of a suitably fiery-looking orator."[10] Thus Koehler's socialist, depicted ninety years earlier performing in a meeting-hall of some German industrial city, became a hard-bitten politician running for office on the Montana frontier! One can almost imagine a Colt .45 revolver protruding from his belt.

From the beginning, *The Socialist* provoked ambivalent interpretations that may or may not have accorded with Koehler's original intent. After an eventful and peripatetic history, it would eventually, as we shall see, be reunited with Koehler's even more memorable painting of labor protest, *The Strike*, and returned to its country of origin.

PART II

The Origin and Initial Reception of *The Strike*

4

Art Historical Background and the Railway Strike of 1877

Robert Koehler's *The Strike* was first shown at the Spring Exhibition of New York's National Academy of Design in 1886. As we shall see, the timing, whether calculated or coincidental, could not have been better. Labor turmoil and violent confrontation reached a crescendo that spring, riveting public attention and creating a ready audience for Koehler's powerful representation of just such a fraught encounter. Attention-getting at the time, Koehler's masterwork drew together contemporary social, political, and economic concerns with an immediacy that continues to engage viewers today.

This background chapter looks at the small number of earlier paintings dealing with the new industrial order and the even smaller number showing instances of labor protest. The chapter concludes with attention to the explosion of labor protest in America in 1877 that decisively influenced Koehler's decision to paint *The Strike*.

Only a few earlier paintings approached the tense interaction of opposing parties in labor disputes so dramatically staged in Koehler's portrayal of some forty completely absorbed individuals at a moment of confrontation between angry workers and their employer. Various paintings of early factory interiors, dating to the beginning of the Industrial Revolution, had exposed their harsh conditions and the workers' backbreaking labor. Among these are Bass Otis's *Interior of a Smithy*, c. 1815; John Ferguson Weir's *The Gun Foundry* and *Forging the Shaft*, 1866 (Figs. 24 and 25); Adolph Menzel's *Eisenwalzwerk* (Iron Rolling Mill), 1872–75 (Fig. 26); Paul Meyerheim's *Machine Factory*,

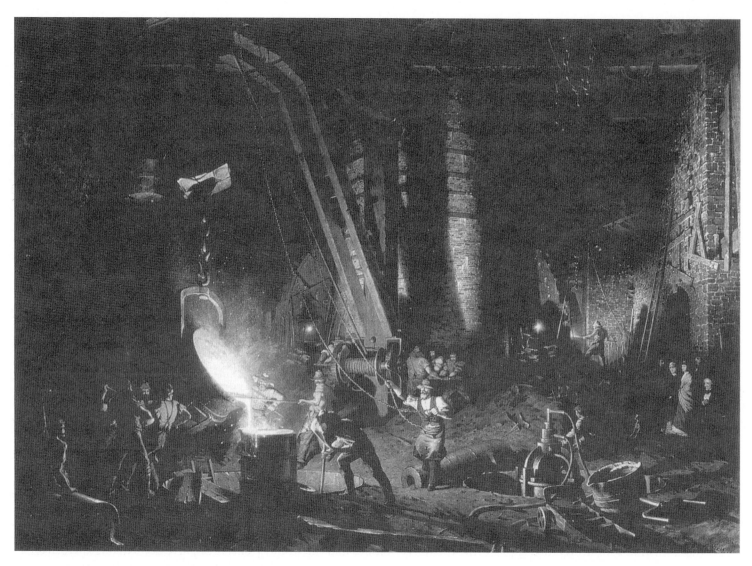

FIGURE 24 John Ferguson Weir, *The Gun Foundry*, o/c, 1866 (Putnam County Historical Society, Cold Spring, New York)

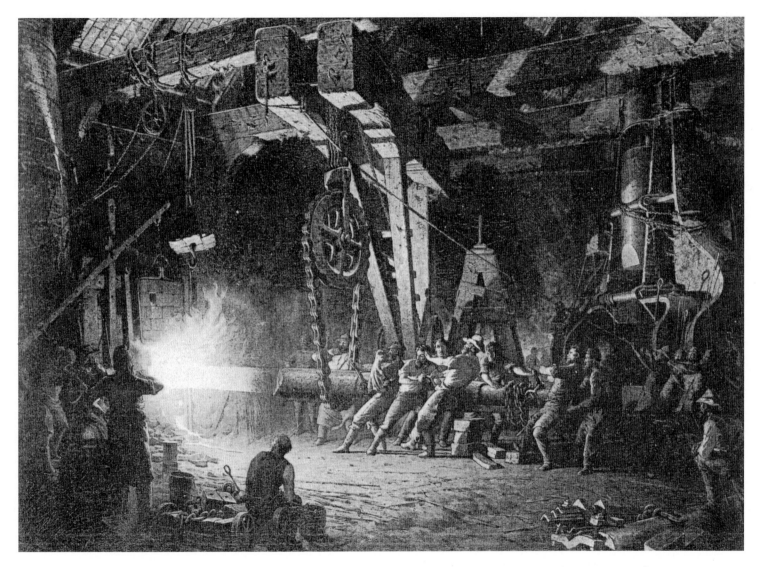

FIGURE 25 John Ferguson Weir, *Forging the Shaft*, o/c, replica of destroyed original, 1877 (Metropolitan Museum of Art, New York, New York)

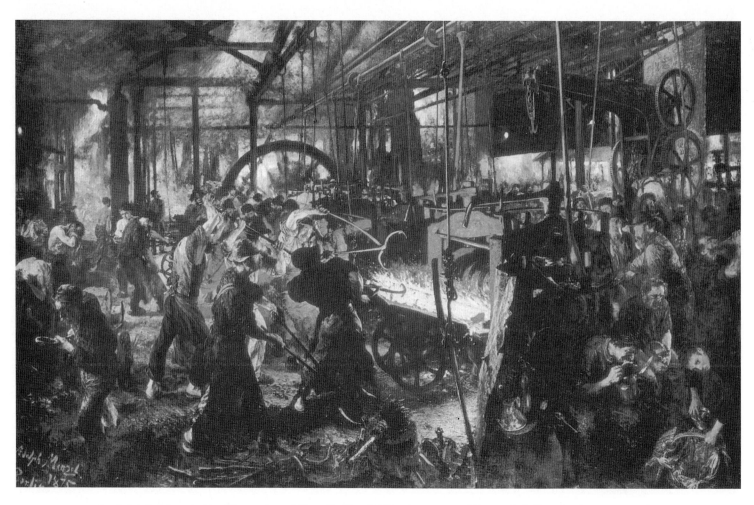

FIGURE 26 Adolph Menzel, *Das Eisenwalzwerk* (Iron Rolling Mill), o/c, 1872–75 (National Gallery, Berlin, Germany)

1873; Max Liebermann's *Weaving Mill in Laren,* 1881; and to a limited extent Koehler's own *Smithy in Bavarian Highlands* (Fig. 20).[1]

While all of these might be viewed as critical of the conditions they portray, depictions of unrest within the industrial working class before *The Strike* are rare. The first overtly political painting of German workers confronting the establishment was executed in Düsseldorf in the wake of the Revolution of 1848. The painting grew out of a new genre of socially conscious *Tendenzbilder* (tendentious pictures) inspired by the exposés of reporter-illustrators in the recently launched *Illustrated London News.* Johann Peter Hasenclever's *Workers Before the Magistrate* depicts a specific event in Düsseldorf on October 9, 1848 (Fig. 27). When the city council announced plans to lay off six hundred workers from short-term emergency jobs, those affected elected a six-man delegation to convey their grievance. Hasenclever's painting portrays the moment when four of the worker-representatives, having gained entrance to the council chamber, make a hat-in-hand appeal for restoration of their jobs and the council members, gathered uneasily around a grand table, reject the appeal, claiming that funds are exhausted. That they govern on behalf of the Prussian king is indicated by the bust of Friedrich Wilhelm IV high on a wall pedestal. A servant is about to close the large window, shutting out the demonstration on the market square toward which the worker in the rear seemingly gestures. In Hasenclever's preparatory study for the painting, an old man in the rear raises his fist; in the final version, this figure does not appear. Outside, the two organizers of the demonstration, the young Ferdinand Lassalle and the poet Ferdinand Freiligrath, an acquaintance of the painter, flank the elaborate column of a fountain from which they address the crowd. The column is topped with the black, red, and gold flag of the revolution symbolically attached to the lance of a statue of Saint George slaying the dragon.[2]

In *A Fight on a Barricade in the Rue Soufflot, Paris, June 25, 1848* by an unknown French painter (Fig. 28), another depiction of protesting workers during the revolutionary upheavals of that year, a small band of armed revolutionaries defends what remains of a barricade against government troops attacking across the Rue St. Jacques, with the Pantheon in the background. That this area of Paris was a stronghold of the socialist-inclined industrial proletariat is signified by the red flag. Immediately to its left, the painting's most prominent figure lifts a boulder high over his head.

The desperate use of stones as weapons against the massed firepower of an army or police force is also dramatized in Philipp Hoyoll's *Storming the Bakery on the Hay Market of Breslau* of 1848 (Fig. 29). Surrounded by fleeing and falling men, women, and children, two lone stone throwers fight back against the advancing columns of firing soldiers.

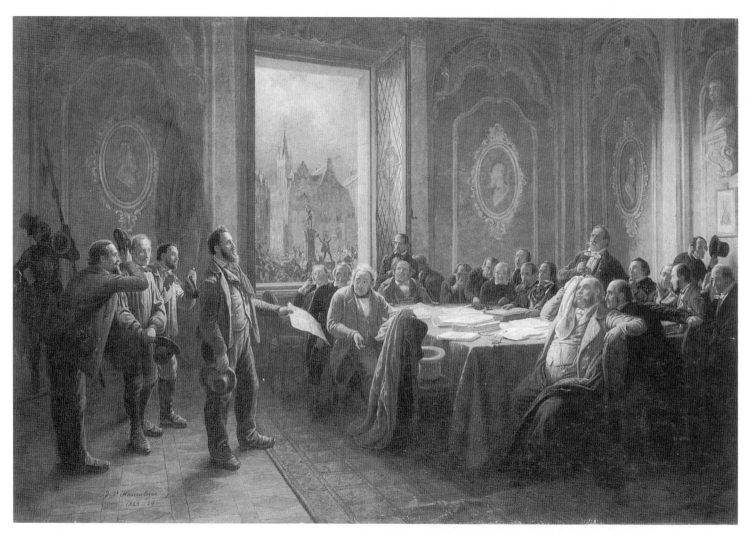

FIGURE 27 Johann Peter Hasenclever, *Workers Before the Magistrate*, o/c, 1848 (Municipal Museum, Schloss Burg an der Wupper, Solingen, Germany)

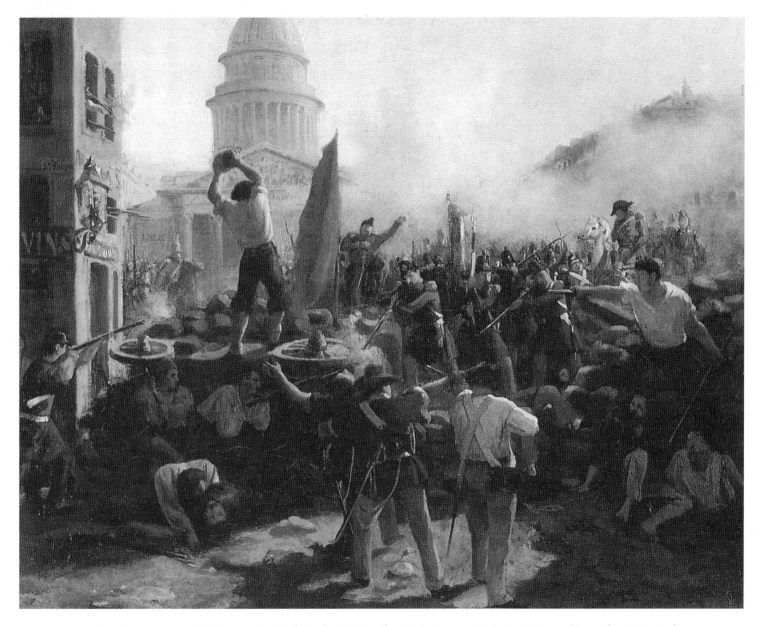

FIGURE 28 Anonymous, *A Fight on a Barricade in the Rue Soufflot, Paris, June 25, 1848*, o/c, 1848–50 (Deutsches Historisches Museum, Berlin, Germany)

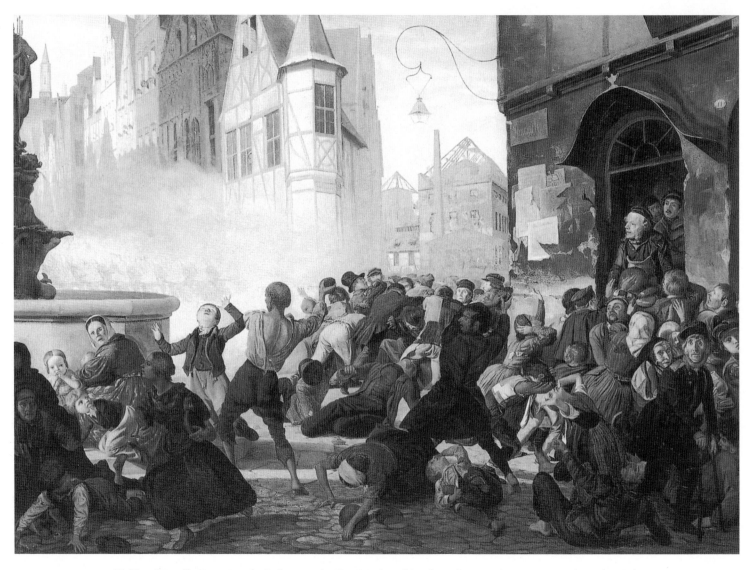

FIGURE 29 Philipp Hoyoll, *Storming the Bakery on the Hay Market of Breslau*, o/c, 1846 (Museum Ostdeutsche Galerie, Regensburg, Germany)

A Breslau native and supporter of the protesters portrayed in his painting, Hoyoll immigrated to England upon the suppression of the 1848 Revolution.

Thirty-two years later, and much closer in time to Koehler's *The Strike*, a less animated but nevertheless prominent image of a worker throwing a stone, or more likely a chunk of coal, appears in *The Miners' Strike* (1880) by the French painter Alfred Philippe Roll (Fig. 30). The thrower's barefoot wife attempts to hold him back in the face of two mounted police, one of whom has dismounted and is seemingly strip-searching a captive miner. A crowd of miners and family members, including a breastfeeding mother, has gathered around the grim coal plant silhouetted against the sky. A small banner, presumably red, flutters bravely, as if to rally the miners, but they remain impassive, with no leader in view. In fact, the foremost figure sits exhausted, a picture of resignation. His chin pushes down into the palm of one hand as the opposite arm hangs loosely between his legs. He epitomizes the suffering of overworked coal miners—sufferings Émile Zola would describe in his 1885 novel *Germinal.*

In Thomas Kittelsen's *Striking Workers Before Their Employer* (Fig. 31), painted in Munich in 1879 and doubtless seen by Koehler, a group of deferential but at least mildly confrontational strikers, including one woman, approach their employer's desk in his dark and forbidding office. The employer anticipates the factory owner in *The Strike* in age and demeanor, though he is rotund rather than gaunt. Illuminated by a harsh overhead gaslight, he grimly gestures toward a document, perhaps a ledger, his upturned palm indicating the impossibility of a wage increase. His legal or financial advisor sits alongside, thumb under lapel, free hand impatiently tapping the table, cigar in mouth, staring up at the timid workers.

No known work by an American artist comparable to the few European paintings of rebellious or protesting workers precedes that of Koehler. However, the body language in Winslow Homer's *Old Mill, The Morning Bell* of 1871 (Fig. 32) conveys the drudgery of factory labor. As the bell rings atop the mill, the young female worker, lunch pail in hand, slowly mounts a wood ramp leading to a footbridge. The drooping dog preceding her mirrors her lack of enthusiasm. Behind her, three co-workers, each holding a pail, hesitate in conversation at the bottom of the ramp.

In the wood engraving of *The Morning Bell* published in the December 13, 1873, issue of *Harper's Weekly* (Fig. 33) the dog is replaced by a man and a boy who again reinforce the reluctant mood, and the young female worker now wears a sunbonnet in place of the more fashionable straw hat of the painting. One of her female co-workers, bent over in a shawl and looking down despondently, precedes her. Two more women dominate the right foreground, one

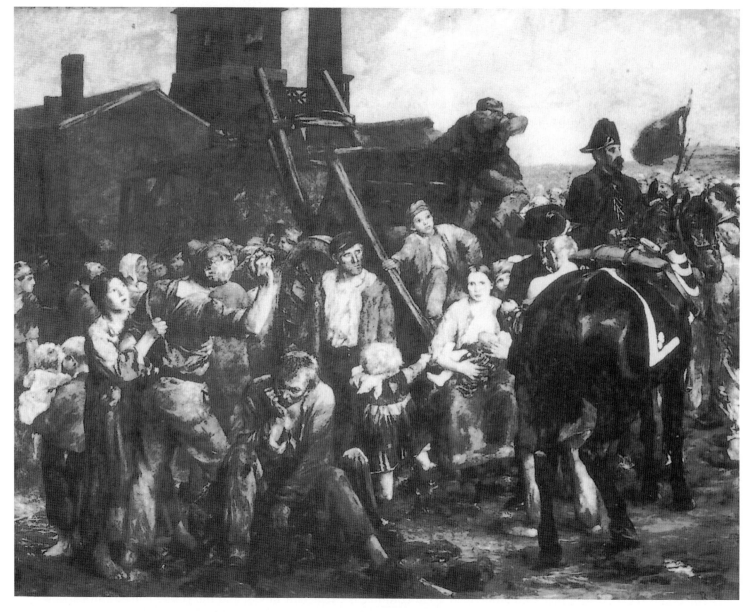

FIGURE 30 Alfred Philippe Roll, *The Miners' Strike*, o/c, 1880, destroyed during World War II (Museum of Fine Arts, Valenciennes, France)

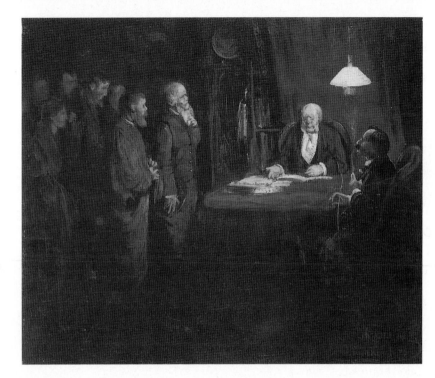

FIGURE 31
Thomas Kittelsen,
*Striking Workers Before
Their Employer*, o/c, 1879
(National Gallery,
Oslo, Norway)

looking down at the makeshift plank approach to the ramp and the other eyeing us forlornly. Everybody carries a lunch pail and the desolate-looking factory continues to wait across the water.

Before the two versions of *The Morning Bell*, Homer created his most ambitious and provocative statement about the spirit-killing nature of factory work. In the wood engraving *New England Factory Life—Bell Time*, published in *Harper's Weekly* on July 25, 1868 (Fig. 34), the pastoral setting of the two later pictures is barely discernable. The factory is enormous, stretching out along the river. The foreground figures, primarily women plus a cluster of small boys and two men, are only the beginning of a huge throng extending as far back as the eye can see. Everyone visible is poorly dressed, including the five otherwise typical Winslow Homer maidens to the left. On the right, two men, a young woman, and an older woman shuffle forward, exhausted even before the workday has begun. The eyes of the older woman open wide and she shakes a forefinger as she appears to scold the younger woman, who listens wearily. The overall mood is one of fatigue, irritability, and resignation.

Thomas Anshutz's *The Ironworkers' Noontime* of 1880 (Fig. 35), a close-up depiction of industrial workers outside an open-hearth steel mill, the LaBelle Ironworks in Wheeling, West Virginia, outdoes Homer's portrayals of

FIGURE 32 Winslow Homer, *Old Mill, The Morning Bell,* o/c, 1871 (Yale University Art Gallery, New Haven, Connecticut)

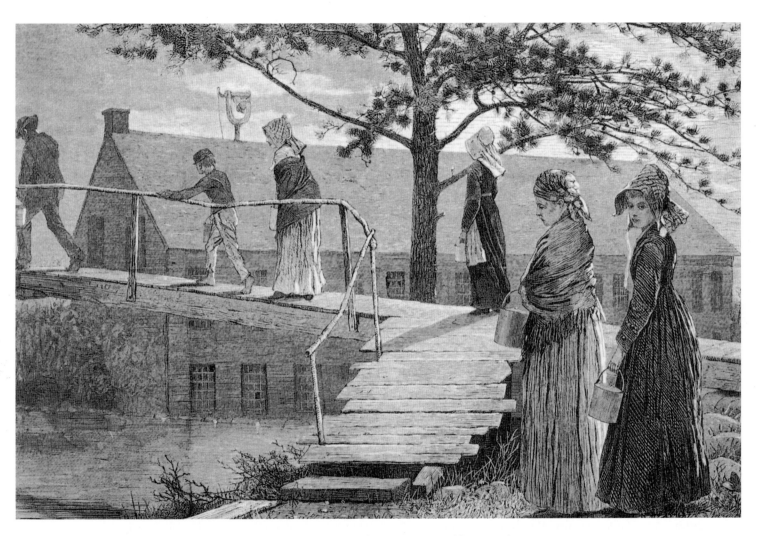

FIGURE 33 Winslow Homer, *The Morning Bell*, wood engraving, *Harper's Weekly*, December 13, 1873

FIGURE 34 Winslow Homer, *New England Factory Life—Bell Time,* wood engraving, *Harper's Weekly,* July 25, 1868

New England factory workers in its grime-covered, smoke-belching, gritty reality. Anshutz, a Kentucky-born student of Thomas Eakins, portrayed his twenty or so individually posed male workers taking a break from the hellishly hot labor inside the mill. Six, doubtless those working nearest the hearth, are stripped to the waist. Three men and two boys seek relief at a hand pump. Two foreground figures, each wearing a smudged red undershirt, seem disgruntled. One appears to be nursing an aching bicep while his free hand is raised as a clenched fist. The second dons a jacket as he frowns out at us. Two other workers also stare unhappily, one standing far to the left, the other seated far right, both with loosely held lunch buckets. Disturbingly, one worker seems to have fallen to the soot-soaked ground. He looks back angrily at another who is either attempting to hold him down or is massaging his sore shoulders. They are certainly not engaged in idle horseplay, yet no one pays them any attention. Apart from a conversation taking place in the deep shadows of the mill, which appears as a solid black mass, Anshutz's ironworkers on momentary break remain isolated, closed-mouthed, each lost in his own thoughts, and seemingly resigned to their grim lot.[3]

In contrast to the rare depictions of long-suffering but essentially passive groups of factory workers by Homer and Anshutz, at least one crisis-oriented depiction of violent industrial conflict made it to the front page of a popular American periodical in these years. On August 11, 1877, *Frank Leslie's Illustrated Newspaper* carried on its cover the wood engraving of a sketch by staff artist Albert Berghaus (Fig. 36). Entitled *Halsted Street, Chicago*, this engraving sensationalizes a deadly attack of two weeks earlier against striking Chicago railroad workers and their supporters by mounted, sabre-wielding state militiamen.

This bloody confrontation, in turn, was part of a national labor uprising, the most extensive and violent in America up to that time, which came to be dubbed "The Great Railroad Strike." It so happened that Robert Koehler had temporarily left Munich and was in New York City that summer, when he surely encountered the full barrage of reporting about the spreading conflict, very possibly including Berghaus's engraving in *Frank Leslie's Illustrated News*. The event made a profound impression on Koehler, and years later he would pinpoint it as a crucial influence in his decision to paint *The Strike*.

The 1877 rail strike was the culmination of a five-year period when a poor economy and deteriorating working conditions had spawned increasing levels of labor unrest. Following the Panic of 1873 a major depression dragged on, with high unemployment levels accompanied by a drastic drop in union membership and in the number of national unions. Only about one percent of the work force remained organized by mid-decade. Those still working did so at

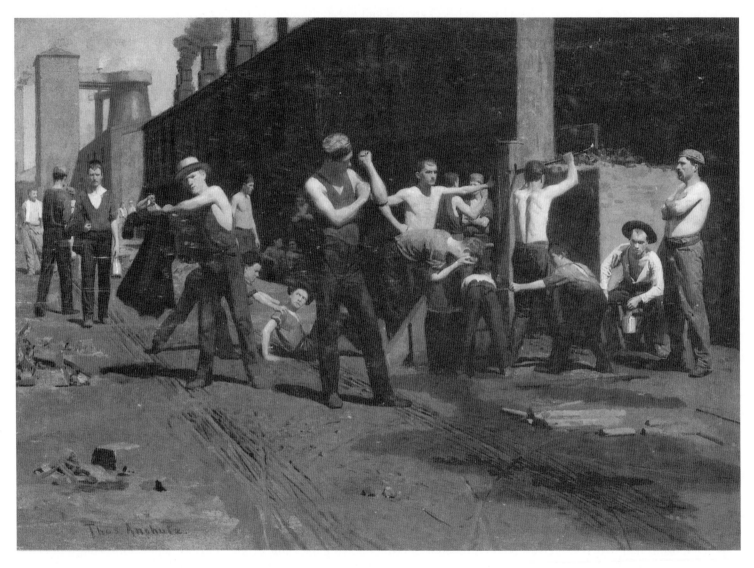

FIGURE 35 Thomas Anshutz, *The Iron Workers' Noontime*, o/c, 1880 (The Fine Arts Museum of San Francisco, San Francisco, California)

FIGURE 36
Albert Berghaus,
Halsted Street, Chicago,
wood engraving, cover,
*Frank Leslie's Illustrated
Newspaper,* August 11, 1877

ever-decreasing wages for lengthening hours. As an isolated consequence, the anthracite coal fields of eastern Pennsylvania saw intermittent strikes led by the Workingmen's Benevolent Association beginning in the late 1860s. Proposals for public works projects were dismissed by conservatives as alien to the principles of economics and even to the natural order, as made clear, they claimed, by Darwinian biology, which saw competition, struggle, and "survival of the fittest" as the key to evolutionary progress in human society no less than in the plant and animal kingdoms.

The railroad outbreak began in mid-July among locomotive firemen and brakemen who walked off the job in Martinsburg, West Virginia, protesting an announcement by John W. Garrett, president of the coal-carrying Baltimore & Ohio Railroad, that all wages over one dollar per day would be cut by 10 percent.[4] Ignited by this spontaneous

wildcat action, a brushfire of strikes spread throughout the nation's northern network of railroads from New York to Illinois, down the Mississippi, and on out to California.

At the request of company officials, state governors persuaded newly elected President Rutherford B. Hayes to declare a state of emergency and to authorize the use of Federal troops in support of state militias to put down the spreading strike. In spite of the presence of heavily armed troops, however, the B & O could not keep its cars rolling. Hundreds of supportive mill workers and boatmen, among others, waylaid scab-operated freight trains up and down the line all the way to Baltimore.

On July 19, strikers, aided by sympathizers, stopped Pennsylvania Railroad trains from moving in and out of Pittsburgh, heart of the nation's steel industry. After a reluctant Pittsburgh militia failed to quell what rapidly became a general strike involving mob action, troops from Philadelphia moved in, killing twenty people or more and occupying Pittsburgh's major roundhouse. The entire yards, nonetheless, were burned to the ground with the destruction of over a hundred locomotives and more than two thousand freight cars. Meanwhile, at nearby McKeesport, one thousand workers marched to the Carnegie Steel Works, successfully calling out workers there. In Pittsburgh proper, workers at the Jones and Laughlin steel mill also struck.[5] After general strikes broke out in a dozen other major cities, including Chicago and Saint Louis, the "rebellion" was finally crushed.

America's middle-class media and even the popular press overwhelmingly condemned the strikers. This hostility is clearly evident in Albert Berghaus's portrayal of a mob of violent, wild-eyed strikers in his front-page engraving for *Frank Leslie's Illustrated Newspaper*. The villainous, dagger-bearing caricature in the lower left corner reflects the fearful editorial bias against the strikers as the tempo of organized protest and confrontation increased in the new industrial era.

But it was precisely the surge of resistance by industrial workers in both the United States and Europe that inspired Koehler's best-known painting. More specifically, the 1877 uprising, particularly accounts of the confrontations in Pittsburgh, ultimately gave rise to his most famous work: "*The Strike* was in my thoughts for years," he told an interviewer in 1901. "It was suggested by the Pittsburgh strike of 1877."[6] But unlike the fear and raw hostility that dominated many contemporary reactions, typified by Berghaus's crude caricature, Koehler gave a human face to industrial protest. His reaction was far more complex and nuanced than was typical for the time, including his attention to the often-overlooked role of women, not only in strikes but in the larger labor movement and ideological ferment of the era.

5

Influences Shaping *The Strike*

DURING THE YEARS LEADING UP TO Robert Koehler's painting of *The Strike*, the artist, now in his early thirties, was completing his course requirements at Munich's Royal Academy of Art while supporting himself by teaching rudimentary art lessons and practicing commercial lithography, his consistent financial backup during his student years. This chapter begins, then, with further background on Koehler's art-school training and the art currents of the day, which will illuminate the aesthetic preconceptions that shaped his best-known painting.

By 1884, Koehler was one of approximately three hundred American students who had enrolled at Munich's Royal Academy since 1870, some 40 percent of whom bore German family names.[1] Among the more advanced, Koehler had moved from classes in drawing and elementary painting under Ludwig Loefftz to a master class taught by Franz Defregger. Academic history painting was traditionally stressed in such a class, but by the time of Koehler's attendance, genre painting was increasingly encouraged. Under the directorship of the realist painter Karl Piloty, in fact, the Academy tolerated a variety of subjects and styles as long as the aspiring artists avoided the "revolutionary individualism" of the Paris Impressionists. Therefore, the American students, informally identified with the American Artist's Club founded in 1874 and with a *Stammtisch* (table reserved for regular guests) at Munich's Max-Emanuel Café, enjoyed a quasi-Bohemian freedom of experimentation tempered by traditional academic demands, including study of the Old Masters—primarily seventeenth-century Dutch works featuring small interiors.

The American Charles F. Ulrich, for example, painted craftsmen at work in minutely detailed shops. In contrast to Ulrich's rather inventorial anecdotalism, *The Strike* exemplifies what art historian Michael Quick calls "a new phase of realism" among Munich painters of the 1880s. Ulrich's "minute Dutch realism," writes Quick, "gave way to a full-scale naturalism, increasingly in daylight or lighted interiors." Koehler clearly welcomed this trend and adopted it in his own work.[2]

The shift to brightly illuminated action paintings may also have been encouraged by Defregger, who in the 1870s produced a series of canvases commemorating the heroism of Tyrolean volunteers during the 1809 war against Napoleon. These culminated in his most celebrated work, *Das letzte Aufgebot* (The Final Levy), from 1872 (Fig. 37). This painting no doubt provided Koehler with at least stylistic and technical inspiration. Although *The Strike* is a naturalistic representation of current reality as opposed to a historic costume genre piece, it adopts Defregger's arrangement of a stage full of figures, with a flurry of activity in the center flanked by widely spaced supporting figures. Architectural side wings lead into a deeply receding background from which figures make their way forward to join the main players. Defregger's women, to no surprise, are cast in roles of care and concern, predominantly as on-looking mothers and grandmothers caring for children. In addition—and crucially in assessing Defregger's relevance for Koehler—each painting includes a woman cautioning an energized member of the central group of men.

Defregger's primary performers in *Das letzte Aufgebot* emerge from deep shadow and stride forward into a spot of light, stage center. In Koehler's more open composition, the lighting is relatively diffused and the activity is concentrated at a point far left of center. His narrative sets up an opposing current, and reads from lower left to lower right, beginning with the impoverished young mother holding her blanket-wrapped baby. She stands with a sad little daughter on a stone pavement that Koehler inscribed with his name and the year of the painting. Dwarfed by the imposing brick and stone office building, she looks imploringly upward at the elderly, top-hatted owner who is accompanied by his alarmed, bespectacled assistant or bookkeeper. Her pathetically patched-up skirt and broken-down shoes draw attention to the painting's iconography of clothing. Rejecting the long tradition of depicting poverty as picturesque, Koehler underscores the issues at stake by emphasizing the desperate plight of the workers and their families as revealed in their shabby garments.

Two contemporaneous drawings by Koehler also speak of impoverishment. A pen-and-ink drawing of a young woman with her back to the wind (Fig. 38) expresses a state of suffering comparable with that of *The Strike*'s young

FIGURE 37 Franz Defregger, *Das letzte Aufgebot* (The Final Levy), o/c, 1872 (Oesterreichische Galerie Belvedere, Vienna, Austria)

mother. Her hair blows wildly around a mournful face. Her tightly clasped hands emerge from a knee-length cloak and ankle-length skirt that swirl out in front of her. Her cold, poorly shod feet press together. In such a state she is far removed from the comfortable middle-class women relaxing in sunlit gardens that Koehler would depict later in the decade. Equally distant from what was to come, the second drawing, a *Studienkopf,* that is, a Defregger-inspired head study, is rendered in crayon and chalk from a live model (Fig. 39). Light from the upper left falls on long, uncombed hair and reflects from the furrowed brow, thin lower lip, and wrinkled neck of a weary, worried, and hard-bitten woman. Deep-seated anger erupts from her sharply focused dark eyes, underlined by a firmly set mouth. Her dark emotions match those of the aging factory owner in *The Strike.* But in contrast to her disheveled, proletarian appearance, the grim, black-suited employer, almost at one with the forbidding Doric column behind him, explicitly embodies a stony, profit-driven capitalism.

The head study was reproduced in 1887 in the newly founded Munich art magazine *Die Kunst für Alle* and interpreted by a brief paragraph. The writer, while intending to compliment Koehler, totally misses the contemporary social commentary implicit in the drawing and jokingly refers to the woman as a mother-in-law, a granddaughter of the Witch of Endor, a hex image from an Indian village, and possibly an Old Testament prophetess.[3]

The elegance and impregnable stone and brick of the factory owner's mansion and all the contrasting figures in its immediate proximity vividly epitomize the "warfare between classes" and the widening "chasm" about which Lyman Abbot pessimistically wrote in his November 1885 *Century* article "Danger Ahead." The skinflint owner and his nervous, hand-wringing associate look down on the forceful spokesman of the striking mill workers. The owner's rather limp, pale hand weakly gestures toward his red-shirted adversary who angrily stares back as he makes a fist at his side. His outstretched left hand points to his comrades, in particular to a select trio comprised of two white-haired workers flanking a younger man also wearing a red shirt. Directly in front of them, the sandy-haired man in a workers' cap matching that of his leader acts as the epicenter of encircling men soon to be joined by a loose assortment of steadily gathering participants. In contrast to the silence of isolated West Virginia foundry laborers in Thomas Anshutz's *The Iron Workers' Noontime,* at least ten of these striking workers pair up in animated discussions.

In the foreground at the center of the painting stand the dominant pair, a woman and a man engaged in a fervent exchange that catches the attention of the little girl who stares at them worriedly. The man appears to be on the defensive, spreading his large hands wide as he counters with a point. The woman, arguably the focal point of the entire

FIGURE 38
Robert Koehler,
Windblown Woman,
pen-and-ink drawing, c. 1884
(private collection)

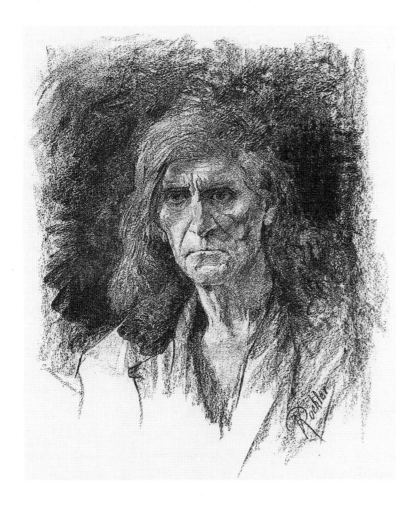

FIGURE 39
Robert Koehler,
Study of the Head of a Woman,
crayon and chalk drawing, 1887
(whereabouts unknown)

composition, looks up at him with great concern (Plate 5). She seems to be touching his chest with some familiarity while raising her left hand in a gesture of caution. Having said something significant, perhaps a word of warning, she now listens to his response as her eyes search his. Her brows knit; her forehead wrinkles.

This woman is often assumed to be the man's wife, and understandably so. Yet her outfit is not that of the impoverished working class. In sharp contrast to the worn clothing of the young mother and the labor-soiled garb of the workers, her dress is fashionably up-to-date and relatively prosperous looking. From head to foot she is well appointed. She wears a dark, close-fitting, bustle-equipped day dress with a pleated skirt, high waist and high collar. The striped material, tight sleeves and buttoned up bodice lend a vertical emphasis to her ensemble, topped by hair dressed close to the head and a red-trimmed cap far back on her crown. What appears to be a black apron is also hardly noticeable and may have been an informal accessory meant to save a fine dress from soiling.[4]

If this well-dressed young woman were a member of the factory owner's family, her presence so close to the factory would be highly unlikely, especially on a day of unrest and potential violence. Similarly, for a female office employee to venture out either to support or discourage the strikers while ignoring her boss on the steps behind her would have been unheard of in either the United States or Europe. She may belong to one of the then-few "helping" professions open to women—teaching, nursing, or social work. Her cap in place of a bonnet lends her a professional tone as opposed to her otherwise stylish air. If Koehler intended her expression and gesture to be viewed as basically sympathetic toward the strikers' cause while at the same time introducing a cautionary note, she can very plausibly be interpreted as representative of a small but socially significant number of contemporary feminist activists who supported the cause of labor, encouraged industrial workers to organize, and in many cases also worked to advance the socialist cause.

Indeed, one of the earliest such women had just died in Milwaukee. Mathilde Franziska Giesler Anneke (1817–84) was born into a well-to-do Westphalian family. In 1848 with her socialist-leaning second husband Fritz Anneke she founded a daily paper for the working class, the *Neue Kölnische Zeitung*, endorsed by Marx and Engels. With the failure of the 1848 Revolution, in which Fritz Anneke fought, accompanied into battle by Mathilde, the couple immigrated to Milwaukee in 1849, shortly before the arrival of Ernst Koehler and his family. In 1852 Mathilde relaunched a paper she had briefly published in Germany, *Die Frauenzeitung* (Women's Newspaper), a radical, free-thinking journal dedicated to the emancipation of women and slaves alike. In 1865 she and Cecilia Kapp opened a

German-language girls' school, the Milwaukee-Töchter-Institut, where she served as director and instructor until her death.[5]

Mathilde Anneke's career would certainly have been familiar to Robert Koehler with his extensive Milwaukee connections, but she was only one of many women of this generation who embraced the cause of labor and socialism, including the youngest of Karl Marx's six daughters, Eleanor Marx Aveling (1855–98). Her father's personal secretary when she was sixteen, she also prepared *Das Kapital* for its English edition following his death and went on to an activist career in support of international socialism and industrial labor unions in Great Britain, Europe, and the United States. (On a fifteen-week speaking tour with her common-law husband, Edward Aveling, and Wilhelm Liebknecht throughout the eastern United States in late 1886, she may have previously seen the reproductions of Koehler's *The Strike* published in *Harper's Weekly* and two German-language periodicals.)[6]

Eleanor Marx Aveling's contemporary Clara Eissner Zetkin (1857–1933) was equally active in unionization as an early non-member associate of the Socialist Workers' Party, forerunner of the Social Democratic Party. (German law forbade women to join any political parties.) In 1882, amid Bismarck's crackdown on socialism, Zetkin sought exile in Austria, Switzerland, and Paris where she and her common-law husband Ossip Zetkin remained deeply engaged in radical politics. Following his death in 1889 she edited *Die Gleichheit* (Equality), an SPD journal dedicated to extending Marxist thought to women, and in 1917 broke from the party to accompany Rosa Luxemburg and others in founding the antiwar Spartacus League. After it became the German Communist Party in November 1918, Zetkin represented it in the Reichstag until Hitler gained power. A few months later she died, exiled in Moscow.[7]

The United States, too, saw the emergence in these years of an intrepid company of female labor activists who would likely have been known to Koehler, with his strong transatlantic contacts. A representative sampling of this large group would include Sarah Bagley, the Massachusetts millworker who launched the Lowell Female Labor Reform Association as early as 1844; Kate Mullaney of Troy, New York, co-founder of the nation's first female labor union, the Collar Laundry Union, in 1864, and later an officer in William Sylvis's National Labor Union; Boston's Aurora Phelps, who championed women in the sewing trades; Augusta Lewis of New York, who became the first president of the Women's Typographical Union No. 1 in 1868; Leonora Kearney Barry, an Irish immigrant who became the "General Investigator" of the Knights of Labor, writing indictments against miserable factory conditions she rooted out; and the celebrated centenarian Mary Harris "Mother" Jones (1830–1930), an Irish-Canadian immigrant

who joined the Knights of Labor in the 1880s while working as a seamstress in Chicago. Backed by "Grand Master Workman" Terence Powderly and, years later, United Mine Workers official and first Secretary of Labor William Wilson, she traveled the country for nearly four decades in defense of striking miners and other industrial workers.[8]

While *The Strike* does not record a specific strike or specific individuals engaged in one, it nevertheless reveals Robert Koehler's intimate knowledge of the history and current realities of industrial unionism. His decision to place an assertive, well-dressed woman at the center of action in contrast to the anxious, sidelined worker's wife and children reflects the key role that women activists were playing in the industrial movements of the era. No other painting to date better expressed the direct results of their efforts to organize workers to stand up for their rights. Its conception resulted from memories of an all-out national railroad strike, and its thoroughly researched, though basically imaginary, enactment of a walkout coincided with one of the industrial labor movement's most alarming early dramas.

Labor-History Context

AN ERA OF STRIFE, 1877–86

I N THE SPRING OF 1886, a moment of crisis for the American labor movement, Robert Koehler's monumental new painting, *The Strike*, was called into play as an iconic expression of unending struggle. Its unprecedented subject matter—industrial workers walking off their jobs—invited identification with various events and locales prominent in the labor movements of the 1880s. Some placed the scene in Belgium, in Germany, or in England. Koehler himself, while making clear that no specific strike is represented, later stated, as we have seen, that his retrospective inspiration was the nationwide American railroad strike of 1877. The years between that outbreak of labor violence and the mid-1880s, when he painted and first exhibited *The Strike*, saw increasing levels of industrial unrest, official repression, and ideological conflict in Germany, where Koehler was living, and in the United States, where he had many contacts and occasionally visited.

How closely Koehler followed the details of these developments remains a matter of conjecture. The answer would depend on the extent to which he read the newspaper accounts that reached Munich and on his correspondence, now lost, with friends, family, or associates back home. What *is* clear is that he was present in New York in 1877 and that he fully understood the general current of events and the rising tensions of these years. This awareness certainly shaped the planning and execution of *The Strike*.

In the United States, this heightened tension exploded in a crescendo of violence in May 1886, just as Koehler's masterwork went on display in New York and reached a broad middle-class audience through a reproduction in

the popular magazine *Harper's Weekly*. This explosion of violence, one of the American labor movement's most-remembered early dramas, was widely reported in both the American and the German press, with differing ideological interpretations depending on the politics of the journal in question. This labor-history and journalistic context is crucial to our reading of the painting, both in its specific details and in its overall message, as well as to our understanding of its initial reception, to which we turn in the next chapter.

In addition to *The Strike*'s female figures and the factory owner with his cowering assistant, discussed in chapter 5, the painting includes other key figures that would have conveyed specific and alarming messages to middle-class viewers in the turbulent, conflict-ridden 1880s and 1890s. Two male figures match the central female figure in narrative importance. The first is the argumentative worker who boldly confronts the employer as the spokesman for his fellow strikers, toward whom he gestures with an outflung arm. He wears a red shirt—the color of socialism—under a loose-fitting jacket and a black, flat-crowned workers' cap typical of the period. In contrast to Koehler's inflamed orator in his 1884 painting *The Socialist* (Plate 4), who called to mind German, English, and American activists who had withdrawn from the workplace to write articles and deliver speeches, this man, for the moment at least, remains a rank-and-file worker, albeit one with clear leadership potential.

The second is the prominent, highlighted figure in the right foreground who bends down at the edge of the pavement to pick up a large rock, possibly with the intent of hurling it toward the arrogant boss standing at his door. Or perhaps the police or militia are on their way, and the workers will soon have to defend themselves against an armed onslaught. As we have seen, the image of a stone gatherer in scenes of confrontation between an armed force and protesters dates back at least to the Revolution of 1848. In *The Strike* he is the painting's most compact and yet animated figure (Plate 6). In contrast to the querulous worker directly behind him wearing a white paper cap and white shirt, he brings passion, determination, and the threat of direct action to their undoubtedly shared opinions.

For some Americans who viewed the painting or the *Harper's Weekly* reproduction, the forceful strike leader and the stone gatherer with his aura of potential violence might well have brought to mind Albert Parsons (1848–87), an outspoken and radical champion of the cause of labor and of revolution in these years, and his equally activist and incendiary wife Lucy Parsons (1853–1942). Indeed, although Koehler cited the confrontation in Pittsburgh in 1877 as *The Strike*'s inspiration, he may well have known of Albert Parsons's role in the Chicago events of that year, widely reported in the New York City newspapers. This possibility aside, a parallel between the most noticeable figures in the

painting and Albert and Lucy Parsons became iconologically plausible as their activism increased in the late seventies and early eighties.

Born in Montgomery, Alabama, to well-to-do Yankee parents who died young, Albert Parsons was raised from the age of five by an older brother in Texas. After apprenticing as a printer at the *Galveston Daily News* he served in the Confederate cavalry in the Civil War under the command of another brother, Major General William H. Parsons. Back in Texas after the war, he worked as a typesetter and tax agent, founded and edited a short-lived weekly newspaper, and in 1871 married Lucy Gonzáles, a poor young woman of Mexican, Native American, and possibly African American ancestry. They soon moved to Chicago where Parsons found work with the *Chicago Times* and in 1875 joined the Social Democratic Party of North America, which a year later became the Workingmen's Party of the United States (WPUS). This party, the American affiliate of the International Workingmen's Association founded by Marx and Engels in 1864, emphasized trade unionism as a means of preparing the proletariat for its role in the inevitable socialist revolution. Of the several thousand members nationwide, 90 percent were German immigrants. In studying and promulgating the party's initial aims, Parsons wrote, he "soon unconsciously became a 'labor agitator.'"[1]

As the 1877 railroad strike hit Chicago, Parsons, now in his late twenties, emerged as a key figure. At a WPUS rally on July 23 attended by some six thousand people, Parsons delivered a fiery address advocating the removal of "all means of production, transportation, communication, and exchange" from the ownership of "private individuals, corporations, monopolies, and syndicates" and placing them under state control.[2] Under pressure from the Chicago Board of Trade, he was immediately fired by the *Chicago Times*, blacklisted from other employment, and summoned to City Hall where the police superintendent browbeat him before a roomful of officials and "leading citizens." Briefly intimidated, Parsons laid low as mobs of men and boys closed down rail yards and factories and as the police broke up two more WPUS rallies. The second, on July 26, resulted in the bloody Halsted Street showdown featured as the front-page wood engraving in the August 11, 1877, issue of *Frank Leslie's Illustrated Newspaper* (Fig. 36) discussed in chapter 4.

Municipal police were also out in force in New York City on July 25, 1877, as participants leaving a peaceable mass meeting at Tompkins Square, many of them German immigrants, were clubbed without provocation. Robert Koehler, in New York at the time, may have witnessed this violent encounter.

Post-1877 U.S. labor relations remained tense, as the careers of Albert and Lucy Parsons illustrate. Blacklisted from employment and dependent on a dress shop operated by Lucy, Albert was now fully occupied by revolutionary and pro-labor activities. As the WPUS changed its name to the Socialist Labor Party (SLP), he organized mass meetings and helped edit the party's publication, *The Socialist.* Lucy Parsons, too, became increasingly radicalized as she and Albert, along with other SLP members, lost faith in the ballot box and came to view the legal system and indeed government itself as nothing more than "an organized conspiracy of the propertied class to deprive the working class of their natural rights."[3] While espousing this revolutionary ideology, they continued to support trade unions as the best short-term means by which wage earners, the "true producers of wealth," could battle for a living wage and a more humane eight-hour workday. In keeping with these goals, they joined the Knights of Labor and Chicago's Central Labor Union.

In 1883 Albert Parsons attended the Pittsburgh congress of the Second International, and a year later became editor of its weekly newspaper, the *Alarm.* Here, in October 1884, Lucy Parsons published her notorious article "To Tramps," advocating the Kropotkin-Most "propaganda of the deed." To counter police violence, she advised "disinherited and miserable" workers should embrace "those little methods of warfare which science has placed in the hands of the poor man," that is, dynamite. "Learn the use of explosives!," she advised. The "rents in your seedy garments" and "the holes in your worn-out shoes," she declared, offered the poor justification enough for overthrowing an unjust social order.[4] In April 1885, Lucy Parsons and a sister activist, Lizzie Holmes, headed a protest march on Chicago's Board of Trade. On Thanksgiving Day of that year, she led a poor people's march down elegant Prairie Avenue, ringing the doorbells of the wealthy.

In drawing inspiration from the railroad strike of 1877 and its aftermath, then, Robert Koehler was evoking a national labor uprising that had involved bloody confrontations, and in which radical, even revolutionary voices, many of them German-accented, had played a central role. The bold, articulate strike leader and his stone-gathering coworker in *The Strike* recalled these aspects of the 1877 strike. Further, the painting also hinted at the official surveillance that often preceded armed intervention by police or troops. On the far left side, between the employer on the porch and the spokesman for the strikers, stands a long-coated man, clearly no laborer, arms folded, silently observing the gathering crowd, concentrating his attention on the speaker. A woman clings to his upper arm and looks up at him, as if to plead with him to turn his attention away. All these details, easily overlooked today, would have carried specific, emotionally fraught connotations for contemporary viewers, particularly since the painting originated in

Germany and was the work of a German American, a group increasingly identified in the popular mind with anarchism and revolutionary ideology.

By including an assertive strike leader, a figure groping for rocks, and possibly a police observer, Koehler invoked the dynamics of class conflict, worker protest, and state repression that underlay the explosive social climate of these years, on both sides of the Atlantic. Not only a work of art, *The Strike* was also a cultural product fully caught up in the passions of the era. In its sweeping vista, viewers could witness the reality of class warfare. If its ragged mother and daughter recalled the shabby garments and worn shoes of Lucy Parsons's essay "To Tramps," the powerful stone grasper personified Parsons's chilling exhortation: "Learn the use of explosives."

From a present-day analytic perspective, Koehler's carefully staged confrontation between labor and capital can be viewed as illustrating the successive phases of any strike. First, the adamant presentation of grievances and demands met by an inflexible response, as summed up in the face-off between the factory owner and the strikers' spokesman. Second, a mediation attempt, illustrated by the interaction of the well-dressed woman and the coarsely clad workingman. Third, the threat or reality of impetuous violence, perhaps under the influence of revolutionary or anarchist outsiders, represented by the workman reaching for a stone. And, finally, forcible police intervention on behalf of the dominant class, represented in prospect by the watchful observer surveying the situation. To contemporary viewers, however, such a schematic interpretation would also have been overlain with powerful emotions, whether of sympathy, anger, or fear.

Of *The Strike*'s other individually portrayed workers, a few stand out. Three raise their fists while a husky, barefoot boy, a reminder of youthful participation in mob action, runs excitedly into the scene. In the background, another would-be leader beckons toward the factory as other men follow him, passing a second stone gatherer. Something extraordinary is obviously happening, an industrial walkout, and the conflict between labor and capital is dramatized not only by a large cast of diverse social types, but architecturally by the factory owner's monumental, classically trimmed office/residence that overpowers the humble workers' cottage in the upper-right background.

Considering compositional details alone, Koehler's sympathy for the industrial workers presenting their demands seems clear. This sympathy was rooted in his own working-class Milwaukee roots. As he recalled in a 1901 interview, "I had always known the working man and with some I had been intimate. My father was a machinist and I was very much at home in the works where he was employed."[5]

Twelve years earlier, only three years after *The Strike*'s first exhibition, Ernst Koehler had emphasized in a newspaper interview his son's highly motivated persistence in portraying an industrial strike: "He spoke of his aim to his professor in Munich and was much encouraged to carry out his plan. His professor only advised him to go to some place where a strike had broken out, so he could paint it from life. And so he traveled to every place a strike threatened to break out—to Belgium, even to England, where a former student lived. But everywhere, the threatened unrests did not happen, until one time he got a sudden message from his former student that sent him immediately to England. That is where my son experienced all the scenes that usually accompany a great strike. That is why he succeeded in making his figures and faces so true to life."[6]

In offering this account of the painting's composition, Ernst Koehler was apparently unaware that the painting did not portray a specific strike, and that models in Munich had posed for the individual figures. But Robert Koehler's visit to English industrial sites—described by Friedrich Engels in his classic 1844 work *The Condition of the Working Class in England*—did influence the tone of the painting. In keeping with the stormy reality of the event, as well as with the bleakness of the industrial wasteland, Koehler painted the sky heavy and grey, penetrated by a forest of factory smokestacks. As he himself explained: "I went from Munich over to England and in London and Birmingham. The atmosphere and setting of the picture were done in England, as I wanted smoke."[7]

Labor relations and ideological ferment were as turbulent in Germany as in the United States during the years when Koehler was planning and painting *The Strike*. Indeed, the fact that he did not seek out strikes to observe in Germany is probably related to the anti-socialist, anti-trade union legislation enacted by the Bismarck-controlled Reichstag in 1878 and enforced throughout the 1880s. While intended in the long run to suppress the Social Democratic Party, its immediate aim was also to prevent industrial strikes. Emboldened by further gains in the Reichstag election of 1884, the Social Democrats attempted in January 1885 to pass worker-protection legislation, including limiting working hours, forbidding child labor, and providing on-the-job health care for young workers and women. Though unsuccessful, this party initiative energized the labor movement, giving rise to a scattering of strikes. In March 1885, nearly 175 workers at a Bielefeld sewing machine factory walked off their jobs, only to be met by troops armed with sabers and bayonets. That summer brought a strike of six hundred cabinetmakers in Königsberg and an even larger strike of masons in Berlin.

Alarmed, Bismarck and his conservative Reichstag majority of industrialists, military officers, and Junkers (members of the Prussian landed nobility) in February 1886 extended the anti-socialist law for two more years. Following Bismarck's secret instructions, the authorities clamped down even more severely on strikers, socialists, and labor organizers. Cities threatened by strikes imposed martial law.[8] The Bismarckian Reich, therefore, was hardly a favorable place for Koehler to witness strikes. Nor, to say the least, did it offer a hospitable climate in which to unveil his painting. Instead, as in the past, he turned to New York City.

The Strike's First Public Exhibition amid Nationwide Labor Protests and Violence

The complex interplay between the origins of Koehler's *The Strike* and industrial conditions in Germany and America in the later 1870s and early 1880s continued more intensely once the painting was completed and entered the public arena. *The Strike* was first put on public view at the beginning of April 1886 in the Spring Exhibition of New York's National Academy of Design. One month later, on May 1, a two-page reproduction of an accurate wood engraving by one H. Gedan of Leipzig appeared in *Harper's Weekly*, America's most widely circulated weekly periodical (Fig. 40).

As fate would have it, the painting's debut coincided precisely with an outbreak of industrial strikes and confrontations between demonstrators and police or militia in major American cities. In Chicago and Milwaukee, these encounters resulted in deaths and injuries. Amid an outpouring of national publicity and controversy, supporters of labor's cause denounced the authorities, while fearful conservatives warned of revolution and anarchy. Viewed within this immediate historical context, *The Strike's* cast of characters in a manner of speaking suddenly found themselves in the thick of tumultuous real-world events. With foreign-born workers prominent among the strikers and German-born orators, journalists, and agitators vying for control of the strike, the painting's German origins heightened its links to the events that were riveting public attention.

On May Day 1886—since the 1850s a day of parades and rallies by workers and socialists—strikes and demonstrations demanding an eight-hour day with no reduction in pay erupted in major cities from Boston and New York to Saint Louis and Kansas City. In Pittsburgh, 1,800 stonemasons and joiners stopped work; in Detroit, brewery workers walked off the job. On Sunday evening, May 2, up to 15,000 demonstrators supporting the eight-hour movement

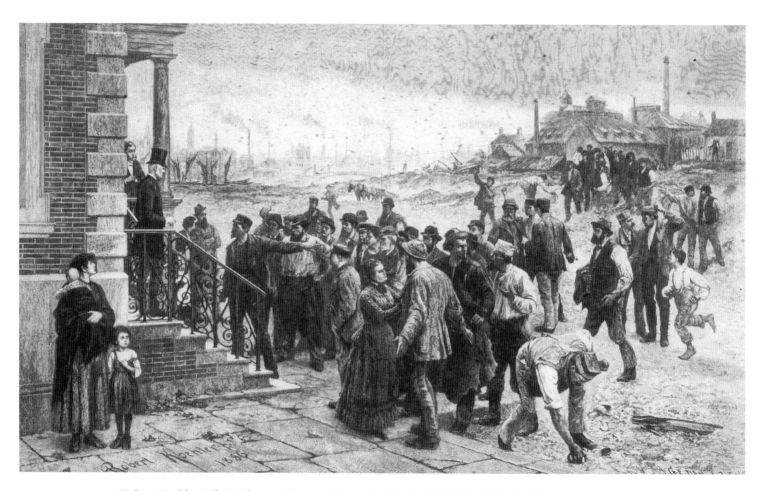

FIGURE 40 Robert Koehler, *The Strike*, wood-engraved reproduction by H. Gedan, Leipzig, Germany, 1886

converged on New York City's Union Square. Some carried red flags, a band played the *Marseillaise*, and speeches were delivered in both English and German.[9]

The most heavily publicized confrontation occurred in Chicago, where sausage makers, brewers, bakers, furniture makers, shoemakers, ironworkers, cigar makers, meatpackers, and other workers joined the mass work stoppage. Fires broke out in lumberyards when the owners refused workers' demands for shorter hours at the ongoing wage level.[10] Once again, Albert and Lucy Parsons joined the fray. On May Day, as readers of *Harper's Weekly* confronted the large engraving of Koehler's painting, the pair led as many as 80,000 workers and supporters in a march up Michigan Avenue, the city's major thoroughfare. Although thousands of miles apart, and hardly ideological soulmates, Albert and Lucy Parsons and Robert Koehler, in their different ways, were mutually engaged in drawing attention to what Parsons in his 1887 autobiography called "the broad distinction and irreconcilable conflict between wage-laborers and capitalists."[11]

On Monday, May 3, striking ironmolders at Chicago's McCormick Harvester plant, fearful of being replaced by pneumatic molding machines and protesting management's hiring of scab labor during an extended labor dispute, marched on the plant. After the sole policeman on guard duty was roughed up and went for help, the strikers broke windows and (acting out in reality the scene anticipated in *The Strike*) pelted the scab workers inside with rocks. As many as two hundred police soon arrived on the scene. In contrast to the timid mother and child cowering on the sidelines in Koehler's painting, a number of workers' wives, some with children in arms, formed a barricade to protect their men. Despite their efforts, five workers and a twelve-year-old boy were shot to death as the police opened fire.[12]

This massacre, in turn, led to calls for a protest rally the next day. The rally was planned by the revolutionary International Working People's Association, whose local leader was the anarchist August Spies, a thirty-two-year-old German immigrant upholsterer and publisher of a German-language newspaper, the *Arbeiter Zeitung*. A leaflet he composed proclaimed: "Revenge! Workers to arms! Your masters have released their bloodhounds, the police. These have killed six of your brothers this afternoon at the McCormick factory. . . . To Arms! We call you to arms! Your brothers! Revenge!"[13] The Tuesday morning issue of Spies's *Arbeiter Zeitung* proclaimed:

The class war has begun and the blood of the workers shot down yesterday in front of the McCormick factory calls
for revenge. Can anything be more modest than the demand for an eight-hour work time? It was made in a peaceful

way a year ago in order to give the plunderers time to answer. Then yesterday blood flowed. This is the way and manner that this devil answers a modest request from its slaves. An unconditional necessity compels the call: to arms, to arms![14]

That evening, Chicago-based anarchist leaders addressed some two thousand people who gathered at Haymarket Square for the spontaneously arranged protest. Using a freight wagon for a stage, August Spies spoke first. By the time he had finished his surprisingly moderate remarks in English in support of the eight-hour movement, Chicago mayor Carter Harrison had left, satisfied that the gathering would be peaceful.[15] Next came Albert Parsons, fresh from a meeting led by his wife and Lizzie Holmes to organize Chicago's seamstresses. He concluded his remarks by inviting the audience to join him at a nearby beer hall. Parsons was followed by Samuel Fielden, a forty-year-old Englishman with a booming voice, broad shoulders, flowing beard, and deep-set eyes. According to Munich's leading liberal newspaper, the *Allgemeine Zeitung*, those present responded enthusiastically to Fielden's anti-capitalist thunder, including a warning that "the day was near when it would be too risky for [capitalists] to be anywhere in the vicinity of their discontented workers."[16] As Fielden's oratory flowed on, the rabidly anti-socialist police inspector, John Bonfield, ordered the meeting to disperse, even though the crowd was already thinning out, threatened by rain. As Bonfield's squad of 125 police closed in, a shout "To arms" rang out and someone—the person's identity remains unknown to this day—threw a pipe bomb, killing one officer instantly. The police retaliated with a blaze of revolver fire that left one worker dead and twenty-five wounded, one of whom later died. Twenty-seven policemen were injured, seven fatally, some in the initial bomb blast and others, apparently, in the wild gunfire that ensued.[17]

As Chicago reeled from these events, Robert Koehler's home town, Milwaukee, also witnessed an explosion of violence. Beginning on May Day, a Saturday, the city was the scene not only of parades and picnics organized by labor and socialist organizations, many featuring German-language oratory, but also of massive walkouts and marches as striking workers closed down factories and breweries. Mass meetings and processions continued on Sunday.[18] On Tuesday, May 4, striking employees at the North Chicago Rolling Mills in southside Milwaukee's Bay View, many of them Polish immigrants, gathered at nearby Saint Stanislaus Church, from which they marched toward the factory to present their demands. They were driven back, however, by three companies of the state militia, including the Kosciuszko Guard, that fired over their heads. The next day, the protesting workers, now fifteen hundred strong,

again defiantly assembled at Saint Stanislaus to repeat their march. Led by the Polish Knights of Labor Assembly and following a red-white-and-blue banner proclaiming "We Stand Up For Eight Hours," they came within two hundred yards of the factory when the troops again blocked their way. They failed to hear the commanding officer's order to halt. Thereupon, under direct orders from Wisconsin governor Jeremiah Rusk, the commanding officer, a German immigrant, Major George Traeumer, ordered the troops to fire directly into the marchers' ranks, killing at least seven and injuring eight more.[19] In an explosion of anger over this massacre, a mob of primarily Polish workers looted the Best Brewery (later Pabst) before pursuing police opened fire. Nineteen alleged ringleaders were arrested and charged with conspiracy to murder and carry out "deadly attacks." "Tremendous agitation fills the city," reported Munich's *Allgemeine Zeitung*, which covered the story closely.[20]

On Saturday, May 8, as panic spread, authorities in Cincinnati, a city with many German immigrants, mustered four militia regiments, an artillery battery, and eight Gatling guns on the strength of police reports that six hundred armed and drilled socialists/anarchists were fabricating dynamite bombs for immediate use.[21] In fact, the reports proved erroneous and nothing happened.

A few days earlier, in New York City, soon after the National Academy of Design opened its spring exhibition featuring *The Strike*, the police arrested Johann Most, the propagandist of Bakunin-inspired anarchy, who in the April 24 issue of his newspaper, *Freiheit*, had published yet another provocative article, "The Last Argument," urging the proletariat to arm itself with dynamite bombs and rockets to destroy all private property, beginning with the mansions of capitalists.[22] Released on bail, he was rearrested in late May hiding under the bed of a lady friend.[23] Arraigned and tried on June 2, Most was sentenced to a year in prison and fined $500. Two of his associates received nine-month sentences and $250 fines. The judge, describing Most as "the greatest scoundrel" he had ever seen, expressed regret that the law did not allow for a stiffer sentence.[24]

In Chicago, meanwhile, the authorities brought charges of conspiracy to commit murder against eight members of the city's anarchist community: August Spies, George Engel, Michael Schwab, Oscar Neebe, Adolph Fischer, Louis Lingg, Samuel Fielden, and Albert Parsons.[25] All but Fielden and Parsons were German-born or of German immigrant stock. Most were associated with Spies's newspaper, the *Arbeiter Zeitung*, where the police claimed to have discovered dynamite, bombs, revolvers, and the printing plate for the leaflet announcing the Haymarket rally. The newspaper's entire staff of twenty-five were also jailed.[26]

Amid a wave of public hysteria, the accused were found guilty. Spies, Parsons, Engel, and Fischer were hanged on November 11, 1887. Schwab and Fielden received life sentences and Neebe a fifteen-year sentence. (Louis Lingg, a type-setter for the *Arbeiter Zeitung*, had committed suicide in his cell, using a blasting cap given him by another prisoner.) Amid rampant fears of anarchy and revolution, a few Americans—including the novelist William Dean Howells—protested the trials and executions. In Germany, three leading Socialist members of the Reichstag, August Bebel, Carl Grillenberger, and Paul Singer, plus former member Wilhelm Liebknecht, vainly telegraphed Illinois governor Richard Oglesby urging leniency.[27] In 1893, Illinois's newly elected governor, John Peter Altgeld, of German immigrant origins, sacrificed his political career by pardoning the three prisoners, citing a prejudiced judge and jury and the lack of proof connecting the accused directly to the unknown bomb thrower.

The wave of strikes and confrontations in the spring of 1886, erupting as Robert Koehler's painting of just such a scene came to public notice, was widely reported in the American press, especially the Haymarket bombing. With Germany, too, torn by conflicts over strikes, labor unions, and the burgeoning socialist movement, these U.S. developments were avidly reported by newspapers in Berlin, Koehler's Munich, and other German cities. As might be expected, the German press focused especially on the role of German immigrants, particularly the anarchists.

The German coverage was often initially wildly inaccurate. In its account of the Haymarket incident, for example, the *Allgemeine Zeitung* first reported that several bombs were thrown, forty-six policemen killed, and at least thirty-eight wounded.[28] As for the bomb-thrower's identity, the *Allgemeine Zeitung* successively blamed Michael Schwab, Albert Parsons, and Louis Lingg. By early June, however, more accurate accounts appeared. "One now speaks of the one bomb that was thrown in Chicago," noted the *Berliner Volksblatt*, "while it was earlier represented as a virtual hail of bombs."[29] The coverage of the confrontation at the McCormick Harvester plant in Berlin's *Vossische Zeitung* and *Deutsches Tageblatt* was similarly marked by initial vagueness and confusion, although a later account in the *Berliner Volksblatt* was more accurate.[30]

In both the United States and Germany, the coverage reflected a newspaper's political orientation. Conservative papers, aimed at elite and middle-class readers, criticized the strikers, denounced socialists and radicals, and tended to tar the labor movement as a whole with the words and deeds of revolutionaries and anarchists.

Some German papers did try to place these fringe elements in context, calling attention to America's many trade and labor organizations, including the 700,000-strong Knights of Labor and Samuel Gompers's fledgling American

Federation of Labor, already numbering approximately 300,000.[31] A few on-the-spot German reporters, as well as the Reuters telegraph-wire service, emphasized the fundamental goal of the strikes: labor's demand for an eight-hour workday with no cut in wages.

On May 5, 1886, the *Allgemeine Zeitung*, with which Koehler as a Munich resident was surely well acquainted, published a lengthy front-page article exploring the economic grievances underlying the wave of U.S. strikes and protests, and placing the eight-hour campaign in a broader frame of reference.[32] The struggle between Labor and Capital was accelerating, wrote the author, as mass-production machinery reduced the need for skilled workers. The eight-hour movement, this article continued, sought to slow this trend by reducing daily work hours and thereby increasing the length of time needed to finish a product, whatever it might be. But success in the campaign (even if achieved at the cost of a corresponding wage cut, a settlement accepted by the primarily German-born cabinetmakers of Saint Louis), the author presciently concluded, would at best only delay, not reverse, the long-term trend toward a diminished role for human labor in industrial production. Echoing the American Lyman Abbot in his 1885 *Century* article, the *Allgemeine Zeitung* proposed a profit-sharing cooperative system as the ultimate solution to labor's problems: "Workers should become participants of industrial enterprise thereby instilling in themselves a living interest and stimulus in a business whose profits they would share through uninterrupted effort." This was no pipe dream, the author insisted; "Many local millionaires in various branches of industry" were already initiating such cooperative systems.[33] (At the symbolic level, the intervening woman in *The Strike*, seeking to avert confrontation, may be read as an endorsement of this panacea.)

Such a calm analysis was not typical, however. Much of the German press coverage, like that in America, was alarmist in tone and focused on the revolutionary and anarchist figures, many of them German immigrants, seeking to exploit labor unrest for their own purposes. Even the *Allgemeine Zeitung*, while cautiously sympathetic to the eight-hour movement, quoted at length from August Spies's inflammatory writings and maintained that immigrant workers were essentially pawns in the hands of political radicals: "The Germans, Bohemians, and Poles who participated in the riots in Chicago and Milwaukee," this newspaper declared on June 2, "are primarily an ignorant, uneducated class misled by anarchist demagogues."[34]

Even harsher in its attitude, the *Berliner Volksblatt* blamed the apparent failure of the eight-hour movement on anarchism: "Today one can maintain with considerable assuredness that the strength of the eight-hour movement has

been broken by the interference of the anarchists. . . . The weakness of the workers in attempting to confront the strength of the industrialists was the fault of the anarchists in America."[35]

In reporting the disastrous Haymarket rally, the liberal *Berliner Volksblatt* simply noted, accurately enough, that the anarchists had exploited workers' outrage over the killings at the McCormick plant to call a mass meeting under their sponsorship.[36] However, the more conservative Berlin papers, *Vossische Zeitung* and *Deutsches Tageblatt*, ignoring the strikers' legitimate grievances and the larger panorama of the American labor movement, focused almost exclusively on the role of anarchists, especially August Spies, in "inflaming" gullible workers with incendiary rhetoric. Underscoring the point, the *Vossische Zeitung*, without citing its source, quoted (in German) the "Revenge! Workers to Arms!" leaflet, along with a particularly lurid passage from Spies's *Arbeiter Zeitung*: "Anarchy is the only way the workers can break the chains of slavery laid on them by the capitalists. It is your only way to freedom. I say: With a revolver in one hand, a knife in the other, and bombs in your pockets march to revolution and freedom."[37]

The Berlin *Volks-Zeitung*, for its part, emphasized that radicals, socialists, and anarchists were a minority of Chicago's German immigrants. The city's 150,000 German Americans, this paper noted, included 25,000 subscribers to Chicago's three *non-socialist* German-language newspapers, including the conservative *Illinois Staatszeitung*.[38]

In both the United States and Germany, in short, press coverage of the bloody events of early May 1886 was marked by an emphasis on violence; skepticism about workers' ability to choose leadership from within their own ranks; their presumed vulnerability to anarchist exploitation; and, in general, fears of bombs and revolution. The actual conditions of industrial workers, their specific goals, and the expansion of organized labor, received less attention. Nor did the fact that the organized violence of May 1886, like that of 1877, was overwhelmingly the work of heavily armed police and government troops.

This inflamed climate of opinion clearly influenced the initial reception of Koehler's *The Strike*. The painting's obvious contemporary relevance attracted attention and created a receptive audience while at the same time stirring nervous uneasiness on the part of museum-goers, exhibition administrators, and potential patrons. Both reactions would be evident as the painting entered its long afterlife beyond the artist's studio.

A Strikebound Debut,
a Conflicting Reception, a Paris Interlude

EARLY EXHIBITIONS, 1886–89

The Strike's CHECKERED RECEPTION THROUGHOUT ITS EXHIBITION HISTORY ranges from intolerance of the painting's subject matter to enthusiastic acceptance, from storage and neglect to rediscovery and honored recognition. Such drastically varied responses in part reflected shifting social and economic realities, the most pertinent being fluctuating levels of labor-management conflict. Upon seeing the painting or a reproduction, an alienated worker could hardly have resisted being drawn into its action. On the other hand, members of the capitalist elite or the uneasy middle class could well have felt threatened by Koehler's swarm of irate workers closing in on the source of their discontent. Through all its vicissitudes, and amid varied responses, *The Strike's* capacity for eliciting strong responses has remained. This chapter traces the beginnings of the painting's long history as a cultural artifact and lightning rod.

A Mixed Reception in New York

The first published description and commentary appeared in *National Academy Notes and Complete Catalogue*, issued in connection with the 1886 Spring Exhibition of New York's National Academy of Design, and edited by Charles M. Kurtz, manager of the American Art Association's New York City gallery. An eight-line description of what Kurtz called a "large painting of contemporary interest" was accompanied by a brief biographical sketch of Robert Koehler

and a line-drawing detail of *The Strike*'s front-porch confrontation between the employer and the nearest group of workers. With no reference to the female figures, the brief commentary concentrated on the "large party" of workers emerging from the "iron foundries" and "making demands of the owner of the works at his residence." The author especially called attention to the workers' threatening appearance: "The expression of dissatisfaction in the faces of the men is intense. Some appear ready to use violence; others are in expectant attitudes." But in a possible effort to reassure exhibition visitors, the commentary suggested that the "factories and tall chimneys" in the painting represent a "manufacturing town" in far-off England, where, as usual, "the day is grey and cloudy."[1]

A more expansive description of the painting appeared in a section of the catalogue devoted to the exhibition hall's South Gallery, where *The Strike* occupied most of one wall. As the exhibiting artists were requested to provide descriptions of their works, the longer account may be based on Koehler's own description. If so, this might explain the surprisingly positive description of the strikers in a conservative publication intended for an upper-middle-class, presumably pro-management, audience fully aware of the labor conflicts daily reported in the newspapers. As the first published assessment of the work, and for the insight it may provide into Koehler's own thinking, this description merits full quotation:

> A crowd of excited workingmen has gathered in front of the residence of the owner of the foundries—seen in the right of the picture—where they have been working. The spokesman of the party is talking earnestly, reciting the grievances of his distressed companions, toward whom he points with his left hand, while his right hand is clenched—showing that he is speaking temperately with an effort. Behind him stands a brawny workman in his shirt sleeves, critically observing the face of the mill owner. Others regard the latter vindictively—some curiously. All, however, are determined. Some would use violence. One is picking up a stone. Only a little thing will turn the crowd into a mob. A woman who dreads possible violent action by the men, is appealing to one of them to urge the crowd to desist. The man holds out his hands;—"Look at the case!" he seems to say; "What can we do?—Must we starve?"
>
> The mill owner's face is pale. It is a hard, unsympathetic face, and shows that the artist, in the selection of his type, was actuated by a feeling of sympathy for the workingmen, whose cause he desired to present in the strongest possible way. The mill owner in the picture is a man whose whole aim is money-getting. There is no sympathy in the man. He seems to desire to temporize with the crowd—to avert present difficulty until he can provide against

danger. Every face in the picture is a study. One man looks sneeringly at the pale face of the mill owner; others have in their eyes the figures of a half-starved woman with an infant in her arms and a scantily clothed child beside her, standing near the steps of the rich man's house—an emphatic illustration of the hard lives lived by the families of the poorly paid men. Beyond the grimy foundries a river divides the city. Through the mist we see sails of river craft, and discern the outlines of a bridge. A gray, cold sky harmonizes well with the general sentiment of the picture.[2]

This perceptive assessment of *The Strike* in the catalogue of its first exhibition remains perhaps the most detailed and thoroughly pro-worker account of the painting's narrative ever published. The only essay dedicated to an individual painting in the exhibition's South Gallery, it is unapologetically supportive of the strikers, whose exploitation by an unsympathetic, profit-obsessed factory owner fully justifies a vindictiveness that threatens to explode into violence. A favorable response to such fervor is all the more impressive at a moment when memories of the national railroad strike of 1877, Koehler's inspiration for the painting, remained vivid and another national strike with unknown consequences loomed on the horizon. As we have seen, owing to police and militia overreaction to the nationwide walkouts that began on May Day, history would repeat itself with a vengeance within weeks of *The Strike*'s first public appearance.

Four reviews of the National Academy of Design's exhibition, with specific commentary on *The Strike*, soon appeared in New York City's newspapers. The *New York Daily Tribune* scooped the rest with a review on April 3 that commended Koehler as one of only two artists in the exhibition "influenced by current events outside their studios." The other, German-born Hugo Breul (1854–1910), also offered an "exposition of the labor question," but despite his painting's promising title, *The Knights of Labor*, he merely described "a foundry interior with figures." Characterizing "Mr. Koehler's conscientious work" as "a painting of the intellectual rather than artistic order," the reviewer found its composition "awkward and faulty." Too much visual information and the "strangely placed mansion" tended to overwhelm the key figures and distract attention from the all-important confrontation. The reviewer found "good pictorial effects in the gray background" and "excellent points in the action of some of the workmen angrily confronting their employer," but overall concluded that "a greater artist might have expressed himself in a briefer but more feeling manner."[3]

The *New York Times*'s April 4 review offered a longer and more favorable evaluation, calling *The Strike* "the most significant work of this spring exhibition." But this reviewer, too, criticized Koehler for not resisting "the temptation

to add other figures which distract and add nothing true to the story." Nevertheless, the review continued, Koehler's realism, earlier displayed in "the rude and true vigor of . . . 'The Socialist,' an orator expounding dynamite doctrines to some willing audience," was again evident in *The Strike*: "The angry mechanics, grouped in irregular fashion behind their spokesman, offer a remarkable series of workman types, both German and Irish; their figures are natural, their gestures generally expressive, and their faces neither too furious, nor too shiny, nor too much begrimed."[4]

As for interpreting the workers' intentions, the *Times* reviewer vacillated: "Mr. Koehler has done well to show the earnest group of sweating workmen, quite possibly with justice on their side, but ready, some of them, to take the law in their own hands. He has contrasted them fairly well to the prim capitalist," described earlier in the review as "the insignificant white-haired capitalist with a tall hat too small for him." Inexplicably ignoring the prominent female figure at the center of the composition, this reviewer read, or misread, the impoverished mother standing to the side with her two children as a needless distraction. Assuming that the confrontation is set in the United States, the reviewer wrote: "In trying to rouse our sympathies with a beggar woman [Koehler's] moral gets heavy. American workmen are not beggars, nor do their women become so through the fault of capitalists. . . . [She] weakens rather than strengthens the moral as she stands to the left, out of the capitalist's range of sight, outlined against his snug residence. As for the little beggar girl beside her, the eyes of this piece of claptrap roll horribly and almost set one laughing."[5]

Thus, the beautifully profiled, curly-haired young mother staring up at the old capitalist, and the sentimental image of her daughter transfixed by the animated woman stage center, are not only dismissed as unnecessary baggage by an ostensibly pro-labor reviewer, but as somehow ideologically damaging to the painting's message.

In sharp contrast to these mixed reviews, thirty-year-old Kenyon Cox, a rising star of academic mural painting and a highly conservative art critic, offered a completely negative, politically motivated assessment in *The Nation*. Dismissing *The Strike* as left-wing propaganda devoid of artistic value, Cox concluded: "Robert Koehler's socialistic painting, 'The Strike,' some twelve feet across, is simply a newspaper illustration, without knowledge of the figure, knowledge of landscape, or other equipment for so ponderous an undertaking."[6]

On April 10, three weeks before its May Day publication of a double-page wood engraving of *The Strike*, calling it the "conspicuous picture of the year," *Harper's Weekly* briefly discussed the painting in a review of the National

Academy of Design's exhibition. Naively implying that Koehler conceived and executed his vast work more or less overnight, the reviewer speculated: "The subject might have been chosen from some of the events incident to the labour troubles of the last few weeks."[7] In fact, a November 1885 *Milwaukee Sentinel* article, while providing some routine information about the painting's genesis, made clear that it had already been completed by then. "Mr. Koehler will come to Milwaukee on a visit next summer," reported the *Sentinel*, "and will bring with him a painting which he has just completed and which he has called 'The Strike.' The scene is suggested by the title. The picture is a very large one, and is said to be Mr. Koehler's masterpiece. He spent some time in London and Amsterdam making studies for the painting. The professors in Munich have spoken very highly of it."[8]

Completion date aside, the *Harper's Weekly* review suggested that *The Strike* could be thematically related to current social-realist painting in Great Britain: "It recalls forcibly a class of pictures which has been very popular in England, and of which we may cite a familiar and vigorous example in Mr. Luke Fildes's Casual Ward." This well-known 1874 painting, whose full title is *Applicants for Admission to a Casual Ward*, depicts wretchedly impoverished men, women, and children huddled against a London building during a winter night, awaiting admission to a shelter for the homeless. Most specifically comparable with Koehler's painting, a ragged mother, baby in arms, trudges along the snow-covered street with her slightly older daughter alongside.

Following this rather tenuous comparison, the *Harper's* reviewer criticized *The Strike* as "a little too obvious in the dramatic methods," but nevertheless praised it as "exceedingly able and effective" and foresaw a bright future for Koehler: "There is no question of his sincerity of purpose, and the force and directness with which he has executed [*The Strike*] show that he is a painter of uncommon power from whom serious and important work may reasonably be expected."[9]

Even as newspaper reviews offered a highly respectful first appraisal of *The Strike*, with its representation of workers walking off the job, editorials in the same papers harshly criticized the actual workers and labor organizations that were mobilizing for just such an action in a few days. In an April 25 editorial, a conservative *New York Times* blamed the threatened industrial walkout for a panicky decline of the stock market. All strikers were guilty of conspiracy, the editorial asserted, and should be indicted and locked up. This would instill "a wholesome terror" in the working class. Labor leaders, in particular, must be harshly punished, thereby frightening their followers into submission.[10]

Taking up the anti-labor cry, the *Tribune*, owned and edited by the Republican Party leader Whitelaw Reid, went to further extremes. The best strategy against strikes, declared an April 26 editorial, "would be to drive the working-men into open mutiny against the law," so the military could deal with them accordingly.[11] One can almost imagine the grim factory owner in Koehler's painting nodding in approval. Indeed, reproductions of *The Strike* could have been published with these editorials as dramatic visual evidence of the dire threat such walkouts allegedly posed to the established order.

On Monday, May 3, the very day the Chicago police attacked strikers at the McCormick Harvester plant, the *New York Daily Tribune* published a second and lengthier review of the National Academy exhibition. With no reference to the general strike that had broken out on Saturday, this review expanded the earlier mild-mannered evaluation of Koehler's painting. Independent of academic tradition, the reviewer wrote, Koehler's pictures indicated the artist's "serious thought" about "the actual life of the world about him" and for this they merited "respectful recognition," unlike "the meaningless cleverness of painters of prettified figures and showy costumes." As "an appreciative student of sociology," the review continued, Koehler revealed "a profound appreciation of the modern labor question and a sympathy with the feelings and thoughts of the workers." In Koehler's paintings, unlike those of "the average French painter," but in common with most German artists, "emotion and form are subordinated to thought." This emphasis could, however, cause compositional problems, and the *Tribune* reviewer again complained that *The Strike*'s center of interest, the angry workers gathered behind their spokesman, "is insufficiently prominent on account of the rigid vertical lines of the philistinistic mansion on the left." In the interest of more direct expression, the reviewer suggested, even the factory buildings, although well painted, were not needed to identify the figures as workers and could have been omitted. Koehler should have told his story through the workers alone, in the manner of Jean-François Millet, "simple, direct, unconscious." After all, this review concluded, with the exception of the employer, "a meaningless figurehead," and the women, "particularly the woman with a child, thrown in as a bit of 'staffage' for relief to the brick wall," the painting contained the best figures Koehler had yet painted.

Thus in spite of growing fears, fueled by the press, that the nation's industrial workers were plotting an anarchist-led revolution against capitalism—fears that would intensify after the May 4 Haymarket tragedy—Koehler's *The Strike* was calmly received by New York reviewers as a significant work relating to "the events of the times" in which "each observer can find a moral for himself."[12]

The German Press Weighs In

Along with its American debut, *The Strike* was also prominently reproduced in several German serial publications in the form of either the well-executed Gedan wood engraving or an inferior one of unknown origin. These periodicals erroneously tended to identify the event as European and, more seriously, to use it to illustrate essays espousing political viewpoints quite contrary to Koehler's own.

In the June 26, 1886, issue of the weekly *Illustrirte Zeitung*, distributed from offices in Leipzig and Berlin, the poorer quality engraving appeared full page, unaccompanied by any text. It was simply captioned *Der Strike* [*sic*], followed by "nach einem Gemälde non Robert Koehler" (after a painting by Robert Koehler), the engraver having eliminated Koehler's signature.[13] Several months later, a full-page reproduction of the Gedan engraving appeared in Berlin's *Deutsche Illustrirte Zeitung*, inaccurately identified as an "Originalzeichnung von Robert Koehler" (original drawing by Robert Koehler) and mistakenly labeled *Arbeiterstreik in Belgien* (Workers' Strike in Belgium). The illustration accompanied a lengthy two-part essay by one Professor K. Lieberman entitled "Kulturgeschichtliche Plauderein: das Eigentum und die Arbeit" (Cultural History Chats: Property and Labor). With no mention of the painting or the confrontational encounter it portrays, the professor plunged into a discussion of what he optimistically saw as a recent growth of harmony between property and labor, following ages of mutual hostility. From the slavery of ancient Greece, Rome, and Germania through the serfdom of the Middle Ages, property and labor had remained antagonistic. By the time of the French Revolution, however, peasants had become free farmers who could earn money, buy land, and compete against a degenerate landed nobility. Even better, according to Lieberman's rose-tinted, anti-Marxist generalizations, the Industrial Revolution, urbanization, and representational legislatures further eased conflicts between property and labor. As capital became more versatile within ever-growing markets, increasingly contented workers enjoyed the benefits of rising wages, progressive taxation, and state-supported cooperative associations. Koehler's painting of angry and potentially violent industrial workers made for an ironic illustration to this essay's Panglossian views.[14]

A curiously deconstructive discussion of the labor-management relationship accompanied a two-page reproduction of the Gedan wood engraving, again titled *Arbeiterstreik in Belgien*, in a special 1887 issue of the Berlin-based magazine *Moderne Kunst* (Modern Art) featuring "Master Woodcuts After Paintings and Sculptures of Famous Masters of the Present." The essayist, identified simply as "d," acknowledged the existence of conflict between capital and labor—that is, between the privileged few "who by their own efforts have daily increased their property" and the impoverished,

property-less "Sklaven des Kapital" (slaves of capital) who "gaze with envy and bitterness on the ones favored with happiness." During strikes, if the factory or mine owners persist in rejecting the strikers' demands, the workers' families sink further into poverty. The distress of this lowest social stratum, "d" continued, had inevitably attracted the attention of Realist writers, most notably Émile Zola in *Germinal*, as well as Realist and even some Impressionist painters.[15]

As for Robert Koehler, "he really offered the goods" ("den Stoff bot") in portraying what the essayist assumed to be the 1886 general strike by Belgian coal miners that began in the Charleroi region and soon spread throughout the coalfields of southern Belgium and northern France. Avoiding "tendentious partisanship," Koehler had focused on a highly charged moment as the dispute threatens to descend into violence. Negotiations are over and the workers' excited attitudes and menacing gestures leave little doubt that whatever desire for a peaceful settlement might have existed earlier has now vanished. What lies ahead could resemble recent events in Belgium, where "plundering and devastation" belied the pledge of socialist labor leaders to seek lawful means of social change. The unrest in Belgium was especially threatening, according to "d," because the strikers had forced all their comrades throughout the mining area to leave their jobs as well.

Using *The Strike* as the jumping-off point for an extended commentary on the situation in Belgium, "d" argued that the strikers' goal of gaining voting rights as a means of improving their lot—a goal their leaders had encouraged them to adopt—failed to recognize that the ballot box had nowhere previously altered existing social conditions. Labor disruptions such as the one portrayed by Koehler did focus attention on an important social problem, "d" conceded, but one whose solution would require a long time and would probably be reached through humanitarian means rather than violent confrontation. In short, militant action, in particular the violence foreshadowed in *The Strike*, was deplorable and ill-advised.[16]

A Round of Expositions: Munich, Paris, Milwaukee

After its New York debut, *The Strike* returned to Europe for exhibition at the 1888 Munich International Exhibition in the Glaspalast, a vast glass-and-iron hall built in the 1850s in imitation of London's famed Crystal Palace. In 1887, the exhibition's planners invited Koehler to organize a "Collective Exhibition of American Art" for the upcoming event. Accepting the invitation, Koehler ambitiously promised "to get together a collection of works that will show our best achievements and establish our claim for a proper place among the artists of all nations beyond dispute." He

assumed this task, he pointed out, even though it meant "[giving] up my school for two or three months, [and] losing a good part of my income thereby."[17] Visiting New York City in November 1887, Koehler described his efforts in a letter to Sylvester Koehler (no relation), curator of prints at Boston's Museum of Fine Arts. He was "'button-holing' Congressmen and enlightening them on the subject of the Munich 'show,'" he reported, and had even written President Grover Cleveland, urging him to "propose an appropriation by Congress" to support the American artists' representation in the Munich exhibition. He further hoped to get Perry Belmont, a socially prominent member of Congress from New York City, to apply his considerable influence in Washington to that end. He also organized a meeting at the National Academy of Design to set up a committee to oversee the participation of American artists in the Munich exhibition.[18] All these efforts paid off in April 1888 when James McNeill Whistler wrote from London enthusiastically accepting Koehler's invitation to be represented in the American Section of the Munich exhibition. "I should be well pleased to place my works in your hands," Whistler wrote, "and . . . I am much flattered by the desire evinced by my countrymen to have me with them."[19]

Unsurprisingly, Koehler included his own largest painting, *The Strike*, in the American section of the Munich show. This audacity gained him a favorable review in *Die Kunst für Alle* (Art for Everyone), a widely read German art periodical. The author was none other than Friedrich Pecht, its publisher, editor, and premier critic. In Pecht's opinion, most of the American artists in the show were too dependent on French academic painting, an affliction many of them had acquired while studying in Paris. Consequently, he claimed, these "Parvenus" and "Parisian reserves" ("Pariser Nachschub") seldom expressed anything of their own country's national life or culture. By contrast, Pecht warmly praised *The Strike* as among the very best of the "sounder" ("gesunder") paintings in the exhibition, all of them originating in Munich. He especially admired Koehler's factory owner, a "singular" American type, "obviously a genuine, tenacious Yankee," who has emerged courageously from his "villa" to confront his idle workers. The latter, further incited by their employer's appearance and attitude, must be restrained by their wives. (Pecht assumed that the two women without children in the painting are, indeed, married to the men with whom they are interacting.) However questionable the strikers' intent, Pecht conceded, they reflected Koehler's skills in characterization. All are "dramatically lively" and surrounded by a fine, grey coloring that successfully simulates a dense factory atmosphere impregnated with coal haze. Therefore, concluded this influential German critic, "Here is indeed a very respectable, independent, artistic force of which to take notice."[20]

Friedrich Pecht's admiration of *The Strike* was echoed a few weeks later in the Munich weekly *Die Gesellschaft: Realistische Wochenschrift für Literatur, Kunst, and Öffentliches Leben* (Society: Realistic Weekly for Literature, Art, and Public Life). A certain Miss Webster, perhaps British or American, reviewing the American section of the Munich exhibition, called *The Strike* "a spirited, well-thought-out work of cultural historical interest." In her view, the painting's importance as a well-conceived visual document relating to a vital social issue of the day trumped the works' aesthetic weaknesses: "The figures of the striking workers are so finely observed, that one can excuse several troublesome spots in the painting technique. The figure of the old factory owner gives the effect of being very characteristic of a truly modern type." By this peculiar ambiguity she possibly means that he comes off as a caricatured stereotype of the contemporary industrialist.[21]

Awarded a silver medal at the Munich exhibition, *The Strike* rested in Koehler's studio at 27 Gabelsberger Strasse until the following spring, when it was off to Paris, having been accepted into the art exhibition at the Palais des Beaux-Arts of the great Exposition Universelle, or world's fair, which opened on May 6 in the French capital. To Koehler's dismay, however, the jury "skied" his painting, hanging it high above a door of the main gallery. From that distance, one may speculate, its realistic representation of a potentially violent clash between workers and the police was less apt to upset the wealthy patrons of a predominantly industrial exposition, or to remind primarily bourgeois viewers of the working-class unrest in the industrialized regions of Europe, Great Britain, and the United States. The jury's caution may also have reflected the fact that the International Socialist Congress, the "Second International," was scheduled to convene in Paris in July, with Eleanor Marx Aveling present as a reminder of her recently deceased father. In its most memorable resolution, the Congress designated May Day as a socialist and labor holiday in memory of the "Haymarket Martyrs." An American member of the jury for the American section of the Paris exhibition and a fellow painter, Frank A. Bridgman, wrote Koehler that he had protested "that your picture should have such a bad place, but all was done by voting."[22]

This perhaps intentional snub of *The Strike* must have especially annoyed Koehler since another painting of striking workers accepted for exhibition by the Paris jury, Alfred Philippe Roll's *The Miners' Strike* of 1880 (Fig. 30) was displayed at eye level, or "on line," in museum terminology. Roll's painting included a few more human-interest details, such as a nursing mother, and its workers seemed intimidated and weary in the face of a police assault, in contrast to Koehler's aggressive and vigorous workers, including two who gather rocks for resistance in case of attack.

These differences may have disposed the jury to give Roll's painting preference over Koehler's more troubling representation of industrial strife.

The poor location of his prize painting might well have been a factor in Koehler's enthusiastic response to a letter he received four days after the Paris opening from E. J. Becker, secretary of the Milwaukee Industrial Exposition Association.[23] This annual event, launched in 1879, was sponsored by a group of prominent Milwaukee businessmen, including the Bavarian-born brewer and banker Valentine Blatz. Inviting Koehler to submit *The Strike* for late summer exhibition in his native city, Becker also expressed confidence that money could be raised to purchase it for permanent exhibition in the newly opened Layton Art Gallery, a gift to the city from the meatpacker Frederick Layton.[24] "It would be considerably easier to work up the enthusiasm of the people" for *The Strike* than for any other of Koehler's paintings, Becker noted, because this painting after all had made Koehler's reputation, and also because "the subject is a popular one in this city."[25]

That a strike by industrial workers would be a popular subject in Milwaukee might be interpreted as a way of commemorating the mass walkout and deadly confrontation of workers with both police and state militia in May 1886. It might also reflect the continued growth and vitality of the city's labor movement—a process Koehler would have been fully aware of through letters from his father, who must have been as eager as he for the planned Milwaukee exhibition.

Upon receiving Becker's letter, Koehler wrote to General William Buel Franklin, the U.S. Commissioner-General for the Paris Exposition, requesting an immediate return of *The Strike*. (A Civil War general, Franklin had later managed the Colt Firearms Manufacturing Company of Hartford before becoming the U.S. representative at the Paris exposition.) With the exhibition just mounted and the fair newly opened, Franklin replied, the administrators had denied Koehler's request.[26] Spurred by a follow-up cable from Becker on June 14, Koehler again wrote Franklin, proposing to replace the painting with the "not much smaller" sketch on which it was based. "Years of labor . . . [and] long cherished hopes" would be lost if his request were refused, he noted, not to mention "financial success long needed."[27] Ten days later, with no response from Franklin, Koehler appealed to Franklin's assistant, Rush Hawkins, another Civil War general turned bibliophile and art patron who had been in charge of selecting the American paintings for the Paris exhibition. In this letter, Koehler again stressed his dire need of the money that he might realize from the painting's sale in Milwaukee:

If you will consider that the picture in question is thus far my most important work; that owing both to its subject and size it is a difficult one to dispose of, as is amply shown by its having remained unsold for these three years, and that the offer now made promised at length to realize my fondest hopes—then you will readily understand that the refusal is enough to throw me into deepest despair. The sale was to enable me above all to protect my dear parents against the threatening discomforts of old age and inability to adequately support themselves—a duty which I have thus far been unable to perform; while from the encouragement I was myself to derive from this success I had a right to anticipate satisfactory artistic results.[28]

Along with this emotional entreaty, Koehler also wrote to jury member Frank Bridgman and to the newly appointed U.S. ambassador to France, Whitelaw Reid, on leave from his editorship of the *New York Tribune*. Bridgman responded immediately, apologizing for the poor positioning of the painting and promising to speak to "some of the officials" about Koehler's request.[29] Reid in his reply, which did not arrive until July 20, advised "Go straight to the top official!" Acting on this advice, Koehler wrote directly to Georges Berger, Director General of the Exposition, stressing that since the painting was practically out of sight anyway, it would scarcely be missed. Again he played the poverty card: "What is at stake is my entire fortune, the shape of my future, the compensation of a tireless labor requiring several years."[30] Nevertheless, on July 26 Berger wrote to Franklin expressing "profound regret for not being able to respond favorably" to Koehler's request.[31]

In the meantime, Koehler had written to the French Minister in Munich, and on July 30, surprising news arrived from an assistant to Rush Hawkins: Hawkins had just received authorization from Exposition officials to replace *The Strike* with its original sketch! "General Hawkins is very glad you applied to the French Minister in Munich," this letter noted, "as all his efforts here to comply with your wish proved fruitless."[32]

Obviously pleased, Koehler entrusted the framed sketch to Michel & Kimbel, a Paris shipping firm, and on August 11 they informed him that they would make the substitution and ship the painting from Le Havre to New York and from there on to Milwaukee.[33] On August 17, 1889, aboard the steamship *La Gascogne*, pride of the French Line, *The Strike* embarked on its second westward voyage across the Atlantic.[34]

For Koehler, the sale of his painting and its permanent exhibition in the city of his childhood and youth was clearly a high priority. He was undoubtedly reassured by an August 22 letter from his Milwaukee contact, E. J. Becker:

I hope for the best and you can rest assured that there will be nothing that we can do left undone in order to sell the painting in the city. You will, no doubt, hear from your father frequently. Unquestionably he can keep you better informed of the work that we are doing to accomplish that end than I can, as the press of the city is constantly keeping it before the people. I mail you a copy of the *Herold* [a Milwaukee German-language newspaper] of recent date with a cut of yourself and the painting, photographs of which were kindly loaned us by your father.[35]

This goal seemed even more likely when *The Strike*, despite its premature removal, received an Honorable Mention medal from the Paris Exposition's International Jury of Awards.[36] According to Koehler's widow, he treasured this award more than any other he ever received.[37]

Whether either the selection jury or the award jury considered *The Strike* an American subject by an American painter abroad or a European subject by an expatriate was a moot point in view of its thematic universality, at least in the Western world. In any case, at its artist's insistence, it was allowed only brief exposure in the international art capitol, Paris. Once in Milwaukee, *The Strike* received a warm welcome, especially by labor activists and by the German immigrant community, as an internationally honored accomplishment by a good neighbor's son. For the moment, Koehler's career had come full circle.

PART III

Decades of Neglect

Milwaukee and the Chicago World's Fair

1889–94

The range of responses to *The Strike* after it returned to America further underscored the complexity of the painting's open-ended narrative. Interpretations varied widely, depending on their ideological orientation. This is particularly well illustrated in two feature articles published in the Milwaukee press as the painting went on exhibition in Robert Koehler's hometown in 1889. The first appeared in the August 18 issue of the *Milwaukee Herold,* a German-language newspaper, illustrated with a reproduction of the Gedan wood engraving of the painting and a large, idealized, photo engraving of Koehler himself. As one might expect, the *Herold* enthusiastically promoted both the work and its artist.

An interview with Robert Koehler's hospitable, loquacious, and obviously proud father Ernst comprised well over half of the lengthy account. The discussion took place in the elder Koehler's machine shop in a small frame house on Oneida Street between the Milwaukee River and Water Street. As the interview began, "Herr Koehler" is described as wiping his "work-blackened hands" on his leather apron and pulling out from his desk drawer a treasured clipping from the *Berliner Illustrirte Zeitung* of the Gedan engraving. In a dialogue format, the reporter fed Ernst questions, which he answered at length, recounting how his son "had for a long time intended to reenact a workers' strike pictorially" and how his Munich professor (Defregger) advised him to go where a strike was breaking out, in order to "study it from life." Koehler therefore traveled "everywhere" (at least to Belgium and across the Channel to Great Britain), Ernst expansively noted, "in hopes of finding a strike that had not been settled before it began." Finally,

following a tip from a former student, he returned to England where he had the opportunity to experience "all the scenes that so often accompany a large strike and thereby succeed in making the figures and faces true to life."[1]

Having not yet seen his son's "Meisterwerk," Ernst told the reporter, he was eagerly anticipating its arrival, adding that he and his wife were hoping for an autumn visit from Robert himself, whose training and career, he spontaneously observed, had begun in Milwaukee with drawing lessons from "old [Henry] Vianden." Ernst next turned the reporter's attention to photographs of three other of Robert's paintings of workers that preceded *The Strike*: *Smithy in Bavarian Highlands*, *Holy Day Occupation*, and *Her Only Support* (Figs. 20, 3, 18). Obviously identifying with the machinist in *Her Only Support* who concentrates on the broken sewing-machine part, Ernst confided that this was his favorite of the three because of its compassionate treatment of poverty. He clearly sympathized with the poor seamstress, "whose clothes reveal that she had seen better days," and with her little girl, who had probably not been "sung to in her cradle" as her mother "was so preoccupied in earning a living."[2]

The *Milwaukee Herold* feature next turned to Robert Koehler's attempts to gain financial support for American participation in the 1888 International Art Exhibition in Munich. This account was based on an interview with a prominent Milwaukee attorney of the period, Berlin-born Emil Wallber, who had just completed four years as the city's mayor (1884–88). More immediately relevant, Wallber was one of the few Milwaukeeans who attended the Munich exhibition. While disappointed by "the unfortunate weakness" of the American paintings, Wallber insisted that this was not the fault of Koehler, who had "struggled admirably" but with only limited success to raise funds for the American Section of the exhibition. Despite the poor overall quality of the American paintings in Munich, Wallber added, *The Strike* had been a "great sensation, . . . and was much discussed and written about." Once installed in the Milwaukee exhibition, he confidently predicted, it would be "one of the leading paintings in the gallery."[3]

Along with Wallber's pride in *The Strike*'s reception in Munich, however, and in contrast to the elder Koehler's worker-allied sympathies, the *Herold* article included a lengthy description of the painting that expressed a quite different ideological perspective, subtly nudging the viewer toward admiration of the resolute factory owner and hostility and suspicion toward the "wildly excited" strikers and their violent intentions:

Out on the veranda of the house of the factory owner stand two finely dressed gentlemen of whom the most immediate imparts an unwelcome answer to the demands of the delegation of striking workers. One sees in his face that he is not

willing to yield and that the threatening situation lacks the capacity to ruffle his composure. On an open square in front of the house stand a group of wildly excited men and pacifying women (wives). Several of the strikers have raised their fists menacingly while others appear to be shouting wild words. Still others allow themselves to be so far carried away by their agitation that they bend down to pick up fist-thick cobblestones with which they probably intend to demolish the house. The difference that lies between the icy calm of the factory owner and the excitement of the strikers is extremely telling. Factory buildings constitute the background of this, in subject matter, very effective painting. Inside them the busy life of the preceding day has yielded to an unearthly silence.

Following this tendentious reading of *The Strike*, with its obvious hostility to the protesting workers, the *Herold* concluded with another burst of pride in the international recognition achieved by a hometown artist and fellow German American:

That the execution of the painting complies worthily with the aptly chosen subject has already been observed in the kind reviews of German critics. One can therefore be rightly thankful that Herr Becker has brought the painting to Milwaukee for this year's exhibition. Thereby Milwaukeeans have an opportunity to be able to admire the excellent work of their compatriot.[4]

Since the *Herold* reporter had used ex-mayor Emil Wallber as a source for part of the story, it may not be coincidental that the newspaper's anti-labor reading of *The Strike* closely resembled Wallber's own view of the strikes that had hit Milwaukee in May 1886, during his tenure as mayor, when the state militia, on command of the governor, had killed seven marching workers. Wallber offered his version of these events years later, in a 1910 article, "Bay View Labor Riot of 1886," in the *Milwaukee Free Press*.

In this account, he sought both to justify the state militia attack and to shift responsibility from himself to Wisconsin's Republican governor, Jeremiah Rusk. Perhaps inadvertently, however, even his personal version makes clear that the demonstrations, while doubtless raucous, were overwhelmingly peaceful, and that responsibility for the bloodshed lay with the authorities. For purposes of this study, his version is worth examining for the light it sheds on the outlook conservative observers brought to their interpretation of *The Strike*.

According to Wallber's recollections, Milwaukee's May Day activities began when Paul Grottkau, the German-born socialist editor of Milwaukee's *Arbeiter Zeitung* and leader of the Central Labor Union, led a parade of fifteen thousand workers and supporters of the eight-hour movement to a mass picnic at the Milwaukee Gardens on Sunday, May 2. It was organized in support of seven thousand striking skilled workers and five thousand laborers, primarily Polish immigrants, who had also laid down their picks and shovels. Red flags and banners bearing such slogans as "The Workman Does Not Beg, He Demands" worried the city's political and business leaders, but the gathering remained peaceful.

On Monday, as strikers marched from factory to factory persuading others to join them, the narrative continues, Governor Rusk "in some way heard of our labor troubles" and rushed from Madison to Milwaukee to meet with Mayor Wallber, Police Chief Florian Ries, and Sheriff George Paschen in the Plankinton House Hotel. Delegations of merchants urged Rusk "to immediately call out all of the available militia in Wisconsin to protect their property in case of rioting."[5] In fact "absolute quiet reigned over the city," and Wallber was surprised on Tuesday morning to learn that Rusk, having established a command center at the city's armory, had ordered out several companies of state militia from Milwaukee, Madison, and Darlington. Rumors and false alarms gripped the city: "During the day reports came in thick and fast that in all parts of the city uprisings were taking place and that large bodies of laboring men were marching toward the manufacturing plants intent on rioting and destruction. At one time the militia were ordered out but they reported the gatherings peaceful and quiet."[6]

The Tuesday march of primarily Polish workers from Saint Stanislaus Church to the North Chicago Rolling Mills, described in chapter 6, began noisily but peacefully, according to Wallber. When the plant superintendent refused to discuss the strikers' wage and hour demands, or to permit representatives of the Amalgamated Association of Iron and Steel Workers to address his employees, the marchers, joined by workers from inside the mill, lost patience and surged forward. But they quickly dispersed when three companies of militia fired a warning volley over their heads before occupying the mill for the night.

When fifteen hundred marchers reassembled at Saint Stanislaus on Wednesday morning, the ex-mayor's account continued, some carried crude "arms," including stones. Again, however, the marchers remained peaceful, although they did fail to heed the order to halt issued by the militia commander, Major George P. Traeumer, probably because few heard it amid the tumult of the march. At this point, the troops obeyed Governor Rusk's order, transmitted by the German-born major, to "fire on them." From a distance of two hundred yards the volley killed seven people,

including a sixty-nine-year-old man standing at the door of his house and a twelve-year-old boy in the crowd.[7] On Sunday, May 23, a slow-paced parade of twenty five thousand participants, organized by the Knights of Labor, mourned the dead.[8] Strike leaders were arrested and tried, with Paul Grottkau receiving the stiffest sentence. In July the Milwaukee City Council repealed an earlier ordinance approving an eight-hour day for municipal workers. In 1888, Wisconsin's Republican leaders rewarded Governor Rusk by nominating him as a favorite-son presidential candidate at the party's national convention.[9]

While filling in useful details, ex-mayor Wallber's version of these events, recounted many years later, falsified facts and betrayed an ingrained prejudice against the strikers. In his retelling, what occurred was not a needless and panicky massacre but a justified suppression of an anarchist mob. Amazingly, Wallber even claimed that only one person had been killed, a bystander shot accidentally, rather than seven! Here is his narrative of the deadly confrontation:

> Large bodies of men fully armed, were marching toward the rolling mills, red flags were flying and agitators were fanning the flames of anarchy with incendiary speeches. Governor Rusk ordered out four companies of militia under the command of Major Traeumer. The mob by this time was approaching from the South, men and women who seemed to be bearing red flags and fully armed approached within shooting distance and halted. Major Traeumer expecting violence, ordered his troops to fire. They obeyed the order and when the smoke lifted the only casualty was one man killed, an innocent neighbor who happened to be feeding his chickens at this hour managed to stop the fatal bullet. That settled their demonstration.[10]

Despite Wallber's professed admiration for *The Strike*'s artistic merits, the conservative politician's class-based and anti-union prejudice, most likely an influence on the *Herold* article and certainly evident in his 1910 recollections, clearly shaped both his interpretation of Koehler's most famous painting and his exculpatory revisionist account of the May 1886 killing of striking Milwaukee workers at a time when he, as mayor, had been in a position of influence and responsibility.

In contrast to the biased perspective of Wallber and the misguided *Milwaukee Herold* staff writer, the pro-labor *Milwaukee Sentinel*, in a front-page article about *The Strike* on September 10, 1889, accompanied by a reproduction of the painting, offered a rave review of the work, especially praising its sympathetic portrayal of the workers. Having

finally reached Milwaukee the day before, the large canvas was immediately installed in the art gallery of the Milwaukee Industrial Exposition Building.[11] Headlined "It Is Now in Place," the *Sentinel* article opened with the confident prediction that this "production of a native of Milwaukee" would be "welcomed with enthusiasm by all Milwaukeeans who love their city and take pride in everything good that emanates from it." The Honorable Mention just awarded by the international art jury in Paris, the article continued, "is a sufficient recommendation of [*The Strike's*] merit and all honor is due the artist for the triumph."[12]

Turning to the painting's subject matter, the anonymous *Sentinel* reporter expressed thoroughgoing support of Koehler's striking workers, including some "on the point of committing violence." (The setting is once again placed in England, this time "in the environs of London, whose foggy atmosphere is one of the best features of the picture.") The workman stooping to pick up a stone, "one of the best painted figures in the composition," is singled out for special attention, together with the workers' "ring leader and spokesman," who is described this way: "With right hand clinched [*sic*] by his side and the left pointing backward towards his comrades, he regards the grasping capitalist most earnestly and defiantly, demanding higher wages." Directly behind him stands "the sturdy and massive form of a leather-aproned blacksmith, his legs planted staunchly, his arms akimbo." Emblematic of all working trades, he compels admiration as "a perfect rock of defense in attitude and the immediate backer of the leader." Beyond these foreground figures, continues the *Sentinel's* empathic report, "are groups of two and three discussing vehemently and denouncing with uplifted and clinched [*sic*] hands the administration that controls their wages while others still further off are hurrying away from the rolling mills to join the angry crowd."[13]

The two foreground women, the article went on, signified the domestic hardship caused by this ongoing conflict. The woman in the center (again taken to be the wife of the worker to whom she is speaking, despite her incongruously prosperous-looking apparel) is assumed to be "beseeching" her husband "to abstain from violence." The "young mother holding her babe in her arms," although more passive, is, according to the *Sentinel* writer, pinpointing the villainous source of her family's plight by "looking upward toward the inexorable capitalist." He, "the stern-faced proprietor who stands erect and looks wise," is not only removed from his workers by his elevated location but also by his "black Prince Albert [coat] and high silk hat." These sartorial badges of class superiority are complemented by "a servant in livery" whose "furrowed brow and wringing hands" suggest that he, like his employer, is intimidated by "the threatening attitudes of the menacing strikers." All in all, this admiring article concluded, *The Strike* "perfectly conveys the idea intended by the subject, to wit: the inflexible hardness of the rich and the exasperation of the

misused working-class." Commenting on the exhibit itself, the *Sentinel* noted that bad weather and "insufficiency of light" did not prevent *The Strike* from attracting "more admiring eyes and more emphatic words of commendation than ever a strike got in Milwaukee before."[14]

Following this ever-so-slightly cynical jab at the city's conservative establishment, presumably including ex-mayor Wallber, the *Sentinel* article concluded with the hope that the painting, as an internationally celebrated depiction of class warfare on the side of labor, would remain permanently in Milwaukee. This was not to be, however, as the purchase that Koehler so eagerly longed for did not materialize. Prone to exaggeration, his widow claimed that a $6,000 asking price (more than $140,000 in present-day buying power) found no takers. Whether Koehler had any offers at any price remains unknown.[15]

One may speculate that Milwaukee's leading industrialists, brewers, and the business community at large, including the otherwise philanthropic Frederick Layton, had concluded that the painting's subject matter and political content, no matter how well executed or how much a source of local pride, had no business in their new gallery, and that the city's workers did not need a permanent pictorial reminder of the events of May 1886.

What is more, worker activism was once again threatening, as the American Federation of Labor reasserted its demands for an eight-hour work day, and Victor Berger, a German-speaking immigrant from Austria-Hungary who had settled in Milwaukee in 1881, was emerging as a leader of the city's socialist movement. (Whether Berger saw *The Strike* during its Milwaukee exhibition in 1889 is unknown, but as a committed socialist he most likely did.) In 1893, after purchasing the small labor newspaper *Die Volkszeitung* and renaming it *Wisconsin Vorwärts* (Wisconsin Forward), Berger devoted himself full-time to advancing the cause of labor and a pragmatic form of moderate socialism, launching a career that would eventually carry him to the U.S. Congress.[16]

At the national level, at Andrew Carnegie's Homestead steel works near Pittsburgh, a July 1892 clash between striking workers and agents of the anti-union Pinkerton Detective Agency, hired by Carnegie's associate Henry J. Frick, left three Pinkerton agents and seven workers dead. As earlier in Wisconsin, Pennsylvania's governor mobilized a force of eighty-five hundred state militiamen to restore order and break the strike. Overall, the Homestead strike led to at least thirty deaths.[17]

Meanwhile, the newly formed Populist Party adopted a platform at its 1892 convention in Omaha calling for a union of all laboring people, government ownership of the railroads, and other reforms alarming to the nation's capitalist and conservative class. In short, neither in Milwaukee nor in the nation at large was the early 1890s a time when

the economic elite were likely to contribute to the purchase and permanent display of an incendiary painting that many saw as sympathetic to strikers forcibly pressing their demands and about to resort to violence.

In 1892, Koehler's extended residence in Germany came to an end as he moved from Munich to New York City, with plans to work as a portrait artist. From henceforth his career as an artist, and increasingly as an art teacher and administrator, would be in the United States.

Exhibition at the Chicago World's Fair

After its Milwaukee exhibition, *The Strike* next went on display from May through October 1893 at Chicago's World's Columbian Exposition, popularly known as the Chicago World's Fair. It was hung (this time at eye level rather than high above a doorway) in a first-floor corner gallery of the fair's imposing Palace of Fine Arts (now the Field Museum of Natural History) in Jackson Park along Lake Michigan. The gallery was one of nine reserved for paintings by American artists. Listed as number 482 in the exhibition catalogue, it shared little with its nearest neighbor, William H. Howe's *Morning, Kartenhof Meadows, Holland,* a bucolic landscape with contented cows.[18] The gallery space on the second floor, reached by a spiral staircase, contained the rest of the American paintings, including Koehler's *The Carpenter's Family* (Fig. 17) and *At the Café* (Fig. 11).

The New York "jury of acceptance" that had approved *The Strike* and the two other Koehler canvasses included a close acquaintance, William Merritt Chase, and the well-known genre painter, sixty-nine-year-old Eastman Johnson. Of more than a thousand entries submitted, only 325 were accepted.[19] A Minneapolis-based artist who would soon play an important role in Koehler's career, Douglas Volk, was on the twelve-member National Jury that could overrule the decisions of the regional juries.

In contrast to its success at the Paris and Munich exhibitions, *The Strike* was bypassed by the Chicago World's Fair awards jury. And unlike the press coverage it enjoyed in New York, Germany, and Milwaukee, Chicago newspapers paid it no attention whatsoever. Even Charles M. Kurtz, who had written the earliest published appreciation of the painting upon its first public exhibition in New York and who was now the Assistant Chief of the Department of Fine Arts at the Chicago fair, failed to mention it in his various publications relating to the fair's art exhibits, including his *Official Illustrations from the Art Gallery of the World's Columbian Exposition.* To Koehler's possible chagrin, Kurtz did include among 336 engravings in this compilation Gaston La Touche's *Miners on Strike.* A September 1893 special

issue of *The Tribune Monthly* dedicated to the Exposition's art and architecture, in an article entitled "The Brightest Ornaments of the American School," also made no reference to *The Strike*.[20]

One reason for this lack of attention may have been changing aesthetic standards among American painters, critics, and art patrons, who now favored landscape impressions; highly refined portraiture; foliated compositions featuring vaguely allegorical women, with or without children; and outdoor masculine pursuits and pastimes considered distinctly American. Thomas Eakins, John Singer Sargent, Mary Cassatt, James McNeill Whistler, George Inness, and Winslow Homer, together with various lesser-known artists, were adept at one or another of these genres, and several were well represented in the American section of the Chicago exhibition. Homer and Inness were the most abundantly exhibited American artists, tied at fifteen paintings apiece. Each of them answered to the pastoral yearnings of an increasingly urban public weary of oversized history paintings devoted to histrionic dramas performed by academically rendered and anecdotally appointed costume figures.[21]

Robert Koehler's socially engaged painting of oppressed workers demanding their rights fit none of these favored categories. Though *The Strike*, representing a contemporary scene as timely as the day's headlines, did not conform to the "history painting" category either, its stylistic similarities to that genre may have contributed to the lack of attention it received.

A more immediate reason for the neglect of *The Strike* in publications and press commentary about the World's Fair's art exhibitions may be that still another bloody suppression of a strike occurred a few weeks after the opening of the Columbian Exposition. On Friday, June 10, striking construction workers in the town of Lemont on Chicago's south side, reacting to the importation of southern black strikebreakers by the contractor, Warren, Hoge and Company, clashed with a posse of fifty deputy sheriffs at a construction site alongside a sanitary canal. The recently sworn-in officers shot and killed two workers as well as a bystander, and wounded many others.[22] Two weeks later, as we have seen, Illinois Governor John Peter Altgeld reawakened raw memories of the 1886 Haymarket bombing by pardoning the three men still in prison for complicity in the bombing.[23] In response, the *Chicago Tribune* ferociously attacked Altgeld as an "alien" without "a drop of true American blood in his veins. He does not reason like an American, does not feel like one, and consequently does not behave like one!"[24]

Journalists, art critics, and the thousands of fair visitors, in search of anything but social conflict and lethal violence, more than likely shunned a large narrative painting that vividly jarred them back to such realities. Moreover,

1893, the year of the World's Fair, also brought the onset of what would become the nation's severest economic depression to date, creating massive unemployment, causing sixteen thousand businesses and over six hundred banks to fail, and driving fifty railroads into bankruptcy.[25]

Amid all this, the Fair's planners were intent on promoting a positive, whitewashed image of America. The fourteen pristinely pale Beaux-Arts buildings and the equally pallid ornamental sculptures of the plaster-of-Paris "Court of Honor" provided temporary utopian relief not only from violence-ridden industrial strikes, but also from hard times and the urban blight and poverty exposed in Jacob Riis's *How the Other Half Lives*, published three years earlier. Monumental imitations of a supposedly stable Old World culture; myriad products on display in the gigantic Manufactures and Liberal Arts building; thousands of incandescent bulbs illuminating the Palace of Electricity; the belly dancers and other amusements of Sol Bloom's Midway Plaisance; plus the gigantic Ferris Wheel and Buffalo Bill's Wild West Show, certainly overwhelmed any impression a single painting might have left on most Fair visitors.

One possible exception to this assumption was the largest canvas in the American section, the immense *Flagellants* by Koehler's Milwaukee-born, Munich-trained competitor, Carl Marr.[26] It depicts a procession of life-sized, half-naked religious fanatics whipping themselves bloody as they are led past a church in late medieval Italy by two black-robed monks. At the 1889 Munich International Exhibition, where it received a gold medal, *Flagellants* was displayed in its own specially lighted alcove. Impossible to ignore, this agonizing melodrama far outstripped the immediate impact, if not the long-lasting social/political significance, of *The Strike*.

In spite of the competition, changing tastes, and continuing industrial conflict, *The Strike* did find its way into two illustrated surveys of works from the World's Fair art exhibitions. Apparently optimistic that despite the depression a public existed that could afford a deluxe, ten-portfolio edition of large-scale reproductions, Philadelphia publisher William Finley commissioned the renowned eighty-five-year-old engraver John Sartain, most famous for his mezzotint engravings, to oversee a book of one hundred full-page reproductions of paintings, mostly from the fair, and mostly in color. *World's Masterpieces of Modern Painting: Selected from the World's Columbian Exposition at Chicago and Other Great Art Exhibitions of All Nations* went on sale late in 1893.

In a brief introduction, Sartain advocated etchings in preference to other methods of reproduction, including wood engraving, which he dismissed as lifeless. The "spirited effect" of etchings, he said, "corresponds with the rise of Impressionism in recent Art." That he made an exception for *The Strike*, however, is evidenced by the book's

photogravure reproduction of Koehler's painting. More surprising, his one-paragraph description of the painting conveyed a strong feeling of sympathy for the strikers:

> With the essential features of this painful scene we are only too familiar. A reduction of wages—already too low for decent living—has been announced. Whatever the cause assigned by the employers, the workmen feel that the reduction is a bitter injustice to them. The interview in progress is marked by intense excitement on the part of the men. Their spokesman is making a threatening appeal in their behalf. The aged proprietor is pale, but firm. The smoldering passions of the crowd are just ready to burst into flame. One man stoops to gather stones, and many fists are fiercely clenched. A woman with two hungry children looks sullenly up at the old gentleman and two wives seek to dissuade their husbands from participation in the strike, or at least from any act of violence; perhaps they have had sorrowful experience of the usual results of such contests. The picture is sadly realistic, and epitomizes a whole volume of literature upon the subject.[27]

By the time this sensitive response to *The Strike* appeared, another major real-world strike riveted the nation's attention. In May 1894, workers at the Pullman Palace Car Company walked off their jobs, protesting a combination of wage cuts and rent increases in George M. Pullman's paternalistic company town of Pullman, Illinois, just south of Chicago. The American Railway Union, formed the year before by Eugene V. Debs and fellow railroad workers, supported the strike by refusing to handle Pullman cars. In a replay of 1877, all rail traffic originating in Chicago came to a halt.

United States Attorney General Richard Olney filed a court injunction against the blocking of trains, and President Grover Cleveland ordered federal troops to support the Illinois state militia and the Chicago police. After arsonists burned hundreds of cars in Chicago railyards, a combined military and municipal force attacked a crowd of rock-throwing strikers and their supporters on July 7, killing thirteen and seriously wounding fifty-three. The strike was broken. Debs served six months in prison where his reading in Marx and Engels converted him to socialism.

In the midst of all this turmoil, punctuated by a march on Washington by Jacob S. Coxey's "army" of unemployed, D. Appleton & Company, possibly inspired by Finley's pictorial portfolios, published its own oversized, two-volume set entitled *The Art of the World, Illustrated in the Paintings, Statuary, and Architecture of the World's Columbian*

Exposition, edited by Ripley Hitchcock. (Hitchcock was also the editor of Stephen Crane, whose novel of urban poverty and exploitation, *Maggie: A Girl of the Streets*, had appeared the year before.) *The Strike* is reproduced as a full-page, black-and-white "typogravure," accompanied by a photograph of Koehler and a brief description of his painting, possibly by Hitchcock. The description is rather neutral and prosaic, though a few words—"victim," "sad-faced," "hungry"—do suggest compassion for the strikers:

> The crowd of workmen has come from the mills, whose chimneys rise in the distance, to the house of the owner, who stands on the steps listening to the spokesman of the party. The latter points to an old workman, the victim of some special grievance, and the crowd jeers. A man on the outskirts of the group is picking up stones for possible action, and a striker's wife is vainly urging her good man to go home. A sad-faced woman with hungry children crouches at the side of the house and watches her husband's employer with no kindly eye.[28]

The last public attention *The Strike* would receive from the political left for almost eighty years came in the form of a cropped, tipped-in reproduction of the painting, "suitable for framing," for the 1894 edition of the *Pionier*, an illustrated *Volks-Kalender* (people's calendar) published by the *New Yorker Volks-Zeitung*, the organ of the German American socialists in New York City.[29]

By this time, Robert Koehler had made yet another career move, one that took him from New York deep into the American heartland. In 1893 he traveled to Minnesota, to become director of the Minneapolis School of Fine Arts. He took this position at the invitation of the school's founder and first director, Douglas Volk, with recommendations for the position from William Merritt Chase, Walter Shirlaw, and several other well-regarded artists.[30]

As Koehler settled into his new role of combined teaching and art administration, his creative output lessened, consisting primarily of immediate family portraits, self-portraits, and various commissioned likenesses. While other painters followed his bold step of portraying striking workers, his own masterpiece in this genre, *The Strike*, would recede into an obscurity that lasted for some seventy years.

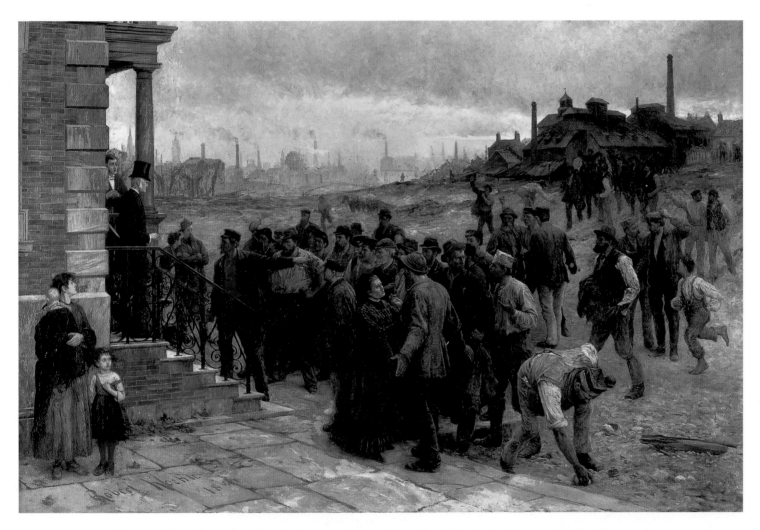

PLATE I Robert Koehler, *The Strike*, o/c, 9′2¾″ × 6′¾″, 1885–86 (Deutsches Historisches Museum, Berlin, Germany)

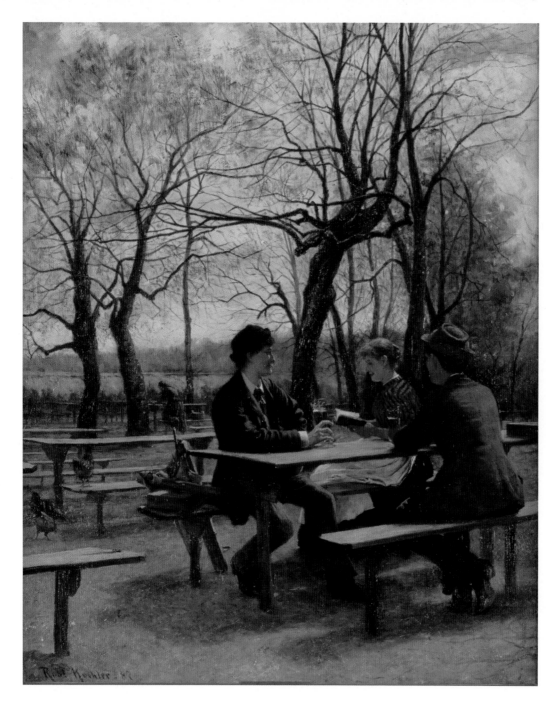

PLATE 2
Robert Koehler,
The First Guests,
o/c, 1887
(Milwaukee Art Museum,
Milwaukee, Wisconsin)

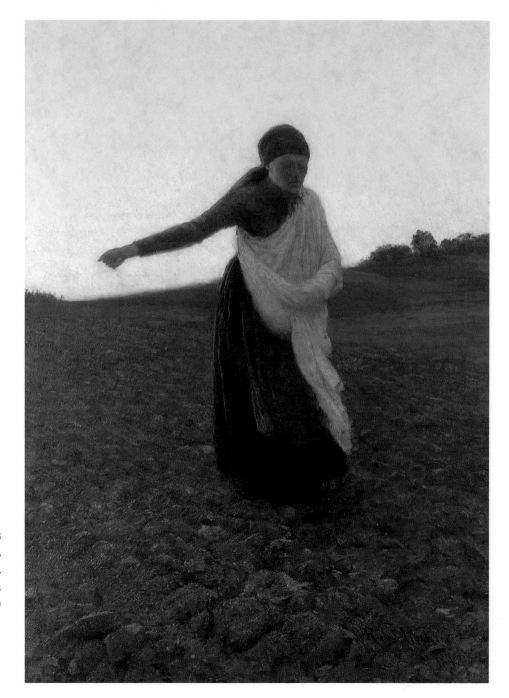

PLATE 3
Robert Koehler,
Sower,
o/c, c.1892
(private collection)

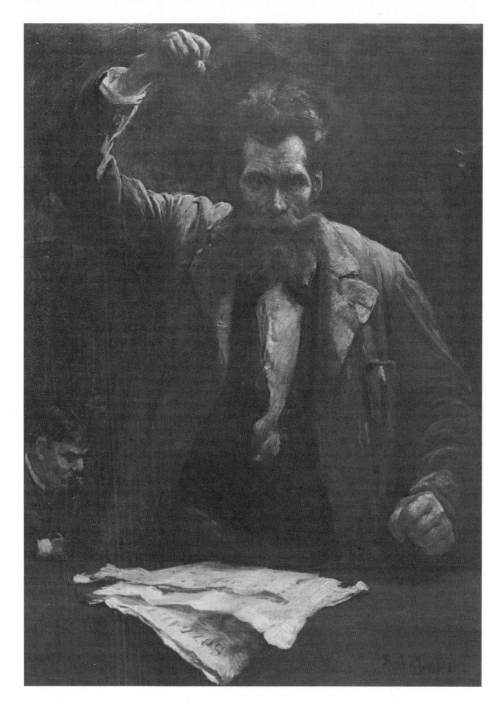

PLATE 4
Robert Koehler,
The Socialist,
o/p, 1884–85
(Deutsches Historisches
Museum, Berlin, Germany)

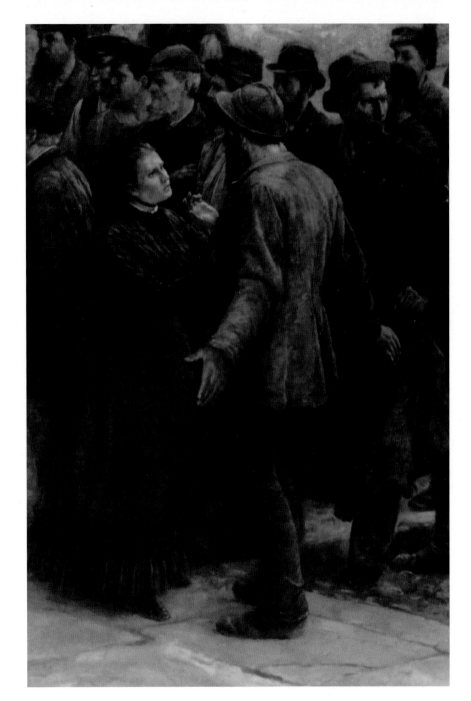

PLATE 5
Robert Koehler,
The Strike,
o/c, 1885–86, detail,
central figures
(Deutsches Historisches
Museum, Berlin, Germany)

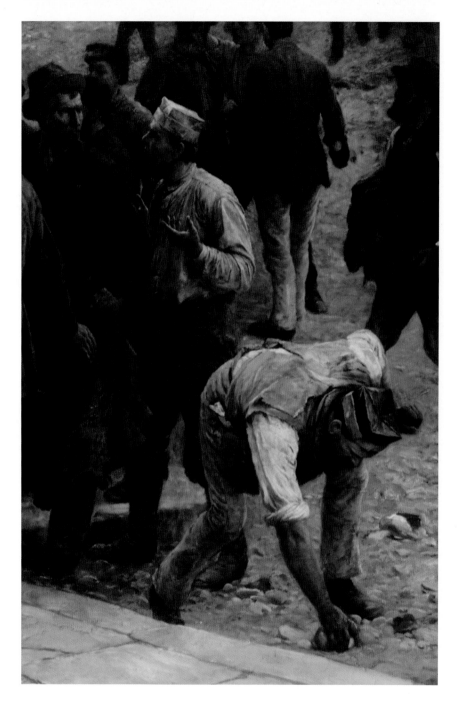

PLATE 6
Robert Koehler,
The Strike,
o/c, 1885–86, detail,
stone gatherer
(Deutsches Historisches
Museum, Berlin, Germany)

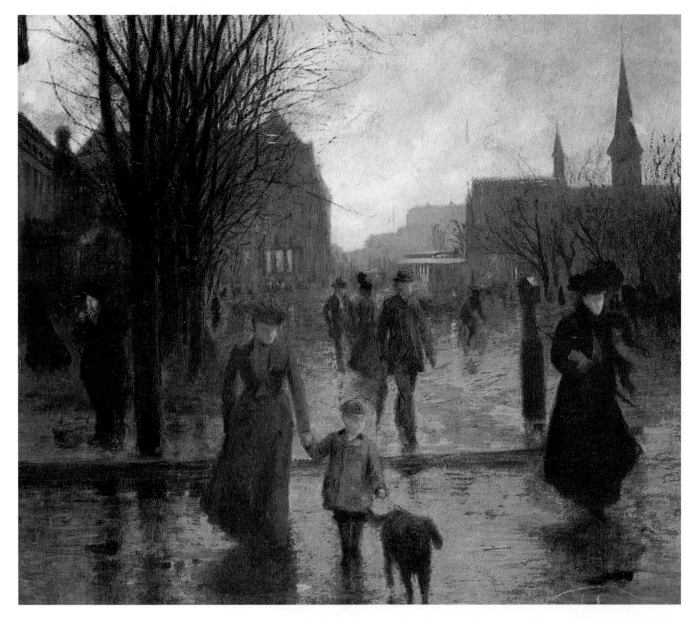

PLATE 7 Robert Koehler, *Rainy Evening on Hennepin Avenue*, o/c, 1902 (The Minneapolis Institute of Arts, Minneapolis, Minnesota)

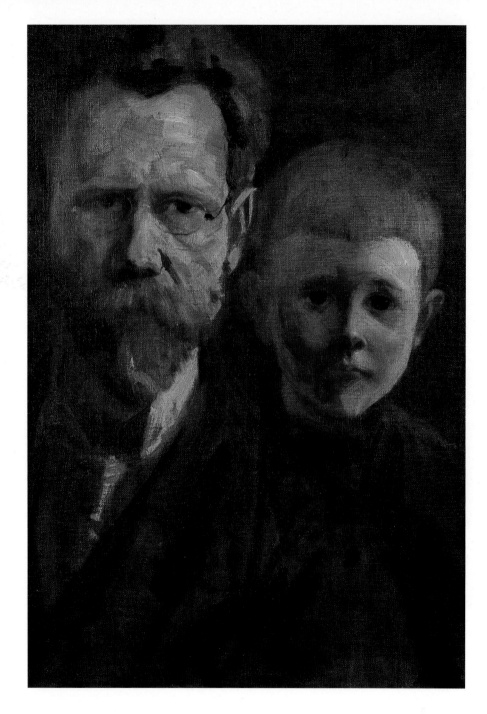

PLATE 8
Robert Koehler,
Self Portrait with Son, Edwin,
o/c, 1907
(private collection)

9

Transatlantic Progeny and a Minneapolis Refuge

1893–1917

EVEN THOUGH IT LACKED a ready market for its subject matter, *The Strike* left a reasonably successful exhibition record behind in 1893 as Robert Koehler ventured to a bustling Midwestern grain, timber, and rail emporium, Minneapolis, to assume the directorship of the Minneapolis School of Fine Arts. Invited to succeed its founding director, fellow painter Douglas Volk, he sacrificed the beginnings of a promising portrait practice in New York City, where he had rented a studio the year before. Under the auspices of the Minneapolis Society of Fine Arts, incorporated in 1883, Volk had launched its school in 1886 in a house on Hennepin Avenue, one of the city's major thoroughfares. In 1888 it moved into a one-story skylighted building erected at the rear of a lot owned by the lumber tycoon and art collector Thomas B. Walker. Fifteen months later it moved again, this time to the fourth floor of the newly built Minneapolis Public Library.[1] Confronted with the challenges of administration and teaching drawing and painting to over a hundred students, Koehler had little leisure time to ponder the fate of his masterpiece painting. He also may have been unaware that a growing number of European artists were following his bold initiative and addressing the same subject.

Industrial Strikes in European Painting after *The Strike*

While striking coalminers had attracted the attention of French painter Alfred Philippe Roll as early as 1880 (Fig. 30) and inspired the ambitious 1888 triptych *De Werkstaking* (Strike) (Fig. 41) by Belgian painter Hendrik Luyten, it was

dock and factory workers who joined the ranks of Koehler's millworkers in strike paintings of the 1890s. The London dockworkers strike of 1889 inspired two contrasting paintings of labor dissent, both of which abandoned *The Strike*'s rather academically staged composition.

Dudley Hardy's *The Dock Strike* of 1890 (Fig. 42), except for its single, deliberately placed repoussoir figure in the lower left corner, reads like a spontaneously shot and cropped press photograph. Union leader John Burns, shaking his fist in the air, rises from a throng of men to exhort them into action. Most, however, appear weary, demoralized by the event or the foggy, wet weather. Unlike the uproarious crowd of arm-waving men and women massed around a red flag in Luyten's jam-packed interior, they stand stock still, some with hands in pockets. A man wearing a top hat edges in from the right side to join the crowd of bowler-topped workers. Just in front of him, a woman wearing what appears to be rain apparel looks up at Burns, listening attentively. That the couple might be Eleanor Marx and her companion/comrade, Edward Aveling, is a tempting conjecture, as both were involved in advancing trade union-ism among unskilled laborers in London's East End.

FIGURE 41 Hendrik Luyten, *De Werkstaking* (Strike), o/c, 1888 (Gemeentemuseum, Roermond, Belgium)

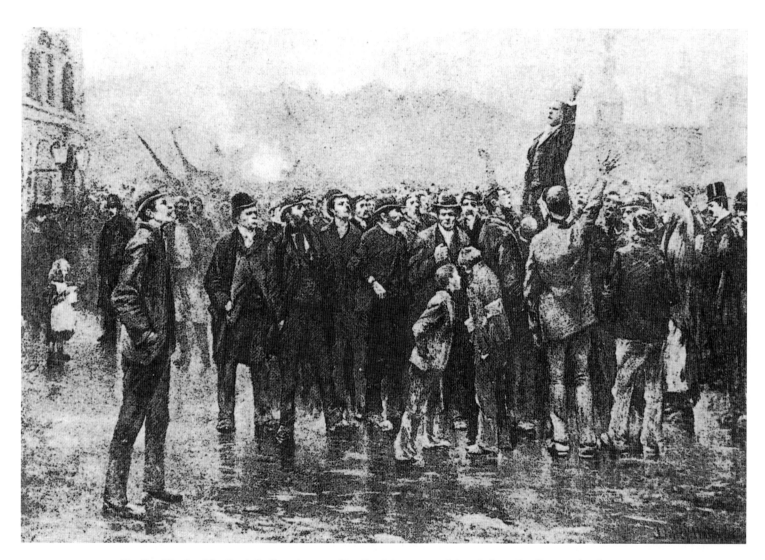

FIGURE 42 Dudley Hardy, *The Dock Strike*, o/c, 1890 (Dudley Museum and Art Gallery, Dudley, England)

Two boys, about the age of Koehler's barefoot urchin running into the action of *The Strike*, lean toward each other in front of Hardy's crowd. One appears to whisper into the other's ear. Their long pants and presumably tweed suit coats are similar to that of the man standing next to them, on line with Burns, to whom he waves. A little girl appears in the far left background—a motif used by Rembrandt in *The Night Watch*, which Koehler also used more than once.

A pair of children, the older usually anxious and the second inevitably a baby carried by its forlorn mother, became a standard accessory in strike paintings following *The Strike*. Vaguely discernable in Luyten's nocturnal side panel, two children blend into their roughly silhouetted mother, trudging along a wet street in her wooden shoes.

In *On Strike* of 1891 (Fig. 43), the best-known social-realist painting by Bavarian-born but American- and British-bred Hubert von Herkomer, a solemn baby, head level with her father, reflects his worried expression. She is held by her mother who stands behind her husband on the worn threshold of a dark interior, resting her head on his. Her free arm hangs limply around his shoulder. In the shadows behind them, the hands of their distraught older daughter resemble those of the anxious head of the family, grasping his clay pipe and hat.[2]

As opposed to Herkomer's concentration on a single striker with his small family, and in keeping with the precedent set by Koehler, paired children in crowded scenes of striking workers underscore a narrative of distress. Such a pair appears, for example, in *Un Soir de grève: Le drapeau rouge* (Strike Evening: The Red Flag) by Belgian artist Eugene Laermans (Fig. 44). Two children with their mother, another mother and child, and two more women follow dispirited men in the foreground of a densely packed mass of strikers following a red flag. In the lower right, a frightened barefoot toddler clings desperately to its mother's skirt. A baby is bundled out of sight in her arms. Slightly ahead, a man and perhaps his wife look back at them compassionately as the second mother walks alongside in silence, her weary child on her back. Looming above and behind them, the whitewashed factories await their inevitable return.

Similar in composition to Luyten's strike meeting although less frantic, the painting *Szrájk* (Strike) was completed by Hungarian artist Mihaly von Munkacsy two years into the depression (Fig. 45). It, too, devotes the lower right corner of its crowded composition to a mother and her two children. True to form, she holds the infant in her arm as her older daughter shares her worried concern for her husband. In contrast to the others at the protest meeting, he and a sleeping worker up front have collapsed into chairs. Clearly separated from the rest, the little family group underscores the harsh consequences of unemployment, while adding a note of doubt and uncertainty to the strike narrative. As in Koehler's *The Strike*, the question lingers: will direct action ever lead to a beneficial outcome?

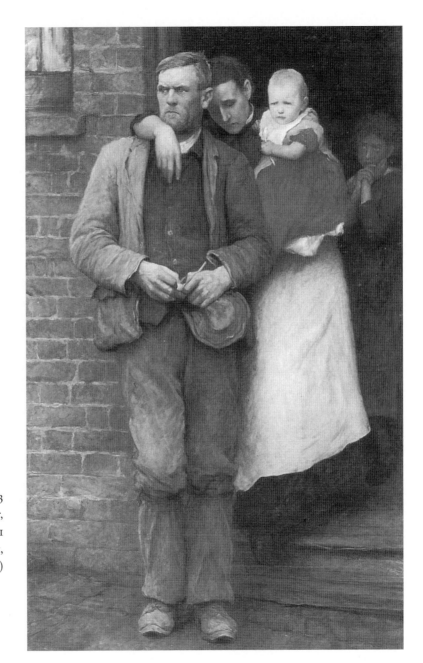

FIGURE 43
Hubert von Herkomer,
On Strike, o/c, 1891
(Royal Academy of Art,
London, England)

FIGURE 44 Eugene Laermans, *Un Soir de grève: Le drapeau rouge* (Strike Evening: The Red Flag), o/c, 1893
(Musées Royaux des Beaux-Arts de Belgique, Brussels, Belgium)

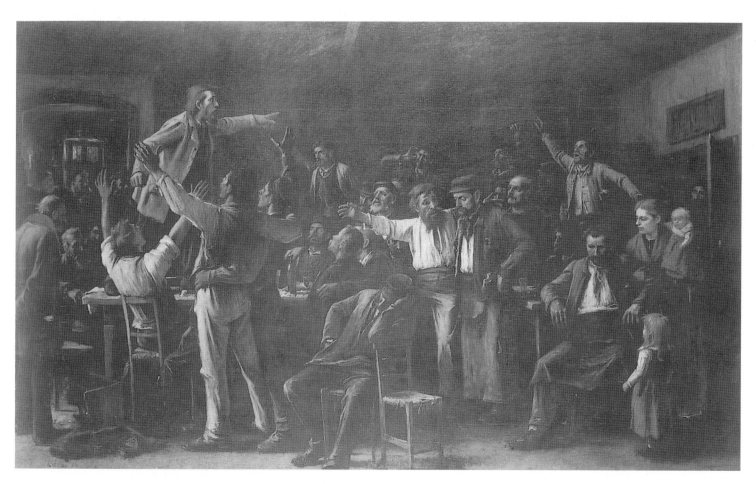

FIGURE 45 Mihaly von Munkacsy, *Szrájk* (Strike), o/c, 1895 (National Gallery, Budapest, Hungary)

During the same year (1895) as von Munkacsy's painting, academically trained Giuseppe Pellizza da Volpedo created the first oil sketch of his most famous painting. Initially called *Fiumana* (Human River), it had evolved into *Il Quarto Stato* (The Fourth Estate) by the time Pellizza completed it in 1901 (Fig. 46). A barefoot mother walks into the central foreground holding on to her naked baby, appealing to two forward-striding leaders with an open left hand. They appear oblivious of her presence. An older child, at the right end of the marching rank-and-file, looks up at her father, possibly the woman's husband, holding the child's hand. Another woman appears in profile behind

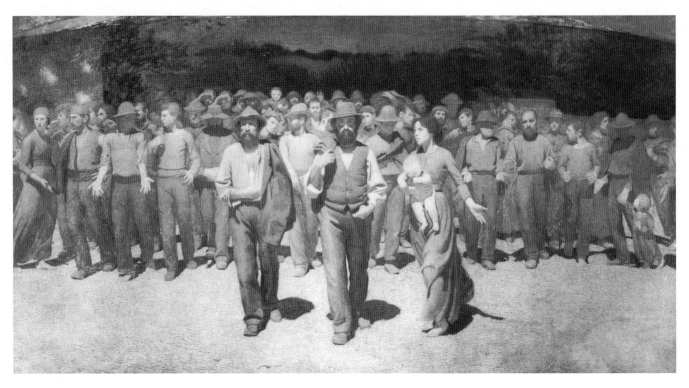

FIGURE 46 Giuseppe Pellizza da Volpedo, *Il Quarto Stato* (The Fourth Estate), o/c, 1895–1901 (Civica Galleria d'Arte Moderna, Milan, Italy)

them, as a third, more prominent woman calls out from the far left end of the front rank. Well versed in Marxist theory, Pellizza planned his masterpiece as an allegorical representation of an exploited proletariat, but without identifying signs of a specific event.[3] Its greater universality thereby evaded the mistaken associations sometimes imposed upon Koehler's *The Strike*.

Actual events, however, called out for representation within the ongoing narrative of strike paintings subsequent to Koehler's path-breaking example. The French artist Jules Adler, for instance, painted a procession of strikers, wives, and a handful of children that he witnessed on October 9, 1899, in Creusot, France (Fig. 47). On that day a long foundry workers' strike was settled, and to celebrate the occasion some five to six thousand strikers and their families marched to nearby Montchanin to thank its citizens for their support. Led by three intimately linked leaders and a vigorous woman in black bearing the tricolor, they stride forward singing *L'Internationale* (as Adler reported). Out of respect for this anthem of workers' solidarity, the drummer boy has thrown his drum over his back and looks reverently upward at the march leaders. Mothers with babies, though relegated to the background, reveal the toll of the lengthy ordeal. Their sallow, sad faces match the dank tone of the foundry towers and smokestacks. But the dawn breaks, a herald of hope.

Arguably the most memorable strike portrayal of the period, Käthe Kollwitz's 1897–98 series of six intaglio prints, *A Weavers Revolt*, merits the attention it continues to receive. Based on *Die Weber* (1892), Gerhart Hauptmann's dramatization of an 1844 uprising by Silesian cottage weavers, it unveils Kollwitz's career-long compassion for the downtrodden. Its ultimate depiction of head-holding despair at the bedside of a starved child overshadows the solemn courage of the foreground mother in *Weavers' March*. In *Storming of the Owner's Gate* (Fig. 48), another mother, with a baby in one arm and an undernourished older child at her side, watches undaunted as three other women tear up cobblestones. One of the men, possibly her husband, reaches eagerly for another stone to throw.

Although such desperate measures played a traditional role in paintings representing uprisings, Kollwitz could have easily remembered Koehler's stone-grasping worker in *The Strike*, a painting she may well have seen during her two art-student years, 1888–90, in Munich. Kollwitz attended the Women's Annex of the Royal Academy of Art; she later remarked that she had little "feel for color," and turned instead to etching, a process that Koehler, although trained as a lithographer, had also embraced. She joined a painting club that may have included some of Koehler's part-time students. The club members chose, for an evening's exercise, the theme of struggle, and Kollwitz represented

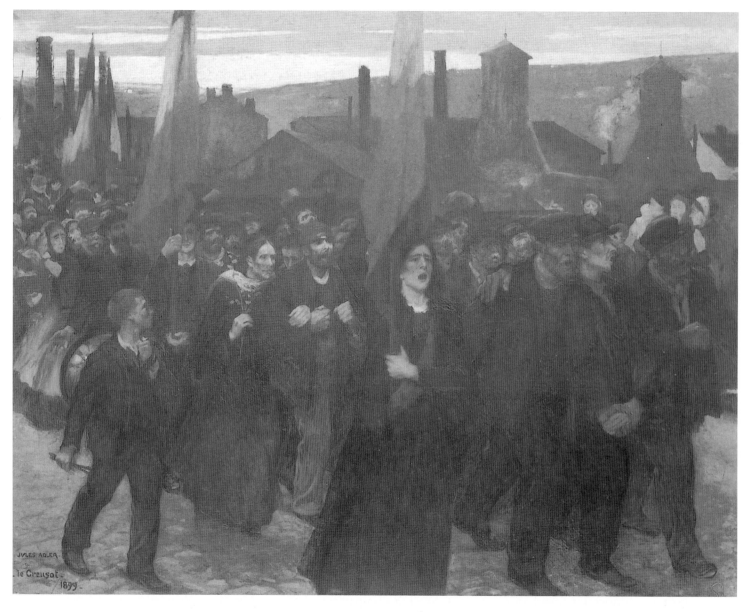

FIGURE 47 Jules Adler, *The Strike at Creusot, October 9, 1899*, o/c, 1899 (Écomusée du Creusot-Montceau, Le Creusot, France)

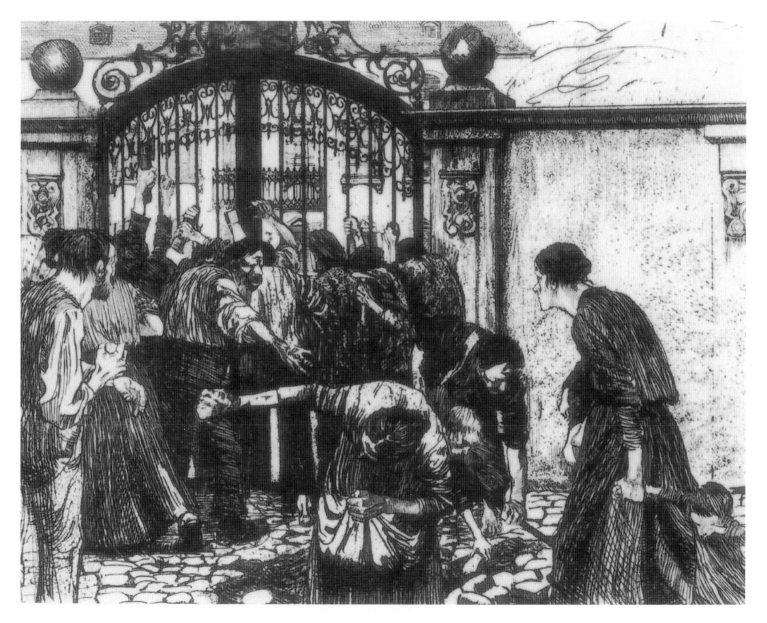

FIGURE 48 Käthe Kollwitz, *A Weavers Revolt: Storming of the Owner's Gate*, etching, 1897–98

a tavern-fighting scene from Zola's *Germinal*. In 1891 she married the young physician Karl Kollwitz and together they pursued their respective careers in a working-class quarter of central Berlin.[4]

Stone throwing as a striker's only defense against armed attack reached an apogee in 1892 with *The Strike of the Blacksmiths*, by a twenty-five-year-old Karlsruhe artist, Theodor Esser (Fig. 49).[5] His choice of an industrial strike about to explode into violence was timely. In 1891, a year after Bismarck's forced retirement under the young Kaiser Wilhelm II, the emboldened Social Democratic Party adopted a new program that not only embraced the Marxist doctrines of class conflict and capitalism's inevitable collapse, but also called for immediate reformist action, in which trade unions, although illegal and harassed by local police, would play an essential role.[6]

In 1892, so motivated, the first general congress of German trade unions convened in Halberstadt where it reaffirmed the authority of the united unions' central committee to call strikes against local employers by a majority vote. This resolution, however, did not completely preclude what in America would be called "wildcat" strikes, and these—indeed, any labor dispute, large or small—the Kaiser found intolerable. As early as March 1890, he had ordered his generals to "use the repeating rifles freely at the first opportunity" against a walkout in Gelsenkirchen, in the Ruhr coal mining district.[7] Widespread strikes continued, nonetheless, as economic conditions worsened. In the winter of 1892–93 several thousand coal miners in the Saar, not far from Karlsruhe, went on strike.

In this immediate context, and probably in response to a strike in Karlsruhe itself, Esser's painting vividly evokes the situation of panicky strikers trapped underneath the exterior shed-roof of their factory. Their backs literally against the wall, they shout, whistle, and at least one frantically gathers stones as an infantry column approaches, rifles at the ready, waiting for its officer's order to fire. The painting's dominant figure, a dark, oddly graceful form silhouetted at the bottom of a large wedge of sunlight, is a hefty, apron-clad blacksmith shouting and brandishing his fist at the unbelievably uniform row of bright helmets. In the middle ground, a still bolder blacksmith, symbolic of traditional craftsmanship struggling to maintain pre-industrial methods of production, openly taunts the troops at short range. Feet planted widely, he, too, clenches his left hand while his right thrusts out a makeshift weapon, a spade. As though mocking his futile defensive measure, a prominent smokestack rises directly behind him.

Parallel to the smokestack's earth-to-sky thrust, a dark roof post accents two other peculiar silhouetted figures. Their behavior seems strange: the foremost, bespectacled and bearded, peers assertively into the somber shed as the other reaches out to caution him. Beside them, a pair of non-workers, almost lost in the sun, appear over the shoulders

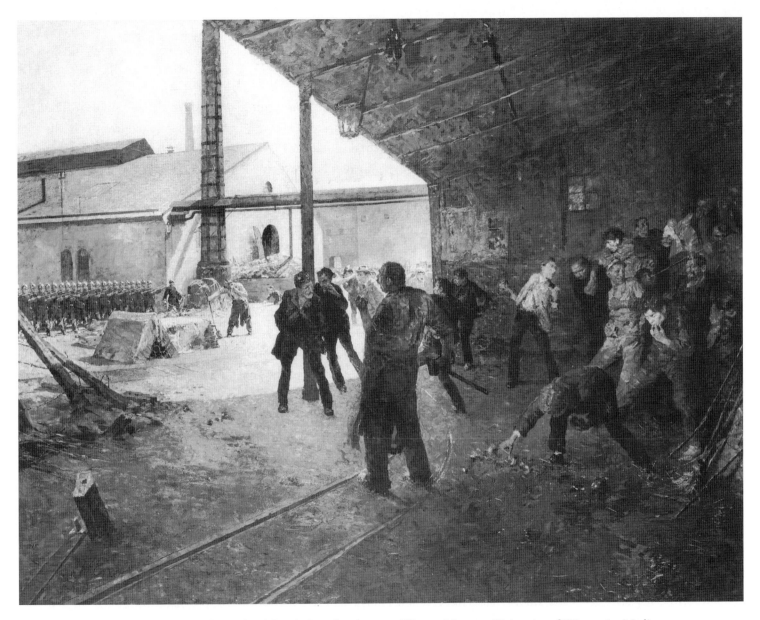

FIGURE 49 Theodor Esser, *The Strike of the Blacksmiths*, o/c, 1892 (Chazen Museum, University of Wisconsin–Madison, Madison, Wisconsin)

of the big blacksmith. One is perhaps a union officer or a reporter wearing a soft felt hat, shirt, tie, and suitcoat. The other, a woman, shouts between her upraised hands toward the strikers. Her relatively minor role reduces the likelihood that Koehler's *The Strike*, in which a woman is so central, influenced Esser's painting. Esser moved to Munich after completing *The Strike of the Blacksmiths*, but by then Koehler had probably left for New York, so the two artists who for a time shared an interest in capturing on canvas the drama of an industrial uprising presumably never crossed paths.

Return to America: Early Years in Minneapolis

Meanwhile, far from these events, Robert Koehler, now living in New York City, was preparing for the next stage of his career. Marie Fischer, who after a nine-year courtship had at long last said yes, arrived there aboard the Hamburg steamship *Palatia*, in early September 1895, her fiancé waiting on the dock. Koehler's friend Edwin Henes, now the treasurer of New York's Hell Gate Brewery, and his wife welcomed Marie into their Manhattan home where the wedding took place on September 17, a German clergyman named Halfmann officiating. The guests included the son of Koehler's patron George Ehret, the wealthy German American owner of the Hell Gate Brewery, who had sent as wedding gifts an Empire clock and a candelabrum from Tiffany. He also canceled a loan owed him by the groom. The next day the newlyweds traveled up the Hudson to Albany. From there they continued by train to Chicago where they visited relatives. Then it was on to Milwaukee, where Marie was "astonished" (as she recalled years later) to find her husband's parents and two siblings "thoroughly different in education" from him.[8]

Arriving at last in Minneapolis, the couple settled first in a modest house near the city's Loring Park, where Robert prepared for the fall term of the School of Fine Arts. A few months after the wedding, Ernst Koehler died in Milwaukee. His widow moved to Minneapolis, where she lived with Robert and Marie until her death in 1897. By that time, Koehler had given a pair of his paintings to a realtor as partial payment for two adjoining lots on Portland Avenue near Washburn Park, just beyond the city's southern boundary. As the economy recovered, his annual salary of $500 allowed for new-home financing. For the newly acquired lots, he helped design a roomy "German Renaissance house" featuring stepped gables and studio space. In November 1897, with Marie two months pregnant, the couple moved in and held a housewarming. While guests sipped red wine or raspberry juice, a pianist friend played a *Festmarsch* he had composed for the occasion.[9] Once settled in, the Koehlers attended concerts, joined a music club, and played

chess in the evenings. Edwin, the Koehlers' only child, then arrived in June 1898. At seven months, he was baptized by a minister of the Universal Evangelical Church with waters from the Mississippi River and Minnehaha Creek.

Every other Saturday evening, Koehler's night out, he attended meetings of the Minneapolis Art League, an institution he had founded soon after his arrival. The League met in a small Hennepin Avenue studio building originally donated as a temporary home for the Art School by the city's foremost art patron, the wealthy lumber baron, philanthropist, and civic leader Thomas Barlow Walker (1840–1928), whose Red River Lumber Company controlled vast tracts of timberland in northern Minnesota and in California. Having inherited this studio space from his predecessor Douglas Volk, Koehler hosted the informal gatherings in front of its fireplace and, according to his friend Harlow Gale, a psychology professor at the University of Minnesota, usually chose the topics for discussion. These ranged widely: from Beethoven to Debussy, Ruskin to Cubism, the Munich actor and theater producer Ernst von Possart to, eventually, the contemporary poet Alan Seeger.[10]

Koehler's own efforts at the easel were increasingly interrupted by household and administrative duties, teaching, and museum work. In addition to portraiture he sketched and painted landscapes, many of them watercolors, during vacations at Lake Minnetonka and other nearby lakes.[11] One oil, a small rustic scene, features a dilapidated rail fence set back from the immediate foreground and approached over a flowery edge of meadow (Fig. 50). A picturesque farmhouse with red-tile gable roofs rises in the background, flanked by two fully leafed trees in compliance with the symmetrically balanced composition favored by the seventeenth-century French landscape painter Claude Lorraine. In the more fanciful *Salve Lune* (Fig. 51), a setting sun, a play of trees above the horizon line, and a centralized patch of sky-reflecting water also betray the Claudian influence. Two nymphs, after bathing in a stream nearly smothered by lush grasses, dance buoyantly in twilight moonbeams. Mythical fantasy aside, reported the *Minneapolis Journal*, "The landscape is a bit of Minnehaha Creek near the artist's quaint home."[12]

Equally well executed and in some cases more innovative are the portraits Koehler continued to paint for the rest of his life. Two examples, *The First Snow* and *Violet* (Figs. 52 and 53), were presumably posed by Marie soon after the newly married couple settled in Minneapolis. Each depicts a perfectly still, completely idle young woman isolated in her thoughts and feelings. Not that unusual by the end of the nineteenth century, this ambivalent image, evoking melancholy and possible estrangement, was repeated in James Whistler's *The Little White Girl: Symphony in White, Number 2*, of 1864, and Lilly Martin Spencer's *We Both Must Fade*, 1869.

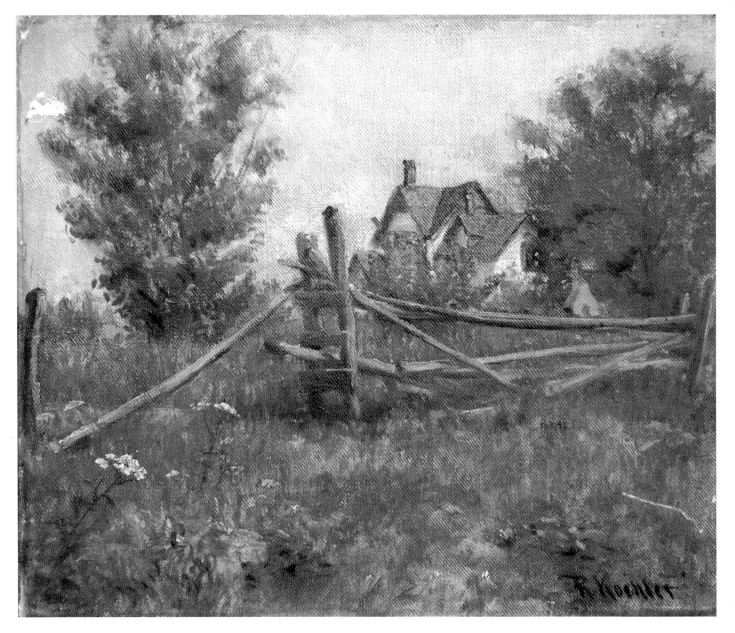

FIGURE 50 Robert Koehler, *Farmhouse and Fence*, o/c, c. 1905 (private collection)

FIGURE 51
Robert Koehler,
Salve Lune,
etching, c. 1900

In *The First Snow*, a solitary, upper-middle-class woman in a flowing blue sacque gown blends into an inundating abundance of lace curtains. Less individuated than the potted plant next to her, she is in peril of becoming a mere compositional foil, a beautiful clothes prop, as it were. Her outward gaze may indicate a longing to be somewhere else, released from confinement, no matter how spacious or well appointed it might be.

In *Violet*, named for the violet attached to the bodice of her gown, the woman sits in an ambiguous state of suspension, staring into space. We are given no contextual clues as to her physical or psychological location. Her thoughts seem to stray from the cluster of blossoms beside her. Her long, tightly covered arms rest on her lap, her hands loosely grasping a beribboned feather fan.

In a departure from these idealized images of women, Koehler's personal portraits of his immediate family and of himself allowed for a subtle element of caricature. A droll self-portrait as a newly instated bourgeois gentleman pictures the artist on a radically red background. He is adorned with a homburg hat, stiff-collared white shirt, black suit, wedding band, and a haughty stare (Fig. 54). One year later he painted his now very plump wife breastfeeding their baby boy (Fig. 55). Shielded from the outside world, mother and child sit in front of a fireplace in their brand-new house. Marie's short brown hair contrasts subtly to the red-brick tone of the mantel as she looks down affectionately at her suckling offspring.

Three years later, in 1902, the two reappear with the family dog in the foreground of Koehler's most ambitious outdoor Minneapolis painting, *Rainy Evening on Hennepin Avenue* (Plate 7). They cross Eighth Street hand-in-hand, at what appears to be the close of a stormy day. A very wet Hennepin Avenue recedes into a murky background dimly countered by the headlight of a streetcar. At a safe distance in front of it, a softly silhouetted bicyclist stands out slightly more than the horse-drawn carriage moving in the opposite direction. The paired spires of the Hennepin Avenue Methodist Church tug the composition toward the right, counterbalancing the leafless tree branches on the left. The trees stand in a row leading to a building especially important to Koehler: the Minneapolis Public Library, home of the School of Fine Arts. Also on the left, the façade of the Walker mansion scarcely makes it into the picture. Of the few people out and about, the most prominent, apart from the fashionably attired Marie and Edwin, is an equally well-dressed woman carrying her tightly rolled-up umbrella. She nearly qualifies as one of the singular female figures dominating Koehler's more significant paintings. The only potential reference to the working class is an isolated man, standing next to a foreground tree where he has put down his basket to light a smoke. The reflection of flame on his face saves it from being lost in the painting's murkiest area.

FIGURE 52
Robert Koehler,"
The First Snow,
o/c, c. 1895–98
(private collection)

FIGURE 53
Robert Koehler,
Violet, o/c, c. 1895–98
(private collection)

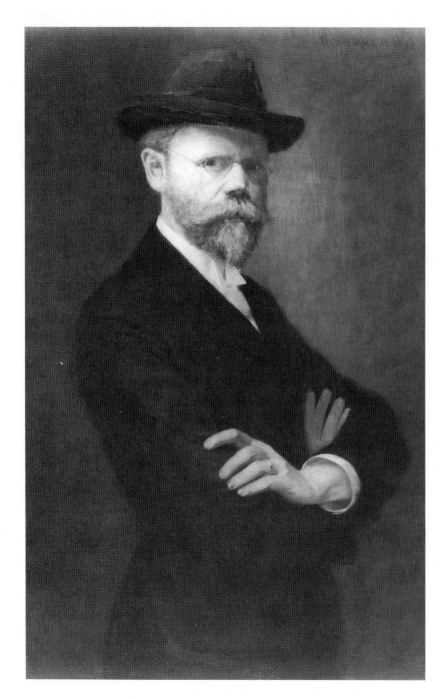

FIGURE 54
Robert Koehler,
Self Portrait, o/c, 1898
(on loan to West Bend
Art Museum, West Bend,
Wisconsin)

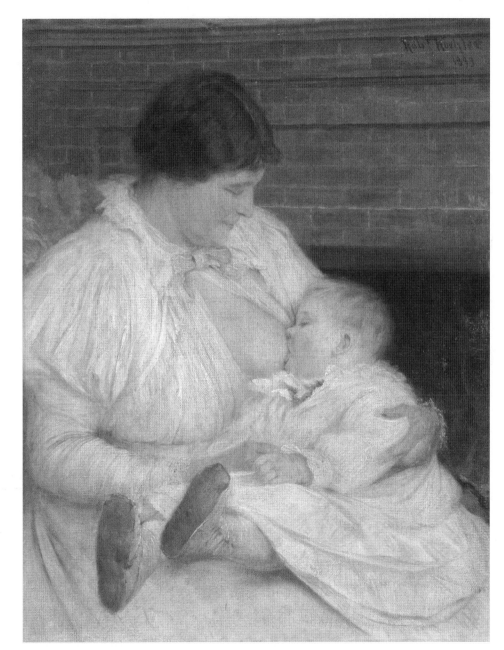

FIGURE 55
Robert Koehler,
Marie Nursing Baby Edwin,
o/c, 1899
(private collection)

The inclusion of a person of lower social status, as well as the prominent positioning of his own family, distinguishes this painting from Koehler's farewell-to-Munich picture, *Promenadenplatz, Munich* (Fig. 56), which is otherwise rather similar, including the leashed pet dogs and twin church spires. First exhibited in 1893 at the National Academy of Design, the Munich street scene is much less personal than *Rainy Evening on Hennepin Avenue* and, in stark contrast to the industrial workers in *The Strike*, its bourgeois figures are obscured, small-scale, and faceless.

In keeping with the predominant social class represented in both of Koehler's city-street scenes, he accepted in 1906 a commission to paint a large, three-quarter-length portrait of Alvina Roosen (Fig. 57). Elegantly dressed and obviously well off, Alvina was the wife of German-born Charles Gerald Roosen, co-founder of the State Bank of rural Delano, Minnesota, and the town's longtime mayor. He was probably the wealthiest of Koehler's Minneapolis-area patrons to commission a portrait from him.[13]

Koehler's affection for his son is touchingly evident in a series of likenesses he painted of him. Looking rather melancholy, Edwin at eight or nine wears a knit hat with a matching high-collared sweater in a little bust-length oil portrait called *Skating Costume, Edwin Koehler* (Fig. 58). True to the title, clamp-on skates hang over his shoulder. From approximately the same time, Edwin looks out at us from behind his father's left shoulder in a double portrait (Plate 8). The boy's slightly forlorn expression contrasts with his father's stern gaze into a mirror (or possibly into a camera lens, as photography came to play an increasing role in his portraiture). Lightening the mood a bit, Koehler emphasized the identical hairlines of father and son, complete with widow's peaks.

In 1908, now ten, Edwin posed for his first full-length portrait in a white shirt and light-toned knickers tinged with blue (Fig. 59). The warmth of his face and hands complements the intense blue-greens of both a round vase and a bent-legged wooden chair with a low back. The chair's ample seat supports the boy's left knee as he reaches down with outstretched arms, both hands grasping its back. This angular configuration encloses and contains the central design of figure and prop, further stabilized by the black-stockinged leg. Once again the boy looks none too happy about posing for his artist father. But even out in the woods in *Edwin Hunting Squirrels* (Fig. 60), his spirits show little sign of lifting. In this case, however, a serious demeanor seems appropriate, since the twelve-year-old is, after all, silently stalking game. Essentially a half-length profile portrait, the tree-braced pattern of blue-denim bibbed overhauls, white shirt, and a red bandana rises above the slightly slanted rifle held at the ready, partially concealed by loosely painted underbrush.

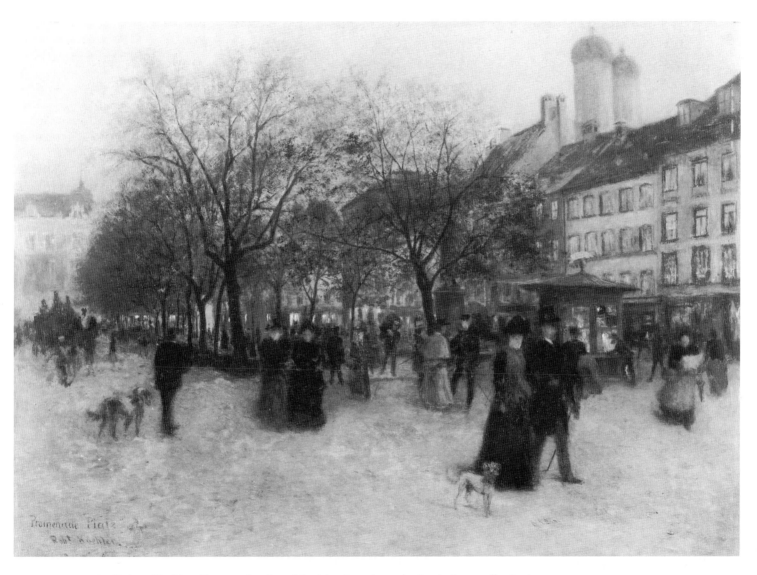

FIGURE 56 Robert Koehler, *Promenadenplatz, Munich*, o/wood panel, 1893 (private collection)

FIGURE 57
Robert Koehler,
Portrait of Alvina Roosen,
o/c, 1906
(The Minneapolis
Institute of Arts)

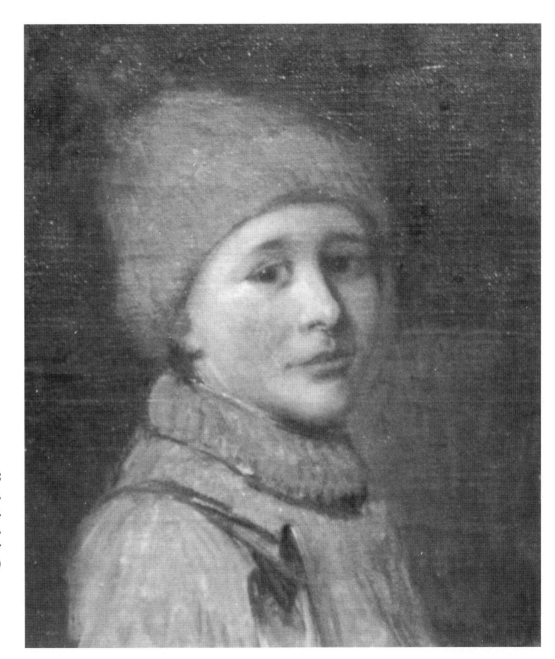

FIGURE 58
Robert Koehler,
Skating Costume,
Edwin Koehler,
o/c, c. 1907
(private collection)

FIGURE 59
Robert Koehler,
Edwin in Knickers,
o/c, 1908
(private collection)

That the image of a pensive young woman never completely disappeared from Koehler's mind's eye is evident in the unfinished painting on his easel when he died in 1917 (Fig. 61). In this self-portrait, the artist wears a smoking jacket and crisp white shirt. In a Rembrandtesque manner he stares intensely at his aging face and thereby peers out at us, his palette front forward, a brush in his left hand. In a luminous background corner there she sits, anonymous, dressed in white. Her bentwood armchair directed away from us, she turns her head around completely in order to

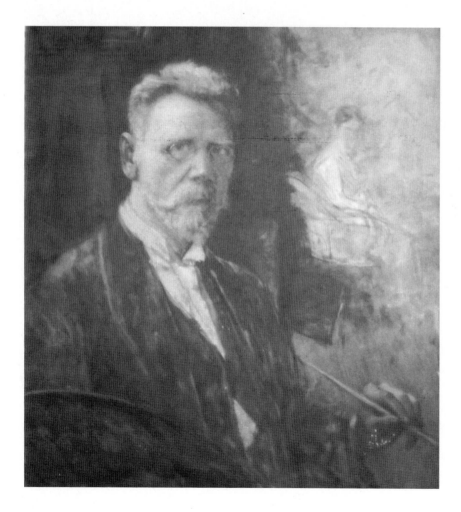

FIGURE 61
Robert Koehler,
Self Portrait with Seated Woman,
o/c, 1917
(private collection)

look toward Koehler and in our direction. In this effort to make contact, she departs from her predecessors in *The First Snow* and *Violet*, who continue to contemplate some distant objective, oblivious of anyone else's presence.

By the time Koehler last touched what was to be his farewell painting, his greatest work, *The Strike*, had been hanging for some fifteen years on a relatively obscure wall of the Minneapolis Public Library. The building on Hennepin Avenue dated to 1889 when it was built through the leadership and generosity of the library's board president, Thomas Walker. A year later, "T. B.," as he liked to be called, greatly expanded the library's miniscule art holdings with a loan of seventeen academic genre and landscape paintings. Over the next two decades Walker accumulated ninety-four more works of primarily conservative, nineteenth-century French artists including numerous rather redundant examples of his favorite, Jules Breton. The growing fame of his collection rested in part on its technically up-to-date display in a gallery attached to his mansion and magnanimously opened to the public.[14]

In view of Walker's taste for nothing more daring than Corot, he would hardly have been prone to purchase a large dramatization of contemporary labor rebelliousness. As Karl Eugen Schmidt was to observe in a 1907 essay in *Pionier*, the yearbook of the socialist *New Yorker Volks-Zeitung*, "the rich man who buys pictures would very reluctantly hang a picture in his salon which continually reproaches him." Any artist seeking patronage, Schmidt continued, is therefore more or less forced to choose "beautiful" subject matter, for example, a pastoral image of peasants in a field, while avoiding "ugly" industrial subjects—especially striking factory workers![15] Thus, the presence of Koehler's masterwork in such close proximity to paintings that Walker considered proper inspiration for art students must have been a matter of curiosity and very possibly controversy.

The Strike's marginalized status in Minneapolis offers a revealing case study of the double-edged sword of art patronage. Although Koehler's diligence as an art teacher, administrator, and exhibition organizer had won over the city's cultural community by the turn of the century, its small art-buying segment, apart from a few portrait commissions, failed to purchase his works. As for his dream of seeing *The Strike* in a public collection, a class-based bias against its subject matter would have had to be overcome, in somewhat the same way a politically provocative sculptural group on the Boston Common is finally understood and accepted by Julian West, the protagonist in Edward Bellamy's utopian novel *Equality* (1897), a sequel to his more famous *Looking Backward*, set in the year 2000. As described by Bellamy, the sculpture portrays three coarsely garbed strikers and two wives, one holding "an emaciated, half-clad infant," the other trying to restrain her husband. As a member of the wealthy and cultured class of the late

nineteenth century, Julian had viewed strikers with "contempt and abhorrence—as pestilent fellows whose demonstrations ought always be condemned and promptly put down with an iron hand the moment there was an excuse for police interference." But his companion and mentor, the kindly Doctor Leete, whose role is to orient Julian as he encounters the new social order of the future, persuades him to change his mind. Although ignorant of the larger social significance of their "perpetual strikes for a few cents more an hour at less working time a day," Leete explains, the organized workers of the late nineteenth century were now honored as "protomartyrs" in the new socialist "industrial republic" of Bellamy's dreams.[16]

While they did not experience Julian West's change of heart toward striking workers, the art patrons of Minneapolis had eventually staged a semi-public purchase of Koehler's most controversial painting. Their motivation was less approval of the painting's subject matter, or even appreciation of Koehler's artistic skill, than gratitude for his contributions to the local arts community. Whatever the reason, *The Strike* would thereby gain a somewhat more secure status in Minneapolis, though not one that prevented its eventual confinement and consequent obscurity.

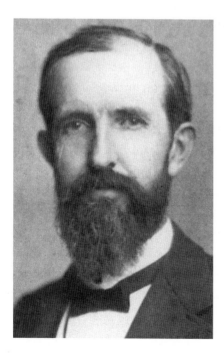

FIGURE 62
Thomas Barlow Walker

10

Ambiguous Purchase and
Gradual Obscurity

1900–1917

Tʜᴇ ʏᴇᴀʀ 1900 ꜰᴏᴜɴᴅ Rᴏʙᴇʀᴛ Kᴏᴇʜʟᴇʀ ɪɴᴠᴏʟᴠᴇᴅ in two major art exhibitions. The first, which he curated, surveyed the peak performers of contemporary American painting. The second, a retrospective of his life's work to date, resulted in a socially exclusive "public" promotion to purchase his pinnacle painting, *The Strike*, whose history forms the central focus of this book.

While organizing the American painting exhibition for an April opening in the Minneapolis Public Library, Koehler, in his capacity as treasurer of the Minneapolis Society of Fine Arts, wrote to John W. Beatty, director of the Carnegie Art Galleries in Pittsburgh. He asked Beatty's help in securing paintings by an impressive array of artists, including John Alexander, John Singer Sargent, Cecilia Beaux, Dwight Tryon, Thomas Dewing, Gari Melchers, Henry Tanner, Winslow Homer, John La Farge, and "above all, James McNeill Whistler, with whom I am personally acquainted and whom I have championed on many occasions for many years and about whom I recently lectured in Saint Paul and at the University in Minneapolis."[1] With such a wish list he revealed his admiration for some of the best painting America had to offer at the close of the nineteenth century.

This alertness to, and enthusiasm for, contemporary art would continue throughout Koehler's life. In March 1902, he lectured on Impressionism to a skeptical Minneapolis audience.[2] Even more daringly, in 1913, after a visit to the Chicago Art Institute to see the celebrated Armory Show, which introduced the post-Impressionists to U.S.

museumgoers, Koehler published an article in the *Minneapolis Journal* defending Cubism and Futurism, including Duchamp's *Nude Descending a Staircase*.[3] That year he also wrote the modernist painter Walt Kuhn, Secretary of the Association of American Painters and Sculptors in New York, requesting photographs of Armory Show paintings in order to make lantern slides for a public lecture. He also inquired about obtaining original works from the Armory Show for exhibition in Minneapolis.[4] From that point on he unrelentingly championed the "modernist" heirs of Cezanne, Van Gogh, and Gauguin for "break[ing] through the hardened surface of lifeless convention and . . . express[ing] naturally and simply the spirit of things instead of their outward appearance."[5]

In November 1900, a week-long "Exhibition and Sale" of Koehler's own "Paintings, Drawings, and Etchings" opened in the gallery of John S. Bradstreet, an early Minneapolis champion of the arts and crafts movement. Featuring, of course, *The Strike*, the exhibition of forty-nine oils, seventeen watercolors, ten drawings, and two etchings (*Prosit!* and *The Socialist*) attracted a fair number of viewers, but the sale failed miserably. Despite an impressive list of patrons, including Mr. and Mrs. T. B. Walker, not a single work sold, leaving Koehler with a bill of three hundred dollars for gallery expenses.[6]

This embarrassment, as it turned out, had a direct bearing on the future of *The Strike*. Among the friends who shared Koehler's disappointment, the political scientist William Watts Folwell, the retired president of the University of Minnesota, took it upon himself to persuade the local art community to reward the dedicated director of its art school by purchasing one of his paintings, specifically *The Strike*.

Folwell launched the campaign in his preface to the Bradstreet exhibition catalogue by scolding the city for not supporting its artists—a failure he attributed to many citizens' "excessive distrust of [their] ability to judge works of art." In fact, he continued, even the aesthetically uninitiated can recognize an exceptional work when they see it, and if they have the financial wherewithal, they should contribute to its acquisition for the cultural good of Minneapolis as "a center of art."[7] When this subtle approach went unheeded, an obviously frustrated Folwell sent a strongly worded letter to the *Minneapolis Journal*. Under the heading "A Timely Suggestion," it minced no words in criticizing the city's art-buying public for snubbing Koehler's work, especially *The Strike*:

> The exhibition closed, the lights went out. We departed our several ways and left the artist to foot the bills of expenses
> for express charges, insurance, printing and labor to the amount of $300. This is not the old Minneapolis way of doing

things. A number of the minor works should have been purchased on the spot. Several of the large paintings having been already sold, were, of course, out of reach. The largest and most important work, "The Strike," is not a picture to be bought by a private person unless he is a collector or owns a gallery. This painting is one of very high merit, although the subject is not in itself pleasing. It was hung on the line at the World's Columbian Exposition and given an award by the judges. The object of this letter is to repeat a suggestion made at the time of Mr. Koehler's exhibition, that it would be a graceful mark of our estimation of Mr. Koehler and his work if this fine painting were to be purchased of him and placed in the gallery of the public library, where it has already been seen. Such a purchase, if made, should be upon liberal terms and not upon such as an artist in a pinch might be willing to accept. This proposition is respectfully submitted to our citizens, to those especially who appreciate good art and its importance to our city.[8]

In conclusion, Folwell proposed that John R. Van Derlip, a prominent attorney and president of the Minneapolis Society of Fine Arts, head a fund-raising campaign to purchase *The Strike.*

Folwell's allusion to a "private person" who was both a collector and a gallery owner most certainly refers to T. B. Walker. Not surprisingly, true to this hint, Walker's name led the subscription list that launched the fund-raising in March 1901. "I took pleasure the other day in placing my name on the subscription list," he told the *Minneapolis Journal.* However, this in no way meant that he liked the painting, which he described merely as "an interesting picture and one which attracts attention where it hangs." His primary purpose, he made clear, was to assure a "just recognition of the faithful and unselfish work" Koehler had rendered to the arts in Minneapolis.[9]

The campaign in Minneapolis's small art community to reward Koehler's services by acquiring his controversial painting was thus underway. An agreed-upon $3,000 purchase price was to be reached through proceeds from the Art Society's annual spring exhibition and the efforts of a subscription committee. In addition to T. B. Walker and John R. Van Derlip, other prominent businessmen who endorsed the campaign included E. H. Moulton, president of the Tri-State Telephone and Telegraph Company; Frank H. Peavey, a shipping and grain-elevator magnate; George H. Partridge of Wyman, Partridge Co., a Minneapolis dry goods wholesaler; and Thomas Lowry, owner of the Twin City Rapid Transit Company. The Reverend M. D. Shutter, retired pastor of the First Baptist Church, blessed the endeavor, calling *The Strike* "a very strong picture." As Van Derlip somewhat impatiently put it, "Let us buy his picture by all means."[10]

Soon after the Society of Fine Arts' spring exhibition closed, the *Minneapolis Journal* reported that the "proposition of buying Robert Koehler's masterpiece had been 'well received,'" and the effort to raise the money was off to "a good beginning." The campaign committee had made clear, the *Journal* added, that the painting would belong to the city, and not to any society or association. In a gender pattern typical for the period, the eighteen-member committee included three men and fifteen women.[11] In December 1901 the Society of Fine Arts purchased *The Strike* from Koehler, officially presented the painting to the city, and announced its "permanent" installation in a hallway of the Minneapolis Public Library.

To commemorate this event, the Minneapolis journalist Charlotte Whitcomb, who had reported the story for the *Minneapolis Journal* and served as secretary of the fund-raising committee, published an illustrated article about Koehler in the popular art magazine *Brush and Pencil*. While no doubt pleased by this recognition in a national publication, Koehler, a good writer, must have been chagrined by the article's overall vagueness and misleading interpretation of *The Strike*. After alluding simplistically to Koehler's "German birthright of strength, energy, and integrity," and more specifically to his years of struggle to complete his art studies, Whitcomb began her cursory survey with a dubious contrast between what a European version of *The Strike* would have been as opposed to an American version, assuming that the event in the painting was, indeed, located in the United States:

> He was humorously regarded by Dufregger [*sic*] as incorrigible in a sense and allowed to go his own way. The composition
> of his picture "The Strike" was a notable instance. The sketch, approved by the master, showed a level ground with the
> workmen in revolt advancing in phalanx, the leader addressing the capitalist respectfully with cap in hand. Koehler felt
> that while that might represent the European ideal strike, the American reality was something very different.[12]

After an appreciative description of *A Holiday Occupation*, which was more to her conventional taste, a passing mention of *Violet*, a bow to *A Spanish Nobleman*, a single-figure costume piece, and a fleeting glance at *Salve Luna*, Whitcomb turned to "the subjects which appeal to [Koehler], . . . workingmen, men at labour, at bench, at forge, in-the-open-air; subjects full of strength and vitality and calling for strong treatment." Her inventory of these, listed without comment, appropriately included *In a Bavarian Smithy* [*sic*], *Twenty Minutes for Refreshments*, *The Carpenter's Family*, and *Her Only Support*.

Whitcomb concluded by denying *The Strike*'s most apparent message, perhaps intentionally misreading it for the sake of complacent, upper-class subscribers, hoping to dismiss any reason for their possible discomfort in supporting the purchase:

"The Strike," as conceived by Mr. Koehler, is not an argument against the encroachments of capital, or in favor of the rights of labor, nor was it painted to commemorate an episode, but to represent a phase of American life, a phase which presented itself to Mr. Koehler during his residence in various factory cities.

As if this attempt at rationalizing Koehler's choice of subject matter and softening the impact of its forceful message were not enough, Whitcomb extended her awkward struggle to make *The Strike* palatable to an elite art-viewing constituency: "The aim of the artist was legitimate, and the result was successful, and neither purpose nor achievement requires an apologist. The work is excellent." One is tempted to add "please believe me, folks, please believe me!"

Koehler simply pictured what he saw of daily life about him, insisted Whitcomb, and "in America this is an age of Industry, of invention, and alas! of struggle and strife for social and financial supremacy." By denying the core meaning of what is clearly a depiction of class conflict, she presumably wished to demonstrate that Koehler objectively reported what she innocently assumes to be an American event, projecting no personal point of view. After all, he did once state: "We can do no better than to paint what we see and know and what appeals to us. This I have done, and this I more than ever feel that I must do." On that reassuring note of realist intention she closes her essay by speculating about Koehler's future work in the American heartland:

The strenuous and unique life in this great section of the Northwest, its harvesters, elevators and millers, its freight boats, its road-makers and bridge-builders, its river boatmen, lake fishers, ice-cutters, and woodsmen, have not been studied in vain, and very soon, perhaps when opportunity of leisure shall arrive, we know that his future will richly fulfill its promise. In electing to become the painter of common folk and common scenes in and about his Northwestern home, Mr. Koehler undertakes to depict a strong, virile life that will ever have a place in legitimate art. It is these subjects that Mr. Koehler's experience fits him to portray, and it is in these that we may expect him to attain his future successes.

As fate would have it, neither the "common folk" nor the "common scenes" of Minneapolis or anywhere else would be further portrayed by Koehler. His reputation for depicting industrial workers would remain centered on *The Strike.*

Despite her misreading of the work, Charlotte Whitcomb's *Brush and Pencil* essay, plus other publicity surrounding the so-called public subscription campaign, represented the most sympathetic tribute *The Strike* had received since it had landed on the front page of the *Milwaukee Sentinel* twenty years earlier. This attention is all the more surprising in view of the fact that the local climate had turned particularly hostile to labor activism of all kinds, and would remain so for years. Reacting to a strike by anthracite coal miners in Pennsylvania in 1902, and to a walkout by local flour and cereal-mill workers, leading Minnesota business owners, including T. B. Walker, founded their own "union against unions" in 1903. Called the "Citizens Alliance," it was dedicated to squelching the growth of any labor organization, whether striking printers in 1905, machinists in 1907, or any other union that showed signs of gaining the national strength enjoyed by John Mitchell's United Mine Workers or Samuel Gompers's American Federation of Labor. In concert with such affiliates as the Chamber of Commerce and with the support of a loyal mainstream press and police department, the Alliance upheld the principle of the anti-union "open shop," later dubbed "the American Plan," by means of strikebreakers and spy systems. At their most paranoid, Minnesota's industrialists and business leaders railed against Socialist Party leader Eugene Debs and the revolutionary Industrial Workers of the World, or "Wobblies."[13]

In remarkable defiance of this anti-union climate, the entry for *The Strike* in a 1909 catalogue of paintings and sculptures exhibited in the Minneapolis Public Library expressed a bold, essentially labor-leaning sentiment. It criticized the inhumanity of the wealthy employer and fretted that the impoverished workers were dangerously vulnerable to agitated violence—an interpretation that aptly caught the sentiment of the painting's central female figure:

> The painting is a sermon without words, an artistic rebuke to present day methods, and has in it a lesson to employer and the employee alike. The smoking chimneys of other factories would indicate prosperous times, yet we see the wives and children of this man's employees ragged, hungry and cold. He has given his men to understand that their appeal for better pay and better conditions would not be granted; men who had worked faithfully at bench or forge were loath to leave their accustomed places, but the poverty and want of their families drove them to desperation. Agitators among them emphasized their wrongs, and now that a general strike has been determined and their employer doggedly ignores

every entreaty, the men lose their self-control and so forget their manhood, their families, and their citizenship as to resort to violence and seem ready to stain their hands with blood. There is something radically wrong in our social fabric or these things could not be, but let us hope that the night is far spent and the day will soon dawn when one law shall rule all classes and conditions of men and that law will be the law of universal brotherhood.[14]

Wherever Koehler stood politically in 1909, and whether he shared the idealistic, Schiller-based hope, as evoked in the choral refrain of Beethoven's Ninth Symphony and expressed in the library catalogue's concluding statement, this tribute to his greatest painting must have pleased him. His remaining years brought a few more exhibition successes and gained him further respect for his pedagogical skills, which he continued to exercise as a lecturer and arts educator even after his 1914 retirement from the Minneapolis School of Fine Art.

In 1910, Koehler's nocturnal view of Minneapolis's Hotel Radisson, titled *The Mantle of Night*, was included in the third annual exhibition of American artists at the Corcoran Gallery of Art in Washington, D.C.[15] A second, apparently more ambitious version of this painting, *In the Grip of Winter (Hotel Radisson)*, attracted favorable attention from the *Minneapolis Journal* in 1912:

It was painted from Mr. Koehler's studio window in the art gallery of the public library and shows the rear of the Hotel Radisson, the rear of Dayton's, and the massive Plymouth Building, terminating in the foreground with residences and store buildings immediately below Mr. Koehler's window. A blanket of snow covers the roofs of the houses in the foreground and through the swirling snow the great bulk of the distant skyscrapers loom grey and mysterious. Mr. Koehler was at work on the picture the greater part of the winter and made repeated studies for it. It is one of his best works and has attracted much attention at the state fair. Were it not for Mr. Koehler's serving on the jury of award, it is thought the picture would have received first award, say art connoisseurs.[16]

The previous spring had brought the announcement that Koehler had won another bronze medal at an international exposition in Argentina for *In Summer*, or *Die Sommerzeit*, a small-scale canvas painted several years earlier of a young woman seated under a blooming rosebush. The Argentinian jury also awarded a diploma of merit to the painting, which was purchased by "a Spanish nobleman," or so his widow Marie would later claim.

Among Koehler's students, several went on to notable careers, including the modernist animal sculptor John Flannagan; the W.P.A. artist Harry Gottlieb, whose paintings and etchings of miners and industrial workers distantly echoed *The Strike*; and Arnold Blanch, the social realist painter and New Deal–era muralist, who later reminisced fondly about Koehler's enthusiastic acceptance of avant-garde art:

> My teacher at the time was a typical German professor who was known for painting pictures of strikes and pictures of workingmen. When part of the Armory Show came to Minneapolis he defended it very vigorously in the face of all the ridicule it got at the time. We accepted these paintings as being very authentic because our professor believed in them.[17]

Another of Koehler's students was Wanda Gág (1893–1946), the author and children's book illustrator whom he discovered as a seventeen-year-old on a visit to her hometown, New Ulm, Minnesota. After viewing her drawings, he encouraged her to enroll in the Minneapolis School of Fine Art. This she did, attending from 1914 to 1917, when she won a scholarship to the Art Students League in New York City.[18]

In 1916, two years after Koehler's retirement, one of his long-term dreams was fulfilled when the school he had directed for many years moved to a new facility: the Julia Morrison Memorial Building. A year earlier, his successor as director, Joseph Breck, had returned to the Metropolitan Museum of Art in New York City, abruptly ending his abbreviated venture into the Midwest. Breck's replacement, Charles Frederick Ramsey, a curator at the Pennsylvania Academy of Fine Arts in Philadelphia, was fired by the school's board of directors midway through his first year on the basis of rumors that he was a Bolshevik sympathizer who held subversive meetings in the boiler room!

Following these upheavals, Mary Moulton Cheney assumed the directorship. A graduate of the Boston Museum of Fine Arts' School of Design, she had been on the Minneapolis School of Fine Art's faculty since 1899, when Koehler hired her to head his newly established Department of Decorative Design. Together, they subsequently launched a jewelry class, a department of architectural and mechanical drawing, and, in 1909, a department of art education for training art teachers. Cheney ran the school with exemplary efficiency until 1926 when she resigned after the board rejected her request for a 60 percent budget increase.[19]

During the two unsettled years before Cheney's appointment, Koehler rejected any suggestion that he come out of retirement to resume the directorship, preferring to spend time at his easel and in volunteer lecturing. In 1916 the

Minneapolis Institute of Arts named him a docent and he was appointed lecturer of art history in the University of Minnesota's College of Science, Literature, and the Arts.[20] In January 1917, the Minneapolis School of Fine Art announced a spring series of slide-illustrated art-history lectures by Koehler.[21] Sadly, the series was cut short when Koehler died suddenly on April 23, 1917, of heart failure while riding the streetcar on his way to meet his class at the school.

Ironically, an upsurge of anti-German, anti-labor, and anti-radical sentiment compounded by America's entry into World War I three weeks before Koehler's death made *The Strike*, now more than thirty years old, timely once again. The U.S. entry into the war led to an outpouring of anti-German pamphlets, posters, magazines, newspaper editorials, and canned speeches inculcating hatred of the "Huns," much of it coordinated by the Wilson administration's Committee on Public Information. The resultant hysteria led to the banning of German music and literature as well as German language courses in public schools.

The war spirit also intensified hostility to radicals of all kinds. By mid-1916 the Industrial Workers of the World had worked its way into Minnesota's Mesabi Iron Range, where organizers led thousands of miners in demanding increased wages and an eight-hour day. Company police crushed this strike by September, but the IWW continued its efforts in the state. They attempted to organize at logging camps in northern Minnesota (a part of T. B. Walker's timber empire) where lumberjacks, working twelve-hour days for $35 a month, struck. This strike, too, was quickly put down by lumber-company thugs and deputy sheriffs who, relying on information supplied by spies planted by the Citizens Alliance, arrested and jailed IWW "trouble makers."[22]

The Alliance's paranoia increased as the socialist Nonpartisan League, having persuaded North Dakota voters to elect its candidate, Lynn Frazier, governor in 1916, moved its national headquarters from Fargo to Saint Paul. Against this background, the machinists' union president and Socialist Party member Thomas Van Lear, campaigning on a platform to "overthrow the power of capitalism," was elected mayor of Minneapolis in 1916. He appointed a fellow socialist as chief of police in a vain attempt to counter the power of the Hennepin County sheriff, who routinely cooperated with the Citizens Alliance by appointing deputies to put down strikes.[23]

On April 16, 1917, the Minnesota legislature created a Commission of Public Safety to root out German sympathizers, socialists, and Nonpartisan Leaguers. The latter, although generally supportive of the war, were targeted for their efforts to promote labor unions, war or no war. They were accused of sedition and disloyalty, and any politician associated with them, including the 1916 Minnesota senatorial candidate Charles A. Lindbergh, Sr., faced harassment and persecution.[24]

In view of this pervasive anti-radical, anti-labor hysteria, the *Minneapolis Tribune* reporter Gladys Hamblin was quite courageous in her brief, pro-worker interpretation of *The Strike* at the close of her sensitive obituary of Koehler:

> "The Strike," which is probably his most important picture, now hangs in the Walker gallery at the Public Library and was the first picture to be given to the library by popular subscription. It represents a strike of factory workers who, made desperate by their wrongs, are rioting before the house of their employer. It is an eloquent plea for the relief of the working classes, and is one of the most popular pictures at the library.[25]

That T. B. Walker would have appreciated his name being associated with the painting is highly doubtful. The claim that it was one of the library's most popular pictures is also questionable. Its popularity would in part have depended on where it was located—in a gallery or a hallway—and how high it was hung, how it was lit, and how accessible it was to an audience comprised of literate borrowers of books. Of these, only a small minority would have belonged to the working class.

The most perceptive and touching obituary tribute came from Koehler's close friend Harlow Gale, who praised his "catholicity of artistic interest," extending from a youthful enthusiasm for Clara Schumann's piano performances to his late-in-life appreciation of Cubism. Koehler's *The Strike*, Gale wrote, "shows beautifully his human sympathy with the hard struggles of labor."[26] As simply put as that may be, Gale conveyed the underlying sentiment and social significance of Koehler's greatest and most original painting.

In the future, during one extended phase of its long and winding history, *The Strike* would again, as in the 1880s and briefly during the reactionary, anti-radical World War I era, be recognized not only for its artistic merit and historic interest, but also for its relevance to the continuing struggle of workers for justice and fair treatment. Indeed, for a decade it would be proudly displayed by a New York City labor union as a reminder of past struggles. That, however, lay many years away, as Koehler's painting entered a long and dreary period of neglect.

PART IV

Rediscovery and Belated Acclaim

Rescue, Restoration, and Return to New York City

1917–72

I N JANUARY 1927, THE MINNEAPOLIS SCHOOL OF FINE ART unveiled a memorial bronze tablet bearing a relief profile-portrait of Robert Koehler, the school's long-time director.[1] Ironically, however, this recognition stood in stark contrast to the Minneapolis Public Library's treatment of Koehler's most memorable painting. Indeed, in September 1927, his widow, Marie, wrote a spirited letter to the *Minneapolis Journal* inquiring why the library kept *The Strike* locked up and out of sight. "The Public Spirit of Minneapolis should not tolerate that!" she protested. She followed this reprimand by ambiguously claiming that "Steps have been taken to have it hung in the Athletic Club, so everybody might see it until Minneapolis has a new library. Miss Countryman [Gratia Countryman, director of the Minneapolis Public Library from 1904 to 1936] . . . consented to loan it to another gallery."[2] Whatever these plans might have been, they failed to materialize. In the early 1930s, according to the recollections of librarian Margaret Mull, the painting was hanging once again in the library, but she did not remember where.[3] In 1946, Koehler's long-time friend (and portrait subject), the eighty-year-old retired University of Minnesota professor Frederick J. Wulling, responding to an inquiry from the head of the library's Art Department about the whereabouts of various art works, commented rather vaguely: "Of course you have seen 'The Strike' and other paintings hanging locally." In fact, *The Strike* was at the time in storage at the library.[4]

In that same year, 1946, with the painting itself out of public view, a large reproduction appeared in hundreds of smaller newspapers across the country to illustrate a column, "Nation & Labor," in the Associated Press's syndicated weekly supplement *The World This Week*. With no mention of the painting, the anonymous staff writer discussed the Truman administration's heavy-handed response to two high-profile strikes currently in the news. Frustrated by a walkout by the 293,000-member Brotherhood of Railroad Trainmen and Engineers following months of negotiations, as well as by a drawn-out strike by John L. Lewis's 400,000-member United Mine Workers, the administration proposed a bill authorizing the president to declare a national emergency and seize any vital industry hit by a strike, induct strikers into the army, issue a federal injunction against the striking union, and subject its leaders to arrest and possible imprisonment.[5] If enacted, the bill would have reversed important features of the New Deal's pro-labor legislation as well as a key clause of the 1914 Clayton Act protecting strikers from prosecution as long as they remained peaceful. Recalling the government-suppressed railroad strikes of 1877 and 1894, the Associated Press writer characterized the measure as "a blunt dictum that powerful unions could not defy the United States government." As it turned out, the Senate rejected the bill after the House had passed it overwhelmingly.

U.S. Labor Relations following *The Strike*: Brighter Prospects, Continued Struggles

In the years after Koehler painted *The Strike*, and during the decades to come when the painting would be largely forgotten, massive changes reshaped the relations between labor and capital. In America, the Progressive era and especially the New Deal of the 1930s brought much pro-labor legislation. The 1935 Wagner Act (National Labor Relations Act), among other New Deal measures, guaranteed the right of collective bargaining, granted labor unions the right to strike when collective bargaining failed, and authorized cease-and-desist orders against employers who attempted unfair labor practices. The Fair Labor Standards Act of 1938 provided for maximum hours, minimum wages, and at long last, prohibition of child labor under the age of sixteen in all industries selling their products across state lines or abroad.[6] Buoyed by such support, much of America's industrial workforce, including that of the giant auto and steel industries, was unionized by 1942. Thanks to such measures as the Civil Rights Act of 1964 and the Equal Employment Opportunity Act of 1972, the prospects of black and female workers improved as well. Violent attacks against union workers subsided after General Motors was forced to recognize the United Auto Workers (UAW) by the "Great Sit-Down Strike" in Flint, Michigan, during the winter of 1936–37.[7] The ultimate victory of striking

truckers and warehouse workers in Omaha in 1939 contributed to this growing acceptance, as did the reluctant recognition of the UAW by the Ford Motor Company in 1941.

Robert Koehler's adopted home town, Minneapolis, shared in this larger trend of gains by organized labor. Spearheaded by the hard-fought Teamsters strikes of 1934, and with Teamsters Local 574 as a front-line bastion against intimidation, Minneapolis became a "union town," providing a model of action for the entire Midwest and beyond.

Given all these developments and more, there seemed reason to conclude that the exploitation and bitter struggles so vividly portrayed in *The Strike* were a thing of the past. But other, less hopeful developments suggested that Koehler's image of industrial conflict in the 1880s remained of more than merely historical interest. As the Truman administration's 1946 response to national strikes by miners and railroad workers made clear, the rights of labor were far from secure, and anti-union sentiment remained strong. Relatively peaceful industrial relations did not preclude a powerful anti-union backlash after World War II. The 1948 Taft-Hartley Act outlawed a series of "unfair labor practices" by unions and even banned the "closed shop" (a requirement that all workers in a unionized plant be union members), a long-time goal of anti-union corporate interests. The 1959 Landrum-Griffin Act further restricted unions in the name of anti-corruption reforms. The postwar Red Scare that produced the investigations by the House Un-American Activities Committee and Senator Joseph McCarthy's anticommunist witch hunt pinpointed radical labor unions among its many targets. In the mid-fifties, before the AFL leader George Meany agreed to a merger with Walter Reuther's CIO, he demanded that Reuther, president of the UAW, purge all radical and communist-led unions from the CIO's ranks.[8]

Nor was labor violence, foreshadowed by the worker in *The Strike* picking up paving stones as potential weapons against attack, entirely a thing of the past. In May 1937, anti-union "security guards" hired by the Ford Motor Company attacked and clubbed Walter Reuther and other UAW officials. The worst outbreak of labor violence in the 1930s occurred in Chicago. While U.S. Steel and other industry giants had at last recognized the steelworkers' union in March 1937, a group of smaller companies known as "Little Steel" refused, leading to a strike by 75,000 "Little Steel" workers. Among the holdouts was the Republic Steel Company in South Chicago, headed by a union-hating president, Tom Girdler. On Memorial Day, May 30, 1937, Chicago police, repeating their predecessors' actions at the McCormick Harvester plant in May 1886, opened fire on unarmed picketers outside the Republic Steel plant, killing ten and wounding seventy-five, among them several women.[9]

This massacre was memorialized by painter Philip Evergood in his powerful *American Tragedy* of 1937 (Fig. 63), a true sequel to Koehler's *The Strike*. Its central woman is again caught up in the thick of the action, this time as the possibly pregnant, foremost figure. Liberated from dark, cumbersome Victorian clothing, she wears white pumps and a sleeveless summer dress. Its light-blue color contrasts sharply with the deep blue uniforms of the club-wielding, revolver-toting police closing in on the white-shirted leader next to her. He extends his muscular arms to protect her.[10] But even without him she would hardly be helpless: she juts out her chin defiantly, flexes a bicep, clenches her left fist, and wields a big stick. The dying man to the right and the dead black worker still gripping an American flag in

FIGURE 63
Phillip Evergood,
American Tragedy,
o/c, 1937
(private collection)

the lower left will soon be joined by other victims under direct fire behind her. This fatal outcome, with its panorama of wounded, clubbed, and falling workers, distinguishes *American Tragedy* from *The Strike*, in which violence remains potential, not an actual reality. Nevertheless, the affinity of the two paintings is striking. While *The Strike* languished in a Minneapolis library storage room, Philip Evergood, together with other pro-labor artists of the 1930s such as Albert Abramowitz, Nan Lurie, and Robert Koehler's own former student Harry Gottlieb (Fig. 64), had taken up the subject that had attracted Koehler half a century earlier.

FIGURE 64
Harry Gottlieb,
*Home Sweet Home
(Their Only Roof)*,
o/c, 1935–36
(Collection of the
University of Arizona
Museum of Art & Archive
of Visual Arts, Tucson)

The Strike Rediscovered, Restored, and Returned to the Public

Robert Koehler painted his masterwork in the 1880s, a decade of labor unrest, social upheaval, and radical ideological ferment in Europe and America. There is thus an intriguing historical symmetry in the fact that *The Strike* was rediscovered and reintroduced to the public nearly a century later at another moment of turmoil, confrontation, and radical challenges to the status quo. It was in the late 1960s and early 1970s, amid massive anti–Vietnam War demonstrations, urban riots, New Left activism, and counterculture affronts to conventional sensibilities that Koehler's masterwork emerged from fifty years of dormancy.

Henry Nash Smith, an English professor at the University of California–Berkeley and a well-known historian of American culture, inadvertently initiated this process when he came across the 1886 *Harper's Weekly* reproduction of *The Strike* and included it in his 1967 anthology *Popular Culture and Industrialism, 1865–1890*. Ignoring the possibility of a spontaneous worker uprising, Smith in his commentary on the painting considered it anachronistic, since the protesting workers seem to lack "any formal organization resembling a union," to which he believed they would likely have belonged by 1886. Late-nineteenth-century factory owners, he claimed, formally negotiated with union leaders, not with individual workers from their front porch.[11]

In April 1969, two years after Smith's book called attention to *The Strike*, the Minneapolis Public Library board ordered fifty art works in its care, all apparently in storage, to be appraised for sale. Among this group, according to librarian Margaret Mull, were about ten pieces thought to have "considerable value," including *The Strike*. "People remember things from the old library," Mull commented, "and frequently ask where they are. But there is not room to display the paintings in the present library. It seems too bad to have them stashed away when someone may get enjoyment from them."[12]

At this point, Lee Baxandall, the most important figure in the history of *The Strike* apart from Robert Koehler himself, enters the picture (Fig. 65). Baxandall (1935–2008) was born in Oshkosh, Wisconsin, where his family, Republican in politics and Congregationalist in religion, owned a thriving printing business. Rising to the rank of Eagle Scout, young Lee in 1951 was one of a select group chosen to represent the Boy Scouts of the Upper Midwest at a national scouting event in Washington, D.C. The group toured the Pentagon and the FBI, where Lee received an autographed photograph from J. Edgar Hoover. At the White House, he shook hands with President Truman. Back

in Oshkosh, he read Upton Sinclair's *The Jungle* on the recommendation of a high-school history teacher. Sinclair's muckraking exposé of the Chicago meatpacking industry and the exploitation of immigrant workers, he later recalled, "was an inspiration."[13]

Attendance at the University of Wisconsin–Madison, and the political ferment of Madison as early as the late 1950s, altered the trajectory of Baxandall's life. Earning his undergraduate degree in 1957 (after brief stints in Delta Tau Delta fraternity and in the Reserve Officers Training Corps), he remained in Madison for graduate study. He received an M.A. in English in 1958, but like many thousands of college and university students in these years, he got caught up in the campaign against nuclear weapons testing and in the New Left activism led by Students for a Democratic Society (SDS) founded in 1960. He joined the Socialist Club, staged Bertolt Brecht's *Caucasian Chalk Circle* in a small playhouse at the university's student union, and helped organize an "Anti-Military Ball" as a countercultural response to ROTC's annual Military Ball. He also wrote for and helped edit *Studies on the Left*, a radical journal published in Madison from 1959 to 1967, and later in New York City.[14]

After a 1960 visit to revolutionary Cuba, he moved to New York City in 1962 where he participated in the antiwar movement, translated plays of Brecht and Peter Weiss, and explored the intersection of cultural theory and Marxist ideology. This interest resulted in articles in such journals as *The Nation, New Politics*, and *Liberation* and three edited books: *Marxism and Aesthetics* (1968), *Radical Perspectives in the Arts* (1972), and *Marx & Engels on Literature & Art* (1973).[15]

In his introduction to the *Radical Perspectives in the Arts* anthology, Baxandall focused on the aesthetic and cultural strands in the classic Marxist texts of Marx and Engels, George Lukàcs, Antonio Gramsci, Walter Benjamin, Herbert Marcuse, and others. A central theme in all the essays collected in the book, he argued, was that one's understanding of works of art is vastly deepened when they are viewed in historical context from a Marxist theoretical perspective:

> The reader will notice the degree to which historical analysis is cited. . . . This awareness becomes a positive artistic asset in the idea of *modern realist art*, which will be informed by the understanding of alienation and social class, and politically positive in the sense that it depicts, in some individualized manner, the increasingly conscious tendency among historical classes and individuals to secure their liberty from class-fostered deprivation.[16]

The tone of the selections that followed was set by the first essay, by feminist scholar Meredith Tax of Milwaukee, entitled "Culture Is Not Neutral: Whom Does It Serve?"

In the dense introduction to *Marx & Engels on Literature & Art*, Baxandall's co-editor, the University of Warsaw philosopher Stefan Morawski (1921–2004), echoed Baxandall's call for recasting aesthetic theory from a historical and Marxist perspective. According to Morawski, Marx and Engels believed that old forms of art would die out with the capitalist system, but that new forms of socially engaged art could provide "hope and comfort to a presently suffering humanity." In this context, the artist faced a stark choice: "Would he bemuse himself in an ivory tower, or participate in revolutionary progress by accepting its vicissitudes?"[17]

In this charged atmosphere of radical politics, antiwar protests, and cultural conflict, and with his knee-deep immersion in Marxist aesthetic theory, Baxandall was well primed to respond with a sense of excited discovery when he learned of the existence of *The Strike*.

Early in 1970, unaware of the painting, let alone its location or availability, Baxandall was by chance alerted to its existence during a visit to Cambridge, Massachusetts. While crossing Harvard Square, he was handed a copy of *The New Foundation*, a nonprofit New Left tabloid written by students and printed in Lawrence, Massachusetts. It

FIGURE 65
Lee Baxandall

bore a large, black-bordered reproduction of the Gedan wood engraving of *The Strike* on its front page illustrating an article entitled "Workers' Power" advocating the familiar Marxist doctrine that industrial workers themselves, the true creators of value through their labor, should control the production process. With no mention of *The Strike*, the unsigned article called for a socialist system of industrial democracy in place of an inefficiently supervised "chain of fear" controlled by an elite system of profit-driven ownership[18]

Fortunately, the reproduction in *The New Foundation* did identify the painting by title and artist's name. So informed, Baxandall returned to his apartment in New York's East Greenwich Village and made his way to the art division of the New York Public Library on Fifth Avenue. There he was misled by the entry on Robert Koehler in the German art encyclopedia *Allgemeines Lexikon der bildenden Künstler von der Antike bis zur Gegenwart*, usually called simply "Thieme-Becker" after its co-editors Ulrich Thieme and Felix Becker. Their entry mistakenly stated that *The Strike* was in the Milwaukee Public Library. Through a phone call to the library, Baxandall learned that the painting had never been there, but was somewhere in Minneapolis. Letters of inquiry to the Minneapolis College of Art and Design (as Koehler's School of Art was now called) went unanswered. However, in a letter of June 4, 1970, Anthony M. Clark, director of the Minneapolis Institute of Arts, accurately advised Baxandall that the Minneapolis Public Library had turned *The Strike* over to the museum for storage. Promising to send a photograph, Clark inaccurately claimed that the painting was now "in restoration."[19] After three months of increasingly impatient correspondence, Baxandall finally received a small black-and-white Polaroid snapshot of the painting from Samuel Sachs II, chief curator of the Institute of Arts, who reported that restoration had been "put off indefinitely." Nevertheless, he added, Baxandall was welcome to view the painting "in its present state."[20]

Before traveling to far-off Minneapolis to see *The Strike* in person, Baxandall interrupted editorial work on *Radical Perspectives in the Arts* to research and write a concise article titled "Robert Koehler: Painter of the People." It was accepted by the Liberation News Service, an alternative news compendium from a Left perspective issued weekly from the basement of an apartment building in Morningside Heights near Columbia University and distributed to some eight hundred subscribers. One of these, the *Milwaukee Kaleidoscope*, carried Baxandall's essay in its May 3, 1971, edition with a three-column illustration of *The Strike* derived from the 1886 *Harper's Weekly* wood engraving.[21] Naively claiming that his was the first article on Koehler since 1901, Baxandall began by stressing the daring and unprecedented nature of Koehler's decision to create a "realist" representation of a contemporary industrial strike as a "salon" painting.

However, his claim that "anti-Red repression," intensified by the May 1886 Haymarket tragedy and the simultaneous wide distribution of the *Harper's Weekly* centerfold, "dealt Robert Koehler's career in America a disastrous blow" was clearly in error. So was his assertion that Koehler "did many paintings that reflected the class struggle" in place of more marketable works. Refusing to become "a portrait maker to the wealthy," Baxandall wrote, Koehler had instead opted for a career as "an art educator to ordinary people." Actually, as we have seen, except for *The Socialist* and, of course, *The Strike*, his few representations of working people are politically benign, and while he did abandon his plan to become a Manhattan-based portrait painter to accept the teaching position in Minneapolis, his personal as well as commissioned portraits in Minneapolis reflect comfortable, upper-middle-class prosperity with little evidence of critical intent.

Ignoring or perhaps unaware of such complacent canvasses, Baxandall's faithfully leftist profile of Koehler shows a particular fondness for the phrase "class conflict," including a reference to the (inaccurate) 1905 lament of the Marxist philosopher and art theorist George Plekhanov decrying the absence of class-conflict themes in the art of his day. Obvious contradictions to this assumption were already abundant in early modern painting and printmaking, most notably in the etchings and lithographs of Käthe Kollwitz. (Since Koehler and *The Strike* were still in Munich during Kollwitz's years there, Baxandall enthusiastically conjectured "it is not unlikely that he influenced her.")[22]

Within three weeks of this article's appearance, Baxandall flew to Wisconsin and, accompanied by his recently widowed mother, drove from Oshkosh to Minneapolis to view *The Strike* firsthand at the Institute of Arts. Although somewhat alerted to its condition by the Polaroid print sent to him by Samuel Sachs, he found the painting in much worse shape than he had anticipated. It looked very "murky" from darkened varnish and had suffered severe damage from neglect and careless handling. A ten-inch gash lay just below the feet of the central woman, adjacent to "broad swaths" of missing pigment. Three more jagged lacerations further defaced the work, a long one above the head of the workers' spokesman and two smaller ones in the central sky area. The corners of the unframed canvas had suffered damage as well.

Fortunately all of the painting's figures remained unscathed and the original frame leaned on a wall nearby. On its back a torn tag dated 1889 still read "Milwaukee Industrial. . . ."[23] This fragment, left over from the long-ago Milwaukee Industrial Exposition, must have heightened Baxandall's eagerness to bring *The Strike* out of hiding. At any rate, he moved rapidly toward its purchase, restoration, and public display in an appropriate institution. He first contacted

Garnett McCoy, deputy director of the Smithsonian Institution's Archives of American Art, who in turn alerted Professor Philip Mason, director of the Archives of Labor History and Urban Affairs at Wayne State University in Detroit, of the painting's potential availability.[24] Baxandall himself wrote Mason describing *The Strike*, including its need for major restoration, and inquiring if the Archives could possibly "house" it.[25] In reply, Mason noted that the wall space required by such a large canvas posed a problem, adding that while he and his staff would "welcome the opportunity to display the painting," a final decision regarding its acquisition would have to wait for as much as two years, pending completion of a planned new building.[26]

The challenge of finding a long-term exhibition site did not prevent Baxandall from agreeing to purchase *The Strike*. On August 16, 1971, Joseph Walton, owner of a Minneapolis art gallery and volunteer agent for the Public Library, wrote Baxandall informing him that the purchase price would be $750, payable by check. Baxandall agreed with alacrity, and in early October, the transaction completed, Walton followed Baxandall's instructions to ship the crated canvas, frame included, to the Julius Lowy Frame & Restoring Company in New York City.[27] After considering various options, Baxandall had chosen this restorer on the advice of the Smithsonian's Garnett McCoy. Eighty-five years after its first proud exhibition at the National Academy of Design, *The Strike*, in its damaged condition, had returned to New York.

At a cost of $2,450, the restoration consisted of mending, relining, and cleaning the torn canvas, "in-painting," and revarnishing.[28] Upon its completion in late April 1972, *The Strike* was back in a truck, this time on its way to Baxandall's cottage at Truro on Cape Cod, where it received a number of notable visitors throughout the summer. Foremost of these was Moscow-born Anton Refregier, a New York–based artist celebrated for such New Deal murals as his twenty-seven-panel work for San Francisco's Rincon Post Office depicting such scenes as the city's 1877 anti-Chinese riots, the rigged 1916 trial of trade unionist Tom Mooney, and the bloody longshoremen's strike of 1934. (Although condemned by Richard Nixon and other Republican politicians as "communistic," the mural is now protected as a National Historic Site.)[29] Recognizing the significance of restoring *The Strike* to public view in a historically appropriate setting, Refregier contacted his friend Morris "Moe" Foner (1915–2002), executive secretary of Local 1199 of the Union of Hospital and Health Care Employees, in New York City. Local 1199's membership of sixty thousand consisted primarily of black, Hispanic, and female workers.[30] A gentle but determined organizer, Foner had survived a 1942 anti-communist investigation by a special committee of the New York State legislature and stood by the union's

president, Russian-born Leon Julius Davis, in a bitter forty-six-day strike in 1959 that won the union recognition by the physician-dominated Hospital League. He subsequently founded "Bread and Roses," a unique program intended to enrich the cultural lives of union members through musical, theatrical, and visual-arts events.[31] To further this goal, he had insisted that an art gallery be installed next to the lobby of the union's recently constructed headquarters at the corner of West 43rd Street and Ninth Avenue. Recognizing this as an ideal location for *The Strike*, given its subject matter, Baxandall jumped at Foner's proposal to showcase it "permanently" at the gallery's entrance for all to see. On November 12, 1972, the *New York Times* (the newspaper that had certain doubts about *The Strike* in its 1886 review) ended an appreciative if not altogether accurate account of the painting and its history with a somewhat ambiguous announcement that earlier in the month Lee Baxandall had made "an extended temporary loan" of *The Strike* to Local 1199 of the Hospital Workers Union, and that the picture was now "on indefinite exhibition" at the union's headquarters.[32]

The *Times* article, which included a reproduction of *The Strike*, stimulated attention in a variety of publications. Steve Murdock, editor of *1199 News*, the union's newsletter, scooped the other periodicals with a November 1972 illustrated article, "1199 Unveils a Historic Labor Painting," offering an extended account of Koehler's career and *The Strike*'s origin, early history, sad fate in Minneapolis, and eventual rediscovery. Continuing the celebratory theme, the next issue of *1199 News* contained a large, double-spread color reproduction of *The Strike* and a full-page cover reproduction of the painting's focal area in which the strikers' spokesman, backed up by his fellow workers, is watched suspiciously by the mysterious outside observer—a detail that undoubtedly appealed to Moe Foner as a union organizer who had himself fallen afoul of snooping legislators. Still another full page of this issue reprinted Murdock's earlier article, this time with a large photograph of Koehler.[33]

In July 1973 the upper floors of Local 1199's building were badly damaged by a powerful explosion, apparently the work of anti-Castro terrorists on the eve of a four-day political and cultural exposition called Expo-Cuba. Both the union and the exposition sponsors had received threats before the exposition opened. The art gallery was fortunately unharmed, and its proudest possession, unscathed, would enjoy the union's active patronage for another nine years. This would include sending it out on a variety of traveling exhibitions that introduced its contentious, dramatically composed subject matter to audiences nationwide.

12

Labor Union Patronage, Museum Exhibitions, and National Fame

1972–82

T HE RIPPLE EFFECT EMANATING FROM LOCAL 1199's exhibition and promotion of *The Strike* crested in 1974 with a major traveling exhibition originating at the Whitney Museum of American Art. Initially, however, the painting's viewing public remained primarily union members, readers of labor periodicals, and the left-wing press. For example, the New York *Daily World* (successor to the U.S. Communist party's *Daily Worker*) became the first newspaper to respond to Local 1199's newsletter feature on *The Strike* by running its own page-wide reproduction of the painting on November 25, 1972. The accompanying article compared Koehler's insurgent workers with a mural titled *Four Hundred Years of Struggle* just completed by a young New York artist, Lucy Mahler, for the Harlem Institute for Marxist Studies. Unlike Koehler's carefully staged narrative, Mahler's mural, reproduced at the bottom of the page, featured large portrait heads of Harriet Tubman, Angela Davis, Malcolm X, and W. E. B. DuBois among others, including, somewhat incongruously, Lenin. After recapping the story of *The Strike*, the anonymous *Daily World* reporter quoted Lee Baxandall, an ideological ally, who insisted that the painting had been "intentionally buried due to its subject matter. Bourgeois art curators just didn't care about the painting."[1]

In December, the *UTU News*, a publication of the United Transportation Workers Union, printed a reproduction of *The Strike* with a caption announcing its acquisition by Local 1199 and (mis)informing readers that it was based on a Pittsburgh railway strike of 1887 (rather than 1877) and that "an art historian found it buried in the cellar of the

Minneapolis Art Institute" rather than on a rack in the museum's storage facility.[2] Moe Foner sent a copy of this article to Baxandall along with a letter informing him that the reproduction of *The Strike* had been distributed to labor papers throughout the country by "press associates" and that Local 1199 had been receiving "all kinds of compliments and requests" for copies of its special November newsletter. Answering an apparent query from Baxandall, Foner added that the union was "not in a position to do anything about a special printing of a poster."[3]

The mostly minor factual errors in articles about *The Strike* did no real harm to the painting's reception. Some of them probably enhanced its spreading notoriety. The December 21, 1972, issue of the *Minneapolis Labor Review* reproduced the painting with the headline "City Library Lets Historic Painting Slip Away." The text that followed mistakenly reported that the "Retail, Wholesale and Department Store Union" was exhibiting the painting in New York and, more egregiously, claimed that *The Strike* had been purchased in 1901 "through a subscription by Minneapolis trade unionists." This unnamed writer then closed with the obvious supposition that the painting "may be a work of art of great importance to the labor movement."[4]

Whatever the confusion and errors in these early accounts of *The Strike*'s rediscovery, requests poured in to Baxandall to reproduce and possibly exhibit it outside the domain of Local 1199. Oliver Jensen, editor of American Heritage Publishing Company, congratulated him for "the recovery and restoration of that remarkable painting" and requested a color transparency for possible use in one of the company's books or magazines.[5] The picture editor of the *New Standard Encyclopedia* requested a glossy photo suitable for its newly revised entry on strikes.[6]

In January 1973, impressed by *The Strike*'s visual impact as revealed by the color reproductions in the November 1972 issue of *1199 News*, a now enthusiastic Philip Mason at Wayne State University sent Baxandall a photograph of an architect's model of the proposed Walter P. Reuther Library, the future home of the Archives of Labor History and Urban Affairs. The first floor, he explained, would include "a large exhibit area" and "'The Strike' would certainly be an appropriate item to include for display." Beyond the "extended loan" he had rather casually suggested in 1971, Mason now urged Baxandall to give "serious consideration" to "preserving" the painting in his new building. In short, he wanted it for keeps.[7]

Equally excited by the publicity *The Strike* was receiving, Anton Refregier wrote an article for *Ogonek*, a popular Russian magazine. After discussing Local 1199's new headquarters (christened "The Martin Luther King Labor Center") and a mural he had designed for the building's façade to accompany a Frederick Douglass slogan, "Without

struggle there is no progress," he focused on the retired union members who cared for the art gallery, and more particularly on its predominant painting, *The Strike*. Following a mostly derivative account of the painting, Refregier added his personal, brother-artist appreciation of Koehler's success in dramatizing social conflict and confrontation:

> The painting is a panoramic view—the smokeless shops of the right in their shabby, depressed appearance contrasting to the stately mansion of the owner. The composition progresses from the group of men leaving the shop—a figure of a man pulling on his coat—another calling to his comrades—a group in discussion—a man with his coat over his arm passing by to join the throng. In this rhythmic flow, the composition moves to the foreground in the mass of people gathered at the entrance of the mansion . . . , figures in a militant mood surrounding their speaker addressing the well-groomed man standing coolly on the porch. A servant in the background expressing in horror his slavish concern for the master. Robert Koehler's workers are alive, painted with care for each character. His factory owner is lifeless and cold. The numerous figures of the strikers make up a single unified mass of people; in contrast, the factory owner stands alone.[8]

Refregier sent a draft of his article to Baxandall, who assured him that Moe Foner would provide a color transparency of *The Strike* to illustrate it. Baxandall went on to describe a poster that he hoped would feature a reproduction of the painting:

> A current artist (why not Refregier?) would do a four-color, militant "emblem" design incorporating Koehler's painting and a few words conveying the struggle of today. Or perhaps the wording could be general; for example: THE STRUGGLE OF LABOR, YESTERDAY, TODAY AND TOMORROW, AND THE STRUGGLE OF HUMANITY![9]

In a thumbnail sketch at the bottom of his letter, Baxandall roughed out a hypothetical poster comprised of a head, a raised arm, a wrench-gripping fist, an empty rectangle reserved for *The Strike*, the "Struggle" slogan above, and the word "STRIKE!" at the bottom. Nothing apparently came of this idea, but in September 1973 Local 1199 offered, for $2.50, a more innocuous poster featuring a color reproduction of *The Strike* and a hardly militant

quotation from Abraham Lincoln: "The strongest bond of human sympathy, outside of the family relation, should be one uniting all working people of all nations and tongues and kindreds."[10] The success of this promotional campaign is unknown.

Meanwhile, the cover of the June 1973 issue of *Monthly Labor Review*, published by the Bureau of Labor Statistics of the U.S. Department of Labor, featured a black-and-white close-up of *The Strike*'s most vital intersection, the strikers' fist-clenching leader pointing leftward, as if to urge the viewer to turn the page and start reading. A small note in the lower right corner invited readers to an inside article discussing "How Workers Are Protected from Discharge." The planning for this special cover dated to late 1972, when Moe Foner had sent Henry Lowenstern, the *Review*'s executive editor, a glossy print of the painting accompanied by Baxandall's permission to reproduce it.[11] Upon receiving his copy of the *Monthly Labor Review* with Koehler's painting prominently displayed, John Dolan, the industrial-relations director at Chicago's Trans Union Corporation, wrote to Lowenstern asking how he could get a reproduction of the painting suitable for framing. He wanted it for his office. "[A] copy of this dramatic event in our labor history" should also be made "available to the public," he added.[12]

Decontextualized as a kind of generic, all-purpose representation of labor on the march, Koehler's painting was put to many uses. In October 1973, *The American Teacher*, the magazine of the American Federation of Teachers (AFT), used it to illustrate an article, "The Treatment of Labor," along with three photographs of victimized turn-of-the-century industrial workers, including a trio of grimy, work-hardened young girls. The article, by Irving Sloan, a Scarsdale, New York, teacher, summarized his just-completed study for the AFT assessing the treatment of organized labor in twenty-seven American history textbooks. Their sporadic, sketchy coverage, he concluded, offered little improvement over the findings of a similar study in 1966.[13]

Also that October, *The New York Teacher*, another AFT publication, used a large reproduction of *The Strike* to illustrate an article on the late-nineteenth-century Chicago organizer and labor reformer Elizabeth Morgan. The text was by historian Ralph Scharnau, who had included a chapter on Morgan in his biography of her socialist husband, Thomas J. Morgan. An early member of the Knights of Labor together with her friend, Mary Harris "Mother" Jones, she later dedicated herself to improving the working conditions of women and children, particularly tenement dwellers exploited by the garment industry's "sweating system" of farming out piecework at rock-bottom wages. This association of Koehler's painting with a female labor reformer was particularly apt, since just such a woman

may be the figure at the very center of action in *The Strike*. Also appropriate was the editor's decision to reproduce Käthe Kollwitz's etching *The Weavers' March,* with its foreground mother and child, at the article's conclusion.[14]

Koehler, once a wage-earning lithographer, would no doubt have been pleased to see his major painting featured in the Winter 1973 issue of *Lithopian,* the graphic arts and public affairs journal of the New York City local of the Amalgamated Lithographers of America. With no reference to past or present union struggles, a brief text accompanying the large color reproduction repeated the customary anecdotal account of the painting's history.

Meanwhile, in late October 1973, Baxandall received a letter from Richard N. Gregg, director of the Allentown, Pennsylvania, Art Museum, inquiring about borrowing *The Strike* for a hoped-for exhibition to be titled "Realism Then and Now: A Contrast of American Genres." His idea was to juxtapose contemporary "scenes of everyday life" created by "the photo-realists and other figurative painters" with examples from the second half of the nineteenth century. Baxandall agreed, but Gregg then responded with apologies: plans had changed, and the exhibition had been postponed.[15]

Despite this disappointment, larger and more significant exhibition plans for *The Strike* were in the making—plans that would extend its reach well beyond the labor-union and radical political constituencies that initially welcomed its recovery and restoration. In the spring of 1972, after *The Strike's* restoration, Baxandall had shown it to Patricia Hills, Associate Curator of Eighteenth and Nineteenth-Century Art at New York's Whitney Museum of American Art. On June 13, Hills wrote to him thanking him for this advance view and expressing interest in including the painting in a fall 1974 "genre exhibition" at the Whitney. This exhibition, she promised, would include a section of works "with deeper social content in which the Koehler would star."[16]

In January 1974, Hills wrote a follow-up letter providing more details about the exhibition schedule and the catalogue, to be published by Praeger. While most of the works would appear in black and white in the catalogue, *The Strike,* as a centerpiece of the show, would be among those reproduced in color. Her planned catalogue essay, she added, would "discuss the origins of American genre painting and its development from the anecdotal painting early in the century (nineteenth) to the realism of the late century."[17]

Under the capacious title *The Painter's America: Rural and Urban Life, 1810–1910,* the exhibition opened at the Whitney on September 18, 1974, for a three-week run. From New York it went to the Houston Museum of Fine Arts and then to the Oakland Museum, where it closed at the end of March 1975. At all three venues, the exhibition

was supported by a grant from the Exxon Corporation—another ironic twist in the history of a painting that was considered dangerously radical by Chicago and Milwaukee industrialists of the 1880s, was kept at arm's length by the business elite of early twentieth-century Minneapolis, and was enthused over by Marxists, union organizers, and the newspaper of the U.S. Communist Party upon its return to public view in 1972.

In view of her corporate patronage and the predominantly anecdotal sentimentality of many of the works in her show, curator Hills's catalogue text steered a safe, uncontroversial course. The tragedy and pain in Thomas Moran's *Slaves Escaping through a Swamp*, dating from the emancipation year of 1863, were offset, she observed, by its implied hope for positive social change. Koehler would no doubt have approved of this reading, since his striking industrial workers also convey a sense of desperate hope, not bleak despair. In a single paragraph devoted to *The Strike*, Hills cited Koehler's statement about why he chose to paint such an unprecedented subject, alluded to the Haymarket tragedy, and quoted the partially negative 1886 *New York Times* review, from which she drew the unmistakable conclusion that "representations of the striking proletariat were perhaps too dangerous and subversive for most patrons."[18]

The Whitney exhibition attracted major reviewers. In his *New York Times* review, the ultra-conservative critic Hilton Kramer called *The Strike* (though not by name) a product of one of the "grimmest" chapters in American history, "the early days of the labor movement," and cited it, together with Moran's depiction of slaves on the run, as evidence that the exhibition was "anything but a Pollyanna view of American experience." Apart from these two works, however, Kramer concluded, "no more than a dozen [of the exhibition paintings] manage to elevate their anecdotal materials" to the level of a "deeply absorbing experience." Despite their "period charm," most were "lightweight," "banal," "repetitious," or "boring."[19]

Lawrence Alloway, art critic for the *Nation*, responded to Hills's exhibition with a rather discursive and progressively more amorphous essay on genre painting as "ideological projections of political and class opinions."[20] *The Strike* would have provided a fruitful case study for exploring this point in the contexts of Robert Koehler's biography and the historical events and social circumstances surrounding his painting, but Alloway failed to pursue either opportunity.

The most extensive press reaction to the exhibition was Jean Bergantini Grillo's review in the *Village Voice*. Under the attention-grabbing title "Strike Painting, Socialism Comes to the Whitney," Grillo devoted five columns to *The*

Strike. After describing the painting's origins and early history, Grillo turned to Lee Baxandall's search-and-rescue mission to restore a "purposely lost" painting to public view. He then compared the exhibition curator, Patricia Hills, "an instinctive Marxist" from a working-class background, with Lee Baxandall, a man from a comfortable middle-class background, once named Oshkosh's "Outstanding Boy Scout of the Year." He later had become an "indignant fellow traveler" on "the Radical Railroad" running from Berkeley and Madison to Cambridge and New York City, where he flourished as a "populist-radical sleuth" tracking down and acquiring a "radical treasure" currently insured by the Whitney for a hundred thousand dollars.

Beyond its monetary value or indeed its aesthetic merits, Grillo concluded, *The Strike*'s "true significance" lay in its power to grip the viewer with its intense drama. "A harsh, brutal painting" that had "bullied" its way into the exhibition, it "shoves for attention and gets it." He continued:

> Koehler boldly presents a dull stream of workmen who pour raggedly out of a mill in the painting's upper right corner
> and rush downward across the canvas to the mill owner's doorstep. Almost as a backstop, a dam to this human tide, the
> mill owner (read Capitalist) stands unnaturally rigid on his fancy brick steps, the shiny top hat he is wearing ludicrous
> looking in comparison to the workers' dirt-encrusted caps.[21]

In contrast to this tribute, the *Minneapolis Star* staff writer Peter Ackerberg chose to write a human-interest story about Baxandall's pursuit and management of the painting rather than discussing the work itself. Playing to his home-town readership with a little inside gossip, Ackerberg disclosed the arrogance of Samuel Sachs II, former chief curator and now director of the Minneapolis Institute of Arts, who dismissed Baxandall as "something of a promoter anxious to make this [the rescue of *The Strike*] seem like quite a coup." Sachs condescendingly called *The Strike* "an interesting curiosity" and added defensively: "If I thought this was a great first-rate museum-quality picture, the Art Institute would have purchased it."[22]

More Exhibitions but a Frustrating Dance with the National Gallery

While selling *The Strike* was always in the back of Baxandall's mind, he put this option aside for the time being as more exhibition opportunities arose. In March 1975, shortly before *The Strike* returned from Oakland to Local 1199's

gallery, he received a letter from Rena Coen, a curator at the University of Minnesota Art Gallery who was organizing an exhibition of Minnesota art to be mounted early in 1976 in the auditorium of Dayton's Department Store in Minneapolis, as part of the nation's bicentennial celebration. In conjunction with this exhibition, Coen added, she was writing a book on Minnesota's first century of painting and sculpture to be published by the University of Minnesota Press. She hoped to include *The Strike* in the exhibition, she noted, as "a very important monument of Minnesota art."[23] Baxandall agreed to the loan, though pointing out that the painting had been executed in Munich, far from Minnesota, and predated Koehler's arrival in the state by seven years. He also urged Coen to include several Koehler portraits, especially the 1898 *Self Portrait*, as well as *Rainy Evening on Hennepin Avenue*, all actually painted in Minneapolis.[24]

In the end, Coen included *The Strike*, along with the *Self Portrait* (Fig. 54), the 1881 Munich study of an old woman's head (Fig. 5), *Rainy Evening on Hennepin Avenue* (Plate 7) (both owned by the Minneapolis Institute of Arts), and a small oil, *Lake Minnetonka Scene*, lent by Koehler's aged niece, Gertrude Hoppe, of Milwaukee. Also, at Baxandall's urging, his 1910 oil portrait of Koehler at his easel by the Massachusetts artist Philip Little made the cut after being restored at the University Gallery's expense.[25] Coen's concentration on pre-1914 Minnesota-related art appropriately emphasized local landscapes, Native American subject matter, and Ojibwa clothing and religious objects. Therefore, *The Strike*'s presence was a thematic stretch, perhaps justified by the locally enacted universality of its subject matter.

As with Exxon's sponsorship of the Whitney exhibition, the irony of *The Strike*'s star billing in a city whose treatment of it had ranged from grudging acceptance to utter neglect was underlined by the support the exhibition received from corporate interests, including General Mills, International Harvester, White Trucks, and Land O' Lakes. It is hard to imagine the top executives and labor-relations officials of these corporations—latter-day successors to the lumber baron T. B. Walker—welcoming the inclusion of *The Strike*, with its depiction of angry workers confronting their boss, in the midst of an exhibition commemorating the Bicentennial.

Meanwhile, reproductions of *The Strike* spread across the country thanks to Green Mountain Editions of Oshkosh, Wisconsin, Baxandall's personal publishing enterprise. It offered full-color "art print originals" of *The Strike* and *The Carpenter's Family* that folded to six by nine inches for mailing, at the price of $1.00 each, plus a poster-size reproduction of *The Strike* for $2.50. Baxandall advertised these reproductions primarily in labor union publications. For example, *The Carpenter*, a monthly journal of the United Brotherhood of Carpenters and Joiners, published in

its August 1975 issue a Green Mountain Editions ad that incorporated a small black-and-white reproduction of each work. This issue also devoted its back cover to a large color print of *The Strike*, bordered top and bottom in bright green and accompanied by a short description.

In February 1976, Celestine Dars, a London-based picture researcher, having first written to Patricia Hills, sent an urgent request to Baxandall for a transparency or black-and-white print of *The Strike* for use in the second volume of a two-volume history of narrative painting by the British art critic Edward Lucie-Smith, to be published by Paddington Press. The book would include over two hundred illustrations, Dars explained, "all from paintings showing without romanticism the conditions of life of the 'laborious' classes between 1870 and 1914." Having already gathered strike paintings from Russia, England, Belgium, and France, she wanted to augment her selection with the world's first painted depiction of industrial workers staging a walkout.[26] In view of this historic distinction, *The Strike* became one of the few color plates in the volume.

A tantalizing but ultimately unrealized proposal to exhibit *The Strike* at the National Gallery of Art in Washington, D.C. (a 1941 gift to the nation from Andrew W. Mellon, heir to a Pittsburgh steel fortune and U.S. treasury secretary in the 1920s) came in an October 1976 letter to Baxandall from Charles Parkhurst, the National Gallery's assistant director. In reply, Baxandall assured Parkhurst of "indeed some possibility" that he would part with his prize painting, as he was concerned that it "be displayed under optimum conditions . . . and find the full public it seems to deserve." He urged Parkhurst to view *The Strike* at Local 1199's gallery or to send William Campbell, the National Gallery's curator of nineteenth-century American art to see it.[27] In place of Campbell, who died suddenly in early December, a young assistant curator, Earl Powell, came to New York two days before Christmas. Powell already knew the painting, having seen it in Houston during the Whitney's tour, and this second viewing confirmed his initial enthusiasm. In early January, Powell informed Baxandall that while the National Gallery lacked funds to purchase *The Strike*, it would welcome a "long-term loan with an option to buy."[28] Baxandall responded favorably, while noting his continuing desire to sell the painting immediately. In reply, Powell reiterated the National Gallery's interest in an indefinite loan and requested the right of first refusal if Baxandall did offer the painting for sale. In true museum-curator style, he added that, of course, the National Gallery would welcome the painting as a gift, for which Baxandall could claim a tax deduction at market value. Once the attached loan form was completed, signed, and returned, wrote Powell, a truck would be sent to (the as-yet uninformed) Local 1199 to haul away its favorite work of art.[29]

Belatedly advising Moe Foner of these developments, Baxandall cited the greater protection and public exposure the National Gallery could provide. Further, he added, appealing to Foner's union loyalties, placing the painting "in Andrew Mellon's museum may cause the old steel baron to spin quite agitatedly in his grave!"[30]

Mellon's repose, however, would continue undisturbed, since the planned transfer to the National Gallery never came about. In April 1977, Baxandall completed his end of the negotiation by agreeing to the National Gallery's policy that all exhibited works could be photographed by visitors,[31] but no truck showed up to convey the painting to Washington. On June 16, Powell wrote Baxandall blaming the delay on "a logistical problem": the painting was too large for the National Gallery's van! Apparently the Federal Government could not afford a vehicle of sufficient size, at least not for purposes of art. In an obvious strategic ploy, Powell proposed a solution to this peculiar dilemma: If Baxandall would arrange for the private crating and shipping of the painting to Washington, the National Gallery would reimburse him—provided the work came as a gift. Meanwhile, he added, the delay would give the recently appointed new curator of American Art, John Wilmerding, an opportunity "to review the loan."[32] After more weeks of no further word, Powell, on August 16, responded to a query from Baxandall with a barrage of museum-speak that essentially terminated the entire transaction: "After reviewing the situation with regard to this loan and in light of the fact that we will begin a major re-installation of many galleries this fall, which would preclude exhibiting the work for an indefinite period, I think it best to try to find another solution for this temporary disposition of your painting."[33]

Thus a long-term loan had become, at best, a "temporary disposition." While disappointing for Baxandall, this outcome undoubtedly came as good news to Moe Foner, who was busy organizing a two-year series of cultural events to celebrate Local 1199's upcoming twentieth anniversary, in which he hoped *The Strike* would figure prominently. Not surprisingly dubbed "Bread and Roses," this ambitious project, along with various conferences and seminars, aimed to provide to union members and their families a diverse arts-and-humanities experience through drama, music, poetry, visual arts, videotapes, films, and a Labor Day street fair. The actors Ossie Davis, Ruby Dee, Eli Wallach, and Anne Jackson, plus folk singers Judy Collins, Pete Seeger, Arlo Guthrie, and Odetta all agreed to participate. Budgeted at $1.5 million, this expansive effort to widen the cultural horizons of workers attracted grants from the National Endowment for the Arts, the National Endowment for the Humanities, the New York Humanities Council, the New York State Arts Council, the Pennsylvania Arts Council, plus several private foundations.

Thinking big as always, Foner scheduled eleven art exhibitions for the gallery at Local 1199's headquarters. The first comprised paintings by children of seventy-eight countries assembled by the United States Committee for UNICEF to commemorate the International Year of the Child. The "kids' show" opened in January 1979 and later toured museums throughout the country. The major exhibition, "The Working American," was to open at Local 1199 in October, and upon closing a month later tour to various venues for the next fifteen months under the auspices of SITES, the Smithsonian Institution Traveling Exhibition Service. Curator Abigail Booth Gerdts borrowed some forty American paintings of workers dating from the mid-nineteenth century to the present, with *The Strike* as the show's centerpiece. Baxandall agreed to let the painting go on tour, provided it was insured for $150,000 and accompanied by *The Socialist*, Koehler's other powerful representation of working-class protest, which he had recently acquired. He offered to lend *The Carpenter's Family* as well, but Gerdts rejected this as a German painting that "would be jarring in our exhibition." *The Socialist* and *The Strike*, on the other hand, were "American" subjects, or so she rationalized, because both had been first exhibited at the National Academy of Design and were, in any event, motivated by "Koehler's sense of his American-ess."[34]

Critical reviews and news articles followed the exhibition as it crisscrossed the Northeast and paid one visit to the Deep South. Including the Detroit Historical Museum, the University of Rochester, the Chicago Historical Society, the New Jersey State Museum in Trenton, and the Museum of Our National Heritage in Lexington, Massachusetts,

FIGURE 66
Moe Foner
(SEIU Archives, Kheel Center,
Cornell University,
courtesy of Anne Foner)

the itinerary underscored the exhibition's sociocultural significance, whatever its aesthetic value. The only art museum on the circuit was the Museum of Fine Art in Birmingham, Alabama. At a moment of growing conservatism, with the percentage of union members in the labor force once again declining and Ronald Reagan about to win the presidency, *The Strike's* inevitable presence in this exhibition offered a forcible reminder of the history of unionization and labor activism. Whatever the mission of an exhibiting museum on the tour, whether historical or art-historical, critics, reviewers, and photography editors paid special attention to *The Strike* and occasionally its companion piece, *The Socialist*.

Reviewing the exhibition for *The Nation*, Lawrence Alloway singled out *The Strike* and Honoré Sharrer's 1951 *Tribute to the American Working People* as its two "outstanding" works. Whereas Sharrer's altarpiece arrangement, centering on a workman "as crystalline as a quattrocento saint," assured it a worshipful response, observed Alloway, *The Strike* offered more interpretive options, depending on whose side the viewer was on, that of the protesting workers or of the paternalistic old factory owner:

> Koehler's painting is as precisely choreographed as a moral genre scene by the 18th-century French artist [Jean-Baptiste] Grueze, but in place of the good mother and the bad son it is a confrontation between capital and labor. At the start of a strike the workers assemble before the classical portico of the office where the factory owner stands; the group is calibrated with precise shades of militancy, anxiety and hesitation.[35]

Carter Ratcliff, reviewing the exhibition for *Art in America*, criticized the "white-collar, degree-certified respectability" of Abigail Gerdt's "curatorial packaging," but cited *The Strike* and Everett Shinn's 1901 pastel *The Docks, New York City* as notable exceptions. Koehler, while not wholly avoiding the temptation to turn oppressed workers into a "catalogable product," said Ratcliff, had been sufficiently moved by late nineteenth-century industrial exploitation and labor unrest to create a "proletarian machine" of "convincing images."[36]

Particularly interesting, in the heat of a presidential campaign that would ratify the conservative turn in U.S. politics and culture by electing Reagan as president, was the decision by editors of the glossy coffee-table magazine *American Heritage* to reproduce in its June/July 1980 issue a full double-page color reproduction of *The Strike* and a single-page reproduction of *The Socialist*. The brief accompanying text argued that while few nineteenth-century paintings of American laborers, either urban or rural, "give the viewer any insight into the worker's lot," in revolutionary

Europe (the inspiration for Koehler's paintings, the author assumed) "artists liked to show labor locked in heroic struggle against class and capital." The angry socialist orator, a "fierce-eyed symbol of growing unrest over exploitation," the caption continued, anticipated the strikers' spokesman in the larger canvas, both "making trouble for the bosses, probably by urging a strike."[37]

Reviewing the exhibition for the liberal Catholic journal *Commonweal*, Nicolaus Mills, an English instructor at Sarah Lawrence College, devoted a full column to *The Strike* as the exhibition's "dominant" work. Shifting the locale back to the United States, Mills praised the painting, despite its somewhat "theatrical" quality, for offering "a visual appreciation of the complexity and hardness of American working life" by "show[ing] the power a single factory owner exercises over his far more numerous employees." Desperately determined to resolve their conflict with the boss, the workers cannot agree how to do so. They must first "settle their own differences," Mills shrewdly observed, and this dilemma creates a dramatic tension lacking in most of the exhibition's paintings.[38]

Mills's observations were strengthened and expanded in Michael Hopkins's astute review of the "Working American" exhibition for the Woodbridge, New Jersey, *News Tribune*. Like Carter Ratcliff, Hopkins expressed disappointment at the exhibition's "lack of polemical energy" and the failure of most of the paintings "to champion the worker's causes." Preferring to "idealize and romanticize the worker's life," most of the artists made no attempt to reveal "the despicable conditions that existed in mills and on plantations." The "startling exception," however, was *The Strike*:

> Its oppressive weight of gray: gray sky, gray stone, gray smoke, gray steel envelops the confusion and pathos of the workers. While we are made to feel the stifling closeness of the environment, we also are made to feel the uncertainty of their world. Their conviction varies in strength; some men hang back, talking. And in a surprising but perfect touch, a woman who seems bathed in a column of light and is the painting's central figure is seen bidding her husband not to participate. These touches, along with the frightened gaze of the little girl clutching her mother's skirts, convey the narrative of these people's story. We see people struggling against an oppression they don't fully understand and with which they don't entirely know how to contend. The painting brings to life a watershed situation, an awakening.[39]

During its "Bread and Roses" travels and after its return to Local 1199, *The Strike* continued to be reproduced in various publications. The Stanford University historian Thomas Bailey included a full-color illustration in the sixth

edition of his widely adopted textbook, *The American Pageant, A History of the Republic* (1979). Bailey compared late nineteenth-century U.S. industrial workers to "Roman galley slaves" as he sympathetically described their often frustrated efforts to organize unions and otherwise improve their lot. With equal concern, Paul Von Blum's *The Critical Vision* (1982) follows its curtailed reference to the Haymarket Square riot with a reproduction of *The Strike* and a brief paragraph ending with the painting's stone gatherer, who "underscores Koehler's vigorous, unambiguous support of labor."[40]

The Meiklejohn Civil Liberties Institute of Berkeley, California, featured *The Strike* on the August page of its 1980 Human Rights Calendar, illustrating Article 22 of the International Human Rights Covenant, "The Right to Join Unions." In July 1981, the Minnesota Historical Society in Saint Paul enlarged the painting to a wall-sized graphic for a three-year exhibition featuring the eccentric Minnesota-based utopian writer, social reformer, and Populist Party leader Ignatius Donnelly (1831–1901).

The following summer, the painting itself was displayed in the Pennsylvania governor's mansion in Harrisburg, as part of an exhibition by the Pennsylvania Historical and Museum Commission honoring "Working Pennsylvania: A Tribute to Labor and the Individual Worker." The inclusion of *The Strike* in this show was particularly apt, since "The Great Railroad Strike" of 1877, and particularly the arson and fatal attacks on strikers by state militia in Pittsburgh, was Koehler's original inspiration. Whether Republican Governor Dick Thornburgh was fully aware of the role this bloody labor conflict played in the painting's genesis is unclear, but in any event he (or a staff member who drafted the letter) thanked Lee Baxandall for lending "one of the more important paintings in this show" whose "poignant message" was now being shared with "thousands of Pennsylvanians and other visitors."[41] Even at a time of conservative backlash and shrinking union influence, the more observant, historically informed, and socially sensitive among these visitors surely recognized the power of *The Strike* as a testament to the long struggle of industrial workers for better working conditions, reasonable wages, and more recent goals such as retirement and health benefits.

This message would soon reach a European audience as well. In early spring 1983, Koehler's much-traveled painting made its first Atlantic crossing since it had been shipped to Chicago for the World's Columbian Exposition ninety years earlier. After touring in a major exhibition throughout western Europe, it would return to Germany for good, as an honored part of that reunited nation's cultural patrimony.

13

Germany Reclaims a National Treasure

1983 TO THE PRESENT

B Y THE EARLY 1980S, AS *The Strike* NEARED ITS CENTENNIAL, its role had become basically a documentary one. It served as a dramatic record of organized labor's early travails. So designated, the painting returned to its country of origin in 1983, to join a touring exhibition designed to inform Germans and other Europeans that a vast majority of those "rich" Americans had actually struggled for a living. In April 1982, Valis Abolins, the executive secretary of West Berlin's Neue Gesellschaft für Bildende Kunst (New Society of Fine Art) and Reinhard Schultz, a freelance Berlin art consultant, visited Lee Baxandall in New York to inform him of an ambitious exhibition, "Art and Culture of the American Labor Movement," scheduled to open at Berlin's Staatliche Kunsthalle (State Art Gallery) on March 13, 1983 (the centennial eve of Karl Marx's death) and run to April 24.[1] Under consideration were approximately eight hundred items, including many photographs, both press photos and predetermined images, by well-known photographers such as Lewis Hine and Dorothea Lange. These, together with paintings, prints, posters, cartoons, and photographs of murals, promised to make the exhibition the largest array of visual materials documenting American labor history ever assembled. Of course, Abolins and Schultz insisted that both *The Strike* and *The Socialist*, whether strictly "American" or not, must be included.

A Welcoming Return to Europe and Sale to an Unknowing Collector

Baxandall agreed, and the two works arrived in Berlin the following February. While they were en route, Baxandall informed Moe Foner that the German shipping firm to which he had entrusted the paintings had alerted him that *The Strike*'s canvas had stretched and the painting had suffered other damage from air pollution and humidity during its years in Local 1199's gallery. While appreciative of Foner's role, he said, he intended to seek a new home for the painting, perhaps in Europe.[2]

The exhibition's Berlin opening attracted a number of reviews, many of them politically slanted, including one in Axel Springer's conservative newspaper, the *Berliner Morgenpost*, and another by Thomas Doberstein in the radically leftist monthly *Konkret*. Neither made more than passing reference to the German emigrant Robert Koehler, though Doberstein did note *The Strike*'s continued relevance.[3] Dismissing as preposterous the charge that it or the exhibition in general was "anti-American," he maintained: "It is as little anti-American as the Communist Angela Davis who is coming to Berlin to attend the opening."[4]

Undoubtedly helping to stimulate attendance, both reviews featured reproductions of *The Strike*. The one in *Konkret* floated over a full-color, double-page montage of city life by Ralph Fasanella, an Italian American organizer for the electrical workers' union and self-taught painter of workers and union members.

An overnight theft of *The Socialist* soon after the exhibition opened caught public attention, and may have increased attendance as well. According to the tabloid *Bild*, the thief struck on Friday, April 1, concealing the small painting under his coat. Its absence was first noticed late in the afternoon. Abolins speculated that the culprit was a serial thief who had been stealing small works from exhibitions for several months.[5] Whoever it was quickly unloaded his loot at an antique shop in the city's Charlottenburg district. The shopkeeper, reading about the theft in the Saturday newspapers, called the police, and by Sunday the painting was back on display.[6]

The lavishly illustrated 554-page exhibition catalogue, *The Other America: History, Art and Culture of the American Workers Movement*, containing over a thousand illustrations and priced at 38 Deutschmarks (about $15), soon went on sale. It would eventually run through at least three editions. The foreword acknowledged Michael Harrington's 1962 book on poverty in the United States, *The Other America*, as the source of the exhibition's title. An abridged version of the catalogue in English appeared in time for the exhibition's London stop in late autumn 1985.[7]

Despite some ambiguity about the authorship of its twenty-four chapters on the history of American labor from the Colonial period to the Reagan era, the catalogue's narrative clearly relied heavily on the multivolume *History of the Labor Movement in the United States* by the American Marxist historian Philip S. Foner (1910–94), brother of Moe Foner. Additional essays on the art of the workers' movement deal with painting, photography, and literature, ending with a short pictorial display featuring Moe Foner's "Bread and Roses" project.

A discussion of *The Strike* appeared in the essay "Comments on the Representations of Work in the Fine Arts since 1800" by Patricia Hills. Based on the secondary sources available to her, Hills quoted Koehler's often-repeated statement about his initial inspiration for the painting, plus the *New York Times* review of 1886. She also repeated the unverified claims that Koehler grew up in a socialist family and added that he had joined the German socialist movement during his student years in Munich.[8]

Of special relevance to *The Strike* was the catalogue's full-page quote from "Das Bild hing schon in Bremen bei uns in der Wohnung" (The Picture Hung in Our Apartment in Bremen), an essay by the German-born Marxist playwright Peter Weiss (1916–82), best remembered for his play *Marat/Sade*. The essay appears in the first volume of Weiss's loosely organized three-volume autobiographical memoir *The Aesthetics of Resistance* (1975–81). Its digressive text opens in Berlin in 1936, as the anonymous narrator relates the experiences of a small, ultimately doomed anti-Nazi resistance group. As the work's title implies, art provided Weiss with a means of comprehending the struggles of common people throughout history, including the modern-day proletariat. He included a dramatic contemplation of the second-century-B.C. altar reliefs in Berlin's Pergamon Museum, whose violence, although of the ancient past, remains an inescapable feature of the human condition. To Weiss, the Pergamon frieze, itself the plunder of latter-day imperialism, expresses "perpetual rebellion."

Supplementing the Pergamon image, Weiss incorporated reproductions of twelve artworks into his text, including Dürer's *Melancholia*, Picasso's *Guernica*, Adolph Menzel's grimly realistic *Das Eisenwalzwerk* (Fig. 26), and the Gedan engraving of Koehler's *The Strike* (Fig. 40). The latter, Weiss recalled, had been clipped from *Harper's Weekly* and tacked to a wall of a Bremen apartment, presumably that of his parents during his boyhood. In contrast to Menzel's lush painting techniques and "prickly" color scheme, Weiss preferred Koehler's painting for its illustrational matter-of-factness, tightly linked to its narrative content. His meditation on the work blended factual detail and imaginative

speculation. Beyond what can be directly observed—the mill owner's arrogance and "cheesy dignity," for example, and the impatiently spreading arms of the worker in the center of the painting as he responds to the woman confronting him—Weiss imagined armed police assembling behind the mansion. Because of this threat, he speculated, the angry but "wisely reflective" workers will not attack, however unbearable their situation. The reached-for stone will not be thrown. (Here the narrator recalls his boyhood fantasy of running up the steps and landing a punch on the old man.) Weiss has no doubt that Koehler (who, he mistakenly believes, died impoverished) also stood on the side of the strikers. This sympathy is demonstrated, he argues, by the way Koehler compassionately conveyed not only their "heavy physicality" but also their inner "self-awareness." In view of the violence that surrounded the painting's first American exhibition in 1886, Weiss concluded, Koehler's historical prescience and persuasive testimony to the "antagonism between the classes" can only be admired.[9]

After leaving Berlin, *The Strike* traveled with the "Other America" exhibition to Oberhausen, a gritty working-class city in the Ruhr mining district, and then on to Stockholm's Kulturhuset museum, where it joined an exhibition memorializing the I.W.W.'s Swedish American martyr Joe Hill, born Joel Higglund. From Sweden it moved to Hamburg, where, appropriately, it opened in the former Kampnagel machinery works, a sprawling factory in the city's working-class district recently refitted as a cultural center.

September 1984 found the exhibition in Rome, as part of a press festival sponsored by the Italian socialist newspaper *l'Unita* and attended by some 30,000 visitors. After a winter's rest, *The Strike* accompanied a pared-down version of the exhibition to Kassel's elegant Orangerie, the former imperial summer residence, where the San Francisco Mime Troupe also performed. After a separate participation in an exhibition entitled "Life and Work in the Industrial Age" at Nuremberg's Germanisches Nationalmuseum, *The Strike* rejoined "The Other America" in early November 1985 for the tour's final stop: London's Royal Festival Hall.

Throughout its history, *The Strike* had been subjected to many interpretations and misinterpretations and been appropriated by various causes, and this remained true during its two-year tour with "The Other America." In his opening essay for the abridged English-language catalogue issued for the London exhibition, Reinhard Schultz repeated Patricia Hill's undocumented claim that Koehler "grew up in a socialist family" and also exaggerated the painting's neglect in the United States, especially during Koehler's lifetime, as a means of aggrandizing the admiring reception it was now receiving in Europe:

The painting, which today is generally considered to be the labor masterpiece of American painting, never received much attention from U.S. art critics until its rediscovery in the 1970s. In fact, after Koehler had stepped down as the Director of the Minneapolis School of Art, the so-called curators storing "The Strike" managed to hide it so well, that for almost 50 years it was considered to have been lost. Since it has again returned to Europe . . . for the traveling "The Other America" exhibit, "The Strike" has been reproduced in many reviews and several books and also as a poster and a postcard.[10]

Compounding the misperceptions, the caption of the reproduction of the *Harper's Weekly* engraving of *The Strike* illustrating Schultz's essay repeated the error of the German tabloids of the 1880s by identifying the painting's subject as "Workers on Strike in Belgium," hardly appropriate for an exhibition devoted to American labor.[11]

Now in London, the "Other America" exhibition, including Koehler's painting, faced the British press. Reporter Jeff Sawtell in the radical-left newspaper *Morning Star* commended the exhibition for living up to Lenin's dictum that a culture arises "from within class and democratic struggles." He, however, rejected the accusation, advanced earlier by the conservative *Frankfurter Allgemeine* newspaper, that the exhibition's contents and commentary were Communist-inspired. *The Strike*, illustrated front and center under the stark heading "FORGOTTEN," received major attention in Sawtell's review. During the nationwide May Day strikes of 1886, he claimed, Koehler's painting "naturally became the image of the people," not only in America but "throughout the world." Paradoxically, this global fame contributed to its being "confined to cold storage" in 1917 (the year of the Bolshevik Revolution) and "conveniently forgotten" until its rediscovery in 1970.[12]

In her review of the exhibition for the left-wing social-science journal *New Society*, the Marxist-feminist scholar and polemicist Sheila Rowbotham focused exclusively on Koehler's "epic painting" as the first to solve "a continuing problem in finding an outlet for an artistic representation of the cause of labour." Oddly making no mention of the women in *The Strike*, Rowbotham noted, as one of the "curious silences" in the exhibition catalogue, its lack of attention to "the downtrodden, sweated women workers" staring out of various photographs on view.[13]

Labour Weekly's Arthur Lipow also singled out *The Strike* as the prime portrayal of American labor's "militant history." To Lipow, the true significance of the painting, and indeed of the exhibition as a whole, lay in the visual documentation they provided of "the long tradition of solidarity, common struggle, and sacrifice of American working

people." A better understanding of this history, he argued, would help counteract the anti-Americanism of the British Left and labor movement, rooted in hostility to U.S. imperialism and intensified by the revulsion aroused by the current Reagan administration.[14]

Meanwhile, the Berlin art consultant Reinhard Schultz, with the encouragement of Lee Baxandall, continued to seek further venues for the "Other America" exhibition, as well as a permanent European home for *The Strike*. For a time, Schultz and Baxandall hoped to ship many of the exhibition items, including the paired Koehler paintings, to the Chicago Historical Society for a 1986 exhibition commemorating the Haymarket Riot. The museum's remodeling plans interfered, however, and finding no other likely venue, they abandoned hope of an American showing.[15] Hence, while a remnant of the exhibition went from London to Manchester and Derry, *The Strike* and *The Socialist* returned to Germany where they were temporarily housed at the Festival Hall in Recklinghausen.

During this interval, the paintings were featured in an exhibition and illustrated publication, "My Fatherland Is International," sponsored by the German Federation of Labor (D.G.B.). Reminiscent of Moe Foner's coup in securing *The Strike* for Local 1199's gallery in New York, D.G.B. leaders expressed interest in a long-term loan of the painting for display in their Düsseldorf headquarters. Baxandall agreed, but as 1986 ended, both paintings remained in Recklinghausen.[16]

Baxandall of course had long wished to sell *The Strike*, and suddenly this prospect unexpectedly materialized. In December 1985, he had responded to a *New York Times* "Wanted to Purchase" ad by New York's Jordan-Volpe Gallery requesting "Works by Artists of the American Renaissance, 1876–1917." In February 1987, Vance Jordan phoned him with an offer. Negotiations ensued, and the two soon entered into a legal agreement for the gallery's purchase of *The Strike* for $250,000.[17] Obviously excited, Baxandall instructed Reinhard Schultz, who was still acting as his agent in Berlin, to ship the painting immediately to New York, and Schultz reluctantly complied.

Having, as it seemed, lost the opportunity to get *The Strike* into a European museum collection, Schultz pursued this end for the other Koehler work in his care, the small panel painting *The Socialist*. It took him two years, but in April 1989 he informed Baxandall that the Deutsches Historisches Museum had offered to purchase it for a price of $47,500. (This premier German history museum, displaced when the Berlin Wall was erected in 1961, was provisionally located in West Berlin's Charlottenburg district, near where a thief had pawned *The Socialist* three years earlier.)[18]

As Baxandall welcomed the offer, the moment was rich in historical ironies. The East German communist regime, indeed the Soviet Union itself, was collapsing, and a once-controversial painting of a revolutionary speaker, dating to the time of Karl Marx's death, returned to a divided city, for decades an outpost of Soviet power and now on the verge of reunification as the Cold War ended and the Berlin Wall crumbled.

All that remained was for *The Socialist* to be joined by its much larger comrade, *The Strike.* This would soon occur, but not before another chapter in the eventful saga of Robert Koehler's masterwork had unfolded.

In 1989, a wealthy manufacturer and highly acquisitive collector of nineteenth-century American paintings, Richard A. Manoogian of Grosse Pointe, Michigan, purchased *The Strike* from the Jordan-Volpe Gallery for $300,000.[19] Manoogian was the CEO of MASCO corporation, a hardware and furniture firm and automotive-industry supplier founded by his Armenian-born father, Alex, the inventor of the single-handled faucet. The purchase, apparently sight unseen, was possibly part of a lot put together by Vance Jordan for a parvenu client whose growing collection of more than two thousand works leaned toward "pleasant pictures"—landscapes, still lifes, and historical portraits.

Like other captains of industry before him, Manoogian may well have disapproved of *The Strike*'s subject matter once he finally laid eyes on it. Such a negative reaction was, in fact, astutely anticipated by Baxandall who, in a spring 1990 letter to Dr. Agnete von Specht, a curator at the Deutsches Historisches Museum, suggested that *The Strike* might soon come on the market, and added: "Because [Manoogian] is a multi-millionaire entrepreneur of a big hardware business, I believe he (or his collection curator) does not fully 'appreciate' its values."[20]

In fact, this conflict of values may have already been revealed by the painting's absence from an exhibition of the Manoogian Collection mounted at the National Gallery of Art in 1989. In November 1987, as this exhibition was being planned, Baxandall had informed Reinhold Schultz that *The Strike* would appear in the exhibition and would "almost certainly . . . become a part of the collection of the National Gallery at that time or soon thereafter."[21] Although he no longer owned *The Strike,* he clearly remained interested in its fate, and desired to see it displayed in a major museum. When it became clear, however, that Manoogian would not be donating *The Strike* to the National Gallery, Baxandall approached Agnete von Specht to test the Deutsches Historisches Museum's interest in obtaining it.[22] The seed Reinhard Schultz had planted was now being nurtured, and would soon reach fruition.

Return to Germany: Berlin's Deutsches Historiches Museum Acquires *The Strike*

On December 11, 1990, von Specht informed Baxandall that, thanks to his advice, the Deutsches Historisches Museum had acquired *The Strike* for $450,000, and hoped to build an exhibition around it as soon as possible.[23] In March 1991 she announced that her director had approved "a small exhibition" featuring *The Strike* along with several other related paintings, including *The Socialist* and another recent acquisition, Ludwig Knaus's *Der Unzufriedene* (The Dissatisfied One), originally entitled *The Social Democrat* (Fig. 21).[24] The exhibition opened on May 21, 1992, as the Deutsches Historische Museum welcomed *The Strike* into its spacious new home, the restored early-eighteenth-century Zeughaus (arsenal building) on Berlin's imposing thoroughfare, Unter den Linden, between Humboldt University and the Cathedral, near the row of museums along the River Spree, "Museum Island," and not far from the Reichstag.

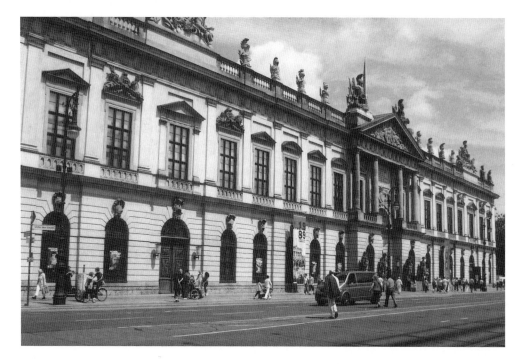

FIGURE 67
Deutsches Historisches
Museum, Unter den Linden,
Berlin, Germany
(photograph by
Paul Boyer, 2009)

Entitled "Streik: Realität und Mythos," the exhibition was considerably larger than von Specht's letter had suggested. The extensive, well-illustrated catalogue included essays on such subjects as eighteenth-century strikes, nineteenth-century food protests, and strike postcards issued in France and Germany from the Revolutions of 1848 to World War I.

The catalogue's glossy cover consisted of a high-quality, color reproduction of *The Strike*. Agnete von Specht's introduction also emphasized Koehler's painting, which she described as the animating impulse for the entire exhibition. The principal large-format painting of a strike "born" during a period of "spectacular" labor unrest, it was "the incunabulum of the workers' movement," and, as such, fully merited its status as the exhibition's centerpiece. Koehler's audacious introduction of contentious imagery—*der Industrieproletariat*—to an art-viewing public accustomed to academic history painting was, she maintained, the period's most important art-historical development. As such, *The Strike* was singled out for exclusive mention in the *Berliner Morgenpost*'s report of the exhibition opening the following morning.[25]

Discussing Koehler's family background, art training, and the evolution of *The Strike* in her closing essay, "Robert Koehler's Painting, *The Strike*, as History Painting," von Specht quoted from the artist's personal statements about the painting; the 1889 *Milwaukee Herold* interview with his father; and brief items from *Harper's Weekly*, the *New York Times*, and *Moderne Kunst*. In a more inventive mode, she put words in the mouth of the painting's central woman (again assumed to be the wife of the brawny worker she is addressing) implying her resigned agreement to the walkout. "We have tried everything," von Specht imagines her saying, "What else can we do?"[26]

Certainly one of the more extensive and thoughtful analyses the painting ever received, von Specht's essay even offered an iconographic comparison of the watchful little girl's red socks with a scene in chapter 25 of Theodor Fontane's posthumously published novel *Der Stechlin* (1899), a critique of the fading Prussian aristocracy at a time of rapid industrialization, labor conflict, and ideological ferment. The novel's pious and conservative heroine, Adelheid, warns her easygoing younger brother Dubslav that the red knee socks worn by a neighbor's child are a sign not only of a political but also a moral revolution, to which he had better be alert before it is too late. Red socks and the red shirt of the strikers' gesticulating spokesman led von Specht to the inevitable mention of Belgium, torn by strikes in the 1880s, and also, she maintained, home of the red dye used in the manufacture of such clothing.

With equal concern for stylistic comparison, von Specht noted Koehler's training in history painting offered at the Munich Royal Academy of Art by Defregger and Piloty. More specifically, she traced *The Strike*'s composition back to the classical landscapes of Claude Lorraine, including *The Expulsion of Hagar* in Munich's Alte Pinakothek museum, surely familiar to Koehler. Its figure of Abraham under the columned portico of an antique temple, she pointed out, is comparable to *The Strike*'s foundry owner, standing on his columned porch. Both men of power are prominently positioned as pinnacle images of their respective hierarchies. By the same token, *The Strike*'s assembled workers, as opposed to the powerless "petitioners" in Alfred Roll's 1880 *Miners' Strike* (Fig. 30), acquired a "nobility" through Koehler's adaptation of the basic format of history painting. The casual viewer may not notice it, but to a museum person such as von Specht, the creative eclecticism evident in the various art-historical strands that come together in *The Strike* was a point worth emphasizing.

Von Specht took a polemical and ideological turn as she discussed Peter Weiss's comments on *The Strike* in *The Aesthetics of Resistance*. Although a self-styled Marxist patiently awaiting the inevitable collapse of capitalism as the dialectic dynamic of history unfolds, Weiss, as von Specht notes, admired Koehler's strikers for confronting not "the state" but a specific enemy capitalist. But she rejected Weiss's reading of the painting as a whole. Citing Koehler's compassionate portrayal of the "helpless and embarrassed" old capitalist seeming to express emotions of "surprise and feeble defensiveness," she takes Weiss to task for interpreting the painting as an expression of irreconcilable class conflict and hostility. This, she argued, was a biased, ideologically driven misreading of Koehler's intentions, reinforced by the myth that he was ostracized and had died impoverished. Had Koehler produced *only* paintings like *The Strike* and *The Socialist*, she conceded, "he would have really ended up in the poorhouse." But in fact, as his later career made clear, these two paintings stand alone in his life's work as documents of industrial unrest and radical protest.[27]

Perhaps in a further effort to reassure conservative middle-class museum visitors put off by Weiss's class-conflict interpretation, von Specht's curatorial associate Klaus-D. Pohl struck a moderate and reassuring note in the catalogue's final essay, "On the Artistic Perceptions of the Strike." Far from suggesting the inevitability of violent confrontation, Pohl argued, *The Strike* hints at the possibility of reconciliation between the antagonists. After all, he pointed out, the painting had been chosen by the editors of a conservative German newspaper, the *Kaiserzeitung*, to illustrate an 1893 article describing a stalemated strike harmful to both sides—an article that ended with a plea for "a little more friendly accommodation, a bit more contented willingness" by strikers and their employer to reach an agreement.[28] Despite

the hint of violence in the prominent detail of a worker picking up a stone, Pohl suggested, Koehler had created a picture that refuses to "close down the front" between the two sides and instead advocates a "process of learning" (*Lernprozesse*), not only between the workers and their boss, but among the workers themselves. Assuming that Koehler's workers will heed what he believes must be the conciliatory advice of the central woman, Pohl ended by quoting a socialist labor leader, August Siegel, who, at the peak of a coal miners strike in the Ruhr district, cautioned his followers that they would best serve their cause by avoiding any impulsive actions: "Vor allem, haltet euch ruhig" (Above all, stay calm).[29]

Once the exhibition ended, *The Strike* and *The Socialist* eventually assumed their assigned places on opposite walls of a second-floor gallery of the Deutsches Historisches Museum devoted to the arts, industry, and politics of the Bismarckian era. Here they are variously viewed by visitors as historical artifacts, works of art, curious relics of a long-ago era, or still-timely social documents.[30] The popularity of the thematically joined pair of paintings, and particularly *The Strike*, continues. As a study of human behavior and emotions in a moment of crisis, *The Strike* attracts passing curiosity in some viewers, close attention in others. As a material-culture document, it opens a window on the past through such mundane details as jackets, caps, hats, and shoes; hair and dress fashions; even architectural design and early industrial construction.

Despite *The Strike*'s curious identification with Belgian coalminers, neither it nor *The Socialist* document a specific historical event or specific individuals. This does not, however, close off the possibility of relating either painting and its after-history to its historical contexts, an approach basic to the method and meaning of this book. Witness again the urgent salience *The Strike* acquired, and the radically different responses it elicited, during the turbulent and often bloody industrial strikes of the late 1880s and 1890s, or its relevance to the class warfare waged in Minnesota from the early twentieth century through the Great Depression.

Informed by the day-by-day particulars of real-life dramas, *The Strike* took on new layers of meaning, as do all cultural productions. As events unfolded and the social context changed, so, too, did interpretations of the painting and its cast of characters. Is the central female figure a worried wife or a mediating intervener? Is the spokesman confronting the owner one of the mill workers or an outside organizer? Is the vaguely menacing background figure a reporter, a curious bystander, or a company spy engaged in surveillance? Did Koehler intend the painting as a ringing endorsement of organized labor, a protest against industrial exploitation, or a call for moderation and compromise

instead of strikes and violence? Or were all these perspectives perhaps present in his mind as he planned and executed the work?

As the painting interacted with changing social circumstances over the years, individuals and groups with different agendas, class interests, and ideological commitments found one or another of these interpretive approaches plausible and even compelling. Over the decades, socialists and capitalists; union leaders and heads of industry; radicals, moderates, and conservatives, have read very different meanings into a cryptic and elusive painting that refuses to reveal its "true" message, but only invites more speculation.

As *The Strike* traveled back and forth between Europe and America, it encountered changing circumstances that affected its reception, whether that reception was enthusiastic approval, hesitant acceptance, or outright rejection. This fluid, unpredictable, give-and-take dynamic is precisely what kept the work vital. Even decades of rejection and neglect ended with a vigorous new lease on life at a turbulent moment in American (and European) history that in some respects mirrored that of the era when Robert Koehler planned and painted the work.

Although *The Strike* missed the Depression-era advances of organized labor, a world war against fascism, and much of the combat-plagued Cold War as it languished in obscurity in a Minneapolis library and museum storage room, it emerged into a rapidly changing postmodern world to experience a succession of quick-change associations before finding a home in a history museum in a reunited Berlin, as one link in the millennia of German history. But who could say what yet lay ahead for an enigmatic painting with such tenacious powers of survival and such a capacity for stirring radically divergent responses in successive generations of viewers and commentators?

Afterword

WITH HARDLY A WORD TO GO ON FROM ROBERT KOEHLER HIMSELF, the question of why he chose such an unheard-of subject for his diploma painting at a major European art academy still remains unresolved as this book reaches its close. What exactly motivated his defiance of classical tradition? Aside from what little he said in a newspaper interview concerning his attraction to the subject of striking industrial work-ers—that he was the son of a mill worker (when his father was actually a self-employed machinist); that he was inspired by the Great Railroad Strike of 1877—the artist himself offered few clues to his motivation.

Lacking direct testimony, we have looked at what might be termed internal evidence of Koehler's motivations in both *The Strike* and its immediate predecessor, *The Socialist*, supplemented by published reactions to these paint-ings arising from within their often unpredictable social and political surroundings. Such are the primary research materials of the art historian bent on probing the reception rather than the inception of a work of art. As a model practitioner of this interpretive approach, the cultural historian Simon Schama, unperturbed by the complete lack of written statements from Rembrandt, cleverly titled his lengthy book on the Dutch master's art and life *Rembrandt's Eyes*. Schama's analyses move from inside Rembrandt's pictures out into the world of Amsterdam and beyond—the world that helped determine the artist's style and subject matter, and which responded to his work both positively and negatively.

Whether Koehler himself completely approved of the explosive behavior of the impassioned orator in *The Socialist*, or of the workers' actions, especially those of the stone gatherer portrayed in *The Strike*, must remain similarly open to debate. In the case of *The Strike*, I would assume that he was on the side of the workers, with whom he claimed to feel "at home." On the other hand, since the painting's central figure, the assertive woman, Koehler's most consistent motif, appears to be advising caution, she could reflect the moderate, noncombative personality that he displayed throughout his life.

However that may be, this biography of a painting has sought to place its obscure genesis, its complex iconography, and its often perilous after-history within a succession of transnational social contexts fraught with economic, political, and class conflict. Coming from many directions and taking many different forms, these surges of political turbulence, social unrest, and labor activism surely fed into the painting's content and character, and shaped its role as a precedent-setting protest against labor exploitation and a potential inspiration to resist it.

The initial notoriety of *The Strike* may have resulted from fears (or hopes) that it represented a propagandistic incitement to violence. From a contemporary art-historical perspective, however, its continuing interest and prestige rest on the bold yet nuanced ways it surpassed preceding paintings of desperate and angry workers, and on its pathbreaking role in anticipating subsequent representations of oppressed people taking action to improve their situation. This lasting legacy comprises a vital component of the story of this memorable and enigmatic painting.

Notes

Introduction

1. Although dealing with a different time period, the essays in *Twenty-First Century Populism: The Spectre of Western European Democracy* (New York: Palgrave Macmillan, 2008), edited by Daniele Albertazzi and Duncan McDonnell, cast an illuminating light on such interactions.

2. James M. Dennis, *Grant Wood: A Study in American Art and Culture* (New York: The Viking Press, 1975; reprinted Columbia: University of Missouri Press, 1987); *Renegade Regionalists: The Modern Independence of Grant Wood, Thomas Hart Benton, and John Steuart Curry* (Madison: University of Wisconsin Press, 1998); Brady Roberts and James M. Dennis, "Grant Wood: An American Master Revealed," *American Art Review*, February–March 1996; Jane C. Melosch and James M. Dennis et al., *Grant Wood's Studio: Birthplace of "American Gothic"* (Munich, Berlin, London, New York: Prestel Publishing, 2005).

3. In Danto's conception of "artworld," or cultural context, a work of art by definition must reveal an attitude or viewpoint concerning its subject. It must, in short, convey its "aboutness." This historically rooted approach to the study of art, which I share, was launched by Arnold Hauser in 1951 with the first volume of his multivolume classic *The Social History of Art* (4 vols., 3rd ed., London and New York: Routledge, 1999). Along with Erwin Panofsky's iconological model, this approach stands in contrast to Heinrich Wölfflin's obsessive stylistic analysis, or, as Hauser dubbed it, "art history without names."

4. See also Donald Drew Egbert's *Socialism and American Art in the Light of European Utopianism, Marxism, and Anarchism* (Princeton: Princeton University Press, 1967); *Social Radicalism and the Arts of Western Europe: A Cultural History from the French Revolution to 1968* (New York: Alfred A. Knopf, 1970); and *Socialism and American Life*, coedited with historian Stow Persons (Princeton: Princeton University Press, 1952).

5. For a case study of the uses of art by a local union engaged in a mid-1980s strike against the Hormel meatpacking plant in Austin, Minnesota, see Peter Rachleff, "Art and Activism in the American Labor Movement," *Artpaper* 10, no. 8 (April 1991). Striking union members and supporters used colorful buttons, T-shirts, posters, and murals to build morale and publicize their cause. Citing this and other examples, Rachleff, a labor historian at Macalester College in Saint Paul, Minnesota, found evidence "of a renewed interest in the arts among grassroots union activists and a tentative rapprochement between some forces in the labor movement and the arts community." In 1991–92, the Center for the Study of Political Graphics in Los Angeles organized a traveling exhibit, "Solidarity Forever: Graphics of the International Labor Movement." See www.politicalgraphics.org. The Labor Heritage Foundation of Washington, D.C., organizes annual conferences promoting "labor arts and culture." Online at www.laborheritage.org. Both websites accessed January 17, 2010.

6. A few representative examples of a large body of scholarship: Carol Becker, ed., *The Subversive Imagination: Artists, Society, and Social Responsibility* (New York: Routledge, 1994); Murray Edelman, *From Art to Politics: How Artistic Creations Shape Political Conceptions* (Chicago: University of Chicago Press, 1995); Mark O'Brien and Craig Little, eds., *Reimagining America: The Art of Social Change* (Philadelphia: New Society, 1990); T. V. Reed, *The Art of Protest: Culture and Activism from the Civil Rights Movement to the Streets of Seattle* (Minneapolis: University of Minnesota Press, 2005); Claire Bishop, "The Social Turn: Collaboration and Its Discontents," *Artforum*, February 2006, 179–85.

Chapter 1. Koehler's Art Training

1. "The History of the Koehler Family," unpublished 36-page manuscript written by Marie Fischer Koehler in 1929, edited by Lee Baxandall, 4–5, 9–10, in Lee Baxandall estate, Oshkosh, Wisconsin.

2. Ibid., 13. Graetz would later die in combat in the Civil War.

3. Ibid., 14–15.

4. Gerald N. Grob, "The Workers' War for Economic Opportunity," *American Worklife*, April 1976, 12–13.

5. Robert C. Nesbit, *Wisconsin: A History*, 2nd ed. revised and updated by William F. Thompson (Madison: University of Wisconsin Press, 1989), 243–44; John Gurda, *The Making of Milwaukee* (Milwaukee: Milwaukee County Historical Society, 1999), 123–25.

6. Nesbit, *Wisconsin*, 328–31.

7. Melvyn Dubofsky and Foster Rhea Dulles, *Labor in America, A History*, 7th ed. (Wheeling, Ill.: Harlan Davidson, 2004), 81–82; Fred Albert Shannon, *America's Economic Growth* (New York: Macmillan, 1940), 506–8.

8. Dubofsky and Dulles, *Labor in America*, 92–99.

9. Nesbit, *Wisconsin*, 392–94; Gurda, *Making of Milwaukee*, 150–51.

10. Nesbit, *Wisconsin*, 388–89.

11. Gurda, *Making of Milwaukee*, 204–11; "Milwaukee Sewer Socialism," http://www.wisconsinhistory.org/turningpoints/tp-043/?action=more essay. Accessed September 7, 2009.

12. Lee Baxandall interview with Augusta Reineck, daughter of Koehler's sister Marie, October 10, 1970, Plymouth, Wisconsin, a typewritten manuscript in Lee Baxandall estate. Robert Koehler's sister Marie attended the somewhat more prestigious Peter Engelmann School, where Louise Koehler taught needlework and crocheting as part of its curriculum for girls.

13. Lydia Ely, "Art and Artists in Milwaukee," in *History of Milwaukee*, ed. Louis Conrad, 71–83 (Chicago and New York: American Biographical Publishing Company, 1895); Peter C. Merrill, "Henry Vianden: Pioneer Artist in Milwaukee," in *Yearbook of German-American Studies* (Lawrence, Kan.: Society for German American Studies, 1987), 137–47.

14. *Milwaukee Sentinel*, January 23, 1871, p. 4.

15. Robert Koehler, "Chapters from a Students Life," *Minneapolis Journal*, April 29, 1917, Amusement Section, p. 3.

16. Ibid.

17. *Milwaukee Sentinel*, July 25, 1876, p. 8.

18. Marie Koehler, "History of the Koehler Family," 20.

19. Robert Koehler, "Chapters from a Students Life," *Minneapolis Institute of Fine Arts Bulletin*, Midsummer, 1907, p. 11.

Chapter 2. Images of Women

1. "The History of the Koehler Family," unpublished 36-page manuscript written by Marie Fischer Koehler in 1929, edited by Lee Baxandall, 22–27, in Lee Baxandall estate.

2. Ibid., 25.

3. At some point the painting sustained serious damage and was destroyed at the request of the artist's son Edwin. See undated letter in the estate of Lee Baxandall.

Chapter 3. Koehler's First Worker Images and *The Socialist*

1. Winfrid Halder, *Innenpolitik im Kaiserreich, 1871–1914* (Darmstadt: Wissenschaftliche Buchgesellschaft, 2003), 49–51; Otto Pflanze, *Bismarck and the Development of Germany*, vol. 2 (Princeton: Princeton University Press, 1990), 392–93.

2. Agnete von Specht, "Maulkorb für Hund und Herrn" ("Muzzle for Dog and Man"), in Rosemarie Beier and Gottfried Korff, *Ausgewählte Objekte aus dem Deutschen Historisches Museum* (Berlin: Deutsches Historisches Museum, 1992), 182. All translations from German to English in this book are by the author.

3. This first principle of a proclamation to the working men of America was drawn up by the twenty-eight delegates, including Most, attending the Anarchist Congress in Pittsburgh in 1883.

4. Lyman Abbot, "Danger Ahead," *The Century Magazine* 3, no. 1 (November 1885), 51–60; "Robert Koehler's Success, Another Milwaukee Artist Meeting with Flattering Recognition," *Milwaukee Sentinel*, November 3, 1885, 2.

5. Karl Heinz Knoche, *The German Immigrant Press in Milwaukee* (New York: Arno Press, 1980), 176–83.

6. Seney was president of New York's Metropolitan National Bank, which failed in 1884 in a speculation involving a railroad project in Michigan's Upper Peninsula. The small town of Seney, Michigan, remains as a relic of the ill-fated venture.

7. Catalogue, Sale Conducted by the American Art Gallery from the Estate of Georg Seney, February 7–9, 1894, #72, New York Public Library. A notation on the New York Public Library's copy of the sale catalogue states that *The Socialist* was purchased by one John R. Dowling for $90.

8. Charlotte Whitcomb, "Robert Koehler, Painter," *Brush and Pencil* 9 (1901), 148.

9. *Montana: The Magazine of Western History*, Summer (1975), 26. On September 13, 1975, Lee Baxandall bought *The Socialist* from Robert Bahssin, owner of Post Road Antiques, Larchmont, New York. Bahssin had purchased it from an art restorer and dealer, Aart Drost of Mahopac, New York, who saw it lying on a chair at a small local auction, and after acquiring it for a song cautiously cleaned it down to its final coat of varnish. See unpublished typed "fact sheet" on *The Socialist*, in Lee Baxandall estate.

10. B. F. Rackly to Lee Baxandall, undated letter, in Lee Baxandall estate.

Chapter 4. Art Historical Background and the Railway Strike of 1877

1. Permanent locations of these works are Putnam County Historical Society, Cold Spring, New York (Weir); National Gallery, Berlin (Menzel); Maerkisches Museum, Berlin (Meyerheim); Georg Schaefer Collection, Schweinfurt, Germany (Lieberman).

2. Hubert Locher, *Die Malerei im 19. Jahrhundert* (Zurich: Primus Verlag AG, 2005), 78–81.

3. All the figures and precise details of their setting remain intact in the wood-engraved reproduction of the painting published in *Harper's Weekly*, August 30, 1884.

4. Robert V. Bruce, *1877, Year of Violence* (Chicago: Quadrangle Books, Inc., 1970), 74–75.

5. Jeremy Brecher, *Strike!* (Cambridge, Mass.: South End Press, 1997), 22–30; Melvin Dubofsky and Foster Rhea Dulles, *Labor in America: A History*, 7th ed. (Wheeling, Ill.: Harlan Davidson, 2005), 108–12.

6. Quoted in an interview with Robert Koehler in the *Minneapolis Journal*, March 23, 1901, sec. 2, p. 10.

Chapter 5. Influences Shaping *The Strike*

1. Richard V. West, Michael Quick, and Eberhard Ruhmer, *Munich and American Realism in the 19th Century* (E. B. Crocker Art Gallery, Cincinnati Art Museum, Milwaukee Art Center, 1978), 32.

2. Ibid., 34.

3. "Unsere Bilder," *Die Kunst für Alle* 2, no. 2 (March 1, 1887), 165, 172.

4. See "Ladies' Dress, 1880–1900," in *Victorian Dress in Photographs*, compiled by Madeleine Ginsburg (New York: Holmes and Meier, 1983), 52–98.

5. Henrietta M. Heinzen and Hertha Anneke Sanne, "Biographical Notes in Commemoration of Fritz Anneke and Mathilde Franziska Anneke," 1940, a two-volume manuscript in the Wisconsin Historical Society, Madison, Wisconsin.

6. Yvonne Mayer Kapp, *Eleanor Marx*, vol. 2: *The Crowded Years* (New York: Pantheon Books, 1976).

7. Roy Rydell, "International Women's Day: Remembering Clara Zetkin," *People's Weekly World*, March 7, 1998.

8. M. B. Stern, *We the Women* (New York: Schulte Publishing Co., 1963), chap. 4; Gloria Stevenson, "That's No Lady, That's Mother Jones," *American Worklife*, July 1976, 24–28; Joseph E. Gannon, "Mary Harris Jones: One Tough 'Mother,'" in three eight-page parts, *The Wild Geese Today-Erin's Far-Flung Exiles*, http://thewildgeese.com.

Chapter 6. Labor-History Context

1. Albert Parsons, "The Autobiography of Albert Parsons" (1887), in Philip S. Foner, ed., *The Autobiographies of the Haymarket Martyrs* (New York: Humanities Press, 1969), 3.

2. Ibid., 4.

3. Ibid., 7.

4. Ibid.; Lucy E. Parsons, "To Tramps," *Alarm*, Oct. 4, 1884.

5. *Minneapolis Journal*, March 23, 1901, section 2, 10.

6. *Milwaukee Herald*, August, 18, 1889, section 2, 1.

7. Quoted in an interview with Koehler in the *Minneapolis Journal*, March 23, 1901, section 2, 10.

8. *Geschichte der Sozialistischen Einheitspartei Deutschlands* 1 (Berlin: Institut für Marxismus-Leninismus, 1988), 409–14.

9. *Berliner Tageblatt* 223, May 4, 1886, 3.

10. *Berliner Volksblatt* 103, May 4, 1886, 3.

11. Parsons, "Autobiography," 8.

12. *Berliner Volksblatt* 132, June 9, 1886, 1.

13. "Rache! Arbeiter, zu den Waffen! Eure Herren haben inre Bluthunde, die Polizei, ausgesandt. Diese hat heute nachmittag bei der McCormick'schen Fabrik sechs eurer Brüder getödtet . . . Zu den Waffen! Wir rufen Euch zu den Waffen! Eure Brüder! Rache!" Quoted in David Roediger and Franklin Rosemont, eds., *Haymarket Scrapbook* (Chicago: Charles H. Kerr, 1986), 14, and James Green, *Death in the Haymarket* (New York: Anchor Books, Random House, 2006), 171.

14. As quoted in the *Allgemeine Zeitung* 128, Munich, May 9, 1886, 4.

15. *Volks-Zeitung* 106, Berlin, May 7, 1886, 3.

16. As quoted in the *Allgemeine Zeitung* 128, Munich, May 9, 1886, 4.

17. *Berliner Volksblatt* 132, June 9, 1886, 1.

18. *Allgemeine Zeitung* 128, Munich, May 8, 1886, 6.

19. *Berliner Volksblatt* 132, June 9, 1886, 2. Among the dead were a retired worker observing the event from his backyard and a thirteen-year-old boy home from school. See the detailed account in John Gurda, *The Making of Milwaukee*, 153–54.

20. *Allgemeine Zeitung* 128, Munich, May 18, 1886, 6.

21. *Allgemeine Zeitung* 132, Munich, May 13, 1886, 5.

22. *Berliner Tageblatt* 225 and 240, May 5 and May 13, 1886, 1.

23. *Berliner Tageblatt* 264, May 27, 1886, 1.

24. *Vossische Zeitung* 256, Berlin, June 4, 1886, 1.

25. Michael Schwab was a brother of the equally prominent anarchist Justus Schwab, leader of the most revolutionary element of anarchism in America. In spite of Lucy Parsons's call for the use of explosives at the end of her "To Tramps" article, her gender saved her from the fate of her husband and his friends.

26. *Tägliche Rundschau* 109, Berlin, May 11, 1886, 2.

27. "Wochenschau," *Berliner Arbeiter-Freund* 48, November 25, 1887, 211.

28. *Allgemeine Zeitung* 128, Munich, May 9, 1886, 4.

29. *Berliner Volksblatt* 132, June 9, 1886, 2.

30. *Vossische Zeitung* 212, *Beilage*, Munich, May 7, 1886, 5; *Deutsches Tageblatt* 124, Berlin, May 8, 1886, 1.

31. "Über die Wirtschaftlichen Zustände in Nordamerika," *Berliner Volksblatt* 101, May 1, 1886, *Beilage zum Berliner Volksblatt*, 1; and "Die Ritter der Arbeit," *Allgemeine Zeitung* 128, May 9, 1886, 1–2.

32. "Arbeitersfrage in den Vereinigten Staaten," *Allgemeine Zeitung* 124, Munich, May 5, 1886, 1.

33. Ibid.

34. *Allgemeine Zeitung* 152, Munich, June 2, 1886, 1. This same dispatch was also carried by other German papers, including Berlin's *Vossische Zeitung* and the *Tägliche Rundschau*.

35. *Berliner Volksblatt* 132, June 9, 1886, 2.

36. Ibid.

37. As quoted in the *Vossische Zeitung* 212, *Beilage*, Berlin, May 7, 1886, 5.

38. *Volks-Zeitung* 106, May 7, 1886, 2.

Chapter 7. A Strikebound Debut, a Conflicting Reception, a Paris Interlude

1. Charles M. Kurtz, *National Academy Notes and Complete Catalogue* (New York, 1886), 103.

2. Ibid.

3. *New York Daily Tribune*, April 3, 1886, 4–5.

4. *New York Times*, April 4, 1886, 4.

5. Ibid.

6. Kenyon Cox, "The National Academy Exhibition," *The Nation* 42 (April 8, 1886), 305.

7. *Harper's Weekly*, April 10, 1886, 235.

8. "Robert Koehler's Success, Another Milwaukee Artist Meeting with Flattering Recognition," *Milwaukee Sentinel*, November 3, 1885, 2.

9. *Harper's Weekly*, April 10, 1886, 235.

10. *New York Times*, April 25, 1886, editorial page.

11. *New York Daily Tribune*, April 26, 1886, editorial page.

12. "The Academy Exhibition, Second Notice," *New York Daily Tribune*, May 3, 1886, 1.

13. *Illustrirte Zeitung* 2243, Leipzig and Berlin, vol. 86, June 26, 1886, 635.

14. *Deutsche Illustrirte Zeitung* 3, no. 7 (1886), 148 and 149.

15. "Meisterholzschnitten Nach Gemälden und Skulpturen Berühmter Meister der Gegenwart," *Moderne Kunst*, vol. 1, 68 (Berlin: Richard Bong Verlag, 1887), 37–38.

16. Ibid. The misidentification of Koehler's factory workers as Belgian miners persists to this day. The wood engraving of *The Strike* by H. Gedan in Charleroi's Municipal Museum of Fine Arts bears the title: *La Greve au pays de Charleroi*.

17. Letter from Robert Koehler addressed "Dear Sir" and dated Munich, September 1, 1887, microfilm no. D187, frame 0190, Archives of American Art, Smithsonian Institution, Washington, D.C.

18. Robert Koehler to Sylvester Rosa Koehler, New York City, November 12, 1887, microfilm no. D187, frame 0197, Archives of American Art, Smithsonian Institution, Washington, D.C.

19. J. McNeill Whistler, London, to Secretary of the American Section, International Exhibition, Munich, March 31, 1888. A copy of this letter is in the Lee Baxandall estate. For his efforts in organizing the American Section at Munich's 1888 International Exhibition, Koehler was awarded the Cross of the Order of Saint Michael by Prince Regent Leopold of Bavaria.

20. Friedrich Pecht, "Die Münchner Ausstellungen non 1888: Part IV: Nord-Amerika," *Die Kunst für Alle* 3, no. 23 (September 1, 1888), 355–56. The first mention of art in the United States by Pecht's periodical, in the December 15, 1885, issue, reported the laying of a cornerstone for a Schiller Monument in Chicago's Lincoln Park on November 11. Seven months later, an ongoing column, "Exhibitions, Collections, etc.," announced the monument's unveiling, with Mayor Carter G. Harrison officiating. The bronze statue had been cast in Stuttgart. The entire cost of the project, $12,000, was raised by German immigrants. The column made no mention of any post-Haymarket turmoil. *Die Kunst für Alle* 1, no. 20 (July 15, 1886), 294.

21. *Die Gesellschaft* 2, no. 38 (October, 1888), 816–19.

22. Frank A. Bridgman to Robert Koehler, Paris, June 26, 1889, in Carl W. Jones Papers, Division of Library and Archives, Minnesota Historical Society, Minneapolis.

23. E. J. Becker to Robert Koehler, Milwaukee, May 10, 1889, in Carl W. Jones Papers.

24. Designed by the Audsley Brothers of England, the Layton Art Gallery opened in April 1888.

25. Becker to Koehler, May 10, 1889. Thirty-four letters of 1888–90 pertain to the Milwaukee Industrial Exposition Association's acquisition of *The Strike* for its 1889 exhibition and its attempt to raise funds to purchase the painting for the Layton Art Gallery. The

letters were donated to the Minnesota Historical Society by Helen Jones, the widow of Koehler's former student Carl W. Jones, in 1957. They had been given to Jones in 1927 by Koehler's widow Marie.

26. W. B. Franklin to Robert Koehler, Paris, June 3, 1889, in Carl W. Jones Papers.

27. Robert Koehler to W. B. Franklin, Munich, June 14, 1889, in Carl W. Jones Papers.

28. Robert Koehler, Munich, to Rush C. Hawkins, June 24, 1889, in Carl W. Jones Papers.

29. Frank A. Bridgman to Robert Koehler, Paris, June 26, 1889, in Carl W. Jones Papers.

30. Robert Koehler to M. Berger, Munich, July 20, 1889, in Carl W. Jones Papers.

31. M. Berger to General W. B. Franklin, Paris, July 26, 1889, in Carl W. Jones Papers.

32. Office of General Rush C. Hawkins to Robert Koehler, Paris, July 30, 1889, in Carl W. Jones Papers.

33. Michel & Kimbel to Robert Koehler, Paris, August 11, 1889, in Carl W. Jones Papers.

34. Michel & Kimbel to Robert Koehler, Paris, August 21, 1889, in Carl W. Jones Papers.

35. E. J. Becker to Robert Koehler, Milwaukee, August 22, 1889, in Carl W. Jones Papers.

36. Rush C. Hawkins to Robert Koehler, Paris, August 28, 1889, in Carl W. Jones Papers. The award, from the "Republique Francaise, Ministere du Commerce, de l'Industrie et des Colonies," is designated "Groupe 1 Classe 1" and, dated Paris, September 29, 1889. It is signed by the Director General of the Exposition, G. Berger, and by "Le President du Conseil Commissaire," S. Chiran.

37. "The History of the Koehler Family," unpublished 36-page manuscript written by Marie Fischer Koehler in 1929, edited by Lee Baxandall, in Lee Baxandall estate. George Inness, who had works accepted into the art exhibitions of every Paris Exposition to date and whom Koehler would praise in print four years later, received a gold medal for his regionalist landscape, *A Short Cut to Watchung Station, New Jersey*. For a general history of French views of American art in these years, in particular of American artists who studied in Paris, see H. Barbara Weinberg, *The Lure of Paris: Nineteenth-Century American Painters and Their French Teachers* (New York: Abbeville Press, 1991).

Chapter 8. Milwaukee and the Chicago World's Fair

1. *Milwaukee Herold*, August 18, 1889, second section, 1.

2. Ibid.

3. Ibid.

4. Ibid.

5. "Bay View Labor Riot of 1886," *Milwaukee Free Press*, July 3, 1910.

6. Ibid.

7. See Wisconsin Bureau of Labor and Industrial Statistics, *Biennial Reports* for 1885–86, 319–34, and *Milwaukee Journal*, May 3 to May 7, 1886.

8. "Eine Riesen-Demonstration," *Milwaukee Volksblatt* 4, no. 22, May 29, 1886, 1.

9. "Milwaukee Had Its Own Haymarket Square Struggle," *Milwaukee Labor Press* (an AFL-CIO publication), special section on Bay View massacre, April 24, 1986, 12.

10. "Bay View Labor Riot of 1886," *Milwaukee Free Press*, July 3, 1910.

11. This domed and turreted building, erected in 1881 on the site of the present Auditorium Building, was destroyed by fire in 1905.

12. "It Is Now in Place, Robert Koehler's Picture 'The Strike' Arrives," *Milwaukee Sentinel*, September 10, 1889, 1.

13. Ibid.

14. Ibid. Immediately adjoining this article, a short notice of the London dockworkers' strike further illuminates the painting's immediate context. Headlined "Wharfingers Yielding," it reported that while some dock-company directors were refusing to negotiate, some wharfingers (i.e., wharf owners or managers) had signaled a willingness to grant the strikers sixpence more an hour. Work had resumed at some wharves, the article continued, but churches were continuing to solicit relief funds for the families of dockworkers who were still on strike. *Milwaukee Sentinel*, September 10, 1889, 1.

15. Marie Koehler's later claim that after the Milwaukee exhibition her husband returned the painting to the Paris International Exposition "where the sketch had meanwhile been" seems highly unlikely since the Paris exposition was scheduled to close in a matter of weeks, on November 6, 1889. Marie Koehler, "The History of the Koehler Family," unpublished 36-page manuscript written in 1929, edited by Lee Baxandall, 1973, in Lee Baxandall estate.

16. See Sally M. Miller, *Victor Berger and the Promise of Constructive Socialism, 1910–1920* (Westport, Conn.: Greenwood Press, 1973).

17. Paul Krause, *The Battle for Homestead, 1890–1892: Politics, Culture, and Steel* (Pittsburgh: University of Pittsburgh Press, 1992), 19–41.

18. Moses, Handy, Chief, *Catalogue, Department of Fine Arts, Department of Publicity and Promotion* (Chicago: W. B. Conkey Co., 1893).

19. Five other juries of acceptance, located in Philadelphia, Boston, Paris, Munich, and Rome, decided which oil paintings by American artists unassociated at the time with New York should be included for exhibition.

20. *The Tribune Monthly* 5, no. 9, September 1893.

21. Robert Koehler himself, in a three-part article assessing the development of the fine arts in the United States published in Friedrich Pecht's Munich art magazine *Die Kunst für Alle*, commented on the American paintings exhibited at the Chicago World's Fair. He especially praised George Inness and a relatively obscure Massachusetts farmer-painter, George Fuller, for the originality of their latest paintings, particularly their blurred landscape forms. Their mysterious illusions of light, he argued, resembled French Impressionism without being directly derivative of it. Robert Koehler, "Die Entwicklung der Schönen Künste in den Vereinigten Staaten von Nord-Amerika," *Die Kunst für Alle* 8, no. 15, May 1, 1893, 225–33; no. 16, May 15, 1893, 241–46; no. 17, June 1, 1893, 257–59.

22. "Blutige Schlacht, Die Striker treffen mit einer Scheriffs 'Posse' zusammen," *Abendpost*, Chicago, 5, no. 137, June 10, 1893, 1; "Aus Lemont," ibid., no. 141, June 15, 1893, 1.

23. "Altgelds Begnadigungsschrift," *Abendpost*, Chicago, 5, no. 151, June 27, 1893, 3.

24. *Chicago Tribune*, June 27, 1893, 3.

25. Howard Zinn, *A People's History of the United States, 1492–Present* (New York: HarperCollins, 2005), 277.

26. Purchased by the wife of a Milwaukee brewer, *The Flagellants* was displayed in the Milwaukee Public Library and then for many years in the Milwaukee Auditorium. In 1975 it went to the West Bend Gallery of Fine Arts, West Bend, Wisconsin, where it still hangs.

27. John Sartain, ed., *World's Masterpieces of Modern Painting: Selected from the World's Columbian Exposition at Chicago and Other Great Art Exhibitions of All Nations* (Philadelphia: William Finley, 1893).

28. Ripley Hitchcock, ed., *The Art of the World, Illustrated in the Paintings, Statuary, and Architecture of the World's Columbian Exposition*, I (New York: D. Appleton & Co., 1895), 93. Beneath the description of *The Strike*, an error-filled biographical note reported that Koehler was born in Bavaria, studied in Düsseldorf, arrived in the United States in 1881, and taught painting classes for several years at the Boston Institute of Fine Arts. In May 1894, the Chicago art periodical *The Graphic* had also run an illustration of *The Strike* followed by a brief profile of Koehler. It began with an ambivalent compliment: "[*The Strike's*] timeliness in these days of frequent industrial disturbances, and the graphic manner in which the artist tells the story of the trouble at the great mill, proclaim the painting as one of unusual power." "Art and Artists: Robert Koehler," *The Graphic*, May 5, 1894, 356.

29. Koehler's *The Socialist* was reproduced in the *Pionier: Illustrierter Volks-Kalender* three years later.

30. *Minneapolis School of Fine Arts Catalogue*, Minneapolis, 1892.

Chapter 9. Transatlantic Progeny and a Minneapolis Refuge

1. From the files of the Minneapolis School of Fine Arts, Minneapolis, Minnesota.

2. *On Strike*, like Koehler's *The Strike*, served as Herkomer's diploma painting upon his election to full membership in the Royal Academy, London, which still owns it.

3. Aurora Scotti, *Pellizza da Volpedo, Catalogo generale* (Milan, 1986), 412.

4. Hans Kollwitz, ed., *The Diaries and Letters of Käthe Kollwitz*, translated by Richard and Clara Winston (Evanston, Ill.: Northwestern University Press, 1988), 39–50.

5. Signed "Th Esser," dated "92," and inscribed "Krhe," the painting was purchased in Germany in 1912 by University of Wisconsin professor Paul Reinsch, who exhibited it that fall at the Wisconsin State Historical Society in Madison. In 1913 Reinsch sold the painting to William C. Brumder of Chicago, who, in turn, donated it to the University of Wisconsin. It suffered from neglect, and in 1984 the university's Elvehjem Museum (now the Chazen Museum) sent it to a conservation laboratory. Restretched, cleaned, and revarnished, it remains one of the museum's favorite attractions.

6. Hajo Holborn, *A History of Modern Germany, 1840–1945* (Princeton, N.J.: Princeton University Press, 1982), 354–57.

7. Otto Pflanze, *Bismarck and the Development of Germany*, vol. 3 (Princeton, N.J.: Princeton University Press, 1990), 401.

8. "The History of the Koehler Family," unpublished 36-page manuscript written by Marie Fischer Koehler in 1929, edited by Lee Baxandall, 27–29, in Lee Baxandall estate.

9. Ibid.

10. Harlow Gale, "Robert Koehler and the Art League," a four-page tribute printed at the time of Koehler's death in 1917. Minnesota Historical Society, Minneapolis.

11. Marie Koehler, "History of the Koehler Family," 29–34.

12. "A Retrospective Exhibition of Robert Koehler," *Minneapolis Journal*, November 10, 1900, part II, 1.

13. The University of Minnesota School of Pharmacology commissioned Koehler to paint portraits of five of its faculty members, including one of his good friend and patron Frederick J. Wulling, dean of the school.

14. Janet Whitmore, "Presentation Strategies in the American Gilded Age: One Case Study," *Nineteenth-Century Art Worldwide. A Journal of Nineteenth Century Visual Culture* 3, no. 2 (Autumn 2004). Online at http://www.19thc-artworldwide.org/autumn_04/whit .shtml. Accessed November 8, 2009.

15. Karl Eugen Schmidt, "Die Arbeiter in der bildenden Kunst," *Pionier*, 1907, 72–78.

16. Edward Bellamy, "The Strikers," in *Equality* (New York: D. Appleton and Co., 1897), 206–11.

Chapter 10. Ambiguous Purchase and Gradual Obscurity

1. Robert Koehler to John W. Beatty, March 3, 1900, Archives of American Art, Smithsonian Institution, Washington, D.C. *Minneapolis Journal*, January 27, 1900, 10, reported: "Robert Koehler gave a lecture on 'James McNeill Whistler and His Works' in the university chapel last evening. Mr. Koehler shared a number of personal anecdotes and illustrated his talk with stereopticon views of paintings and etchings by Whistler."

2. See "Impressionism in Painting," *Minneapolis Journal*, January 27, 1902, 10, reporting on a lecture by Robert Koehler the previous evening in the Public Library art gallery to "a large audience of cultivated people."

3. *Minneapolis Journal*, April 12, 1913, 9.

4. He had already written to Walter Pach at the Art Institute on April 15 with the same two requests. Copies of these letters are in the estate of Lee Baxandall.

5. "Last Day of the Art Exhibition, Examples of Modern Radicals Used as Subject of Koehler Lecture," *Minneapolis Journal*, March 1, 1914, section 2, 6. A nine-page typescript of Koehler's "post-impressionist, cubist" lecture is in the estate of Lee Baxandall.

6. Two days before the opening, *Minneapolis Journal* ran a feature article about the retrospective exhibition with four illustrations of Koehler's paintings, including *The Strike*, and a photograph of his Portland Avenue house, "Waldheim." "A Retrospective Exhibition of Robert Koehler," *Minneapolis Journal*, November 10, 1900, part 2, 1.

7. William Watts Folwell, *Exhibition and Sale of Paintings, Drawings, and Etchings, the Works of Robert Koehler* (Minneapolis: John S. Bradstreet & Co., 1900), preface.

8. "A Timely Suggestion," *Minneapolis Journal*, December 8, 1900, 11. As *The Strike* received no award at the Chicago World's Fair, Folwell may have meant the 1889 Paris Exposition where it was awarded an Honorable Mention.

9. *Minneapolis Journal*, March 31, 1901, part 2, 10.

10. Charlotte Whitcomb, "Buy Koehler's Masterpiece, The Project of Purchasing Robert Koehler's Best Painting, 'The Strike,' Meets with General Approval," *Minneapolis Journal*, March 23, 1901, part 2, 10. In contemporary buying power, the $3,000 purchase price would be the equivalent of around $80,000 today. For references to the origin of the subscription list see brief articles in the *Minneapolis Journal*, March 9, 1901, 8; March 16, 6; and March 31, part 2, 10.

11. Charlotte Whitcomb, "Subscriptions Asked for the Purchase of Koehler's 'The Strike,'" *Minneapolis Journal*, April 18, 1901, 7. The men were J. S. Bradstreet, L. B. Chute, and Robert T. Giles. The women were Mrs. C. C. Bovery, Mlle. H. Clopath, Mrs. C. L. Crocker, Mrs. John Crosby, Miss DeLaittre, Mrs. P. C. Deming, Mrs. J. M. Greaves, Miss Nellie Heffelfinger, Mrs. C. S. Marshall, Miss Kate Moulton, Miss Bonnie E. Snow, Mrs. S. C. Tooker, Mrs. Vrooman Wood, Miss Prudence Wyman, and Charlotte Whitcomb.

12. Charlotte Whitcomb, "Robert Koehler, Painter," *Brush and Pencil* 9, no. 3, December 1901, 144–53. Subsequent quotations are also from this article. The "sketch" to which Whitcomb refers may have been a lost preparatory drawing or the finished "sketch" that replaced the painting at the 1889 Universal Exposition in Paris. Unless a more respectful "cap in hand" version was a figment of Whitcomb's imagination, perhaps a description of it came to her word-of-mouth from the artist himself.

13. William Millikan, *A Union against Unions: The Minneapolis Citizens Alliance and Its Fight against Organized Labor, 1903–1947* (Saint Paul: Minnesota Historical Society Press, 2001), 270–78.

14. *Catalogue of Paintings and Sculpture Placed in the Minneapolis Public Library* (Minneapolis, Minnesota, 1909), 116–17.

15. *Minneapolis Journal*, December 12, 1910, 16. See also *Catalogue, Third Exhibition, Oil Paintings of Contemporary American Artists, December 13, 1910–January 22, 1911* (Washington, D.C.: The Corcoran Gallery of Art), number 222.

16. *Minneapolis Journal*, May 13, 1912. This painting was in the collection of Mrs. Florence Koehler, widow of the artist's son, Edwin, South Fork, Colorado.

17. Undated interview with Arnold Blanch, Archives of American Art, Smithsonian Institute, Washington, D.C.; *Grove Dictionary of Art* online Research Library, http://www.artnet.com/library/02/0285/T028522.asp, accessed September 26, 2009 (John Flannagan); "Harry Gottlieb Is Dead; W.P.A. Artist Was 98," *New York Times*, July 8, 1992.

18. Alma Scott, *Wanda Gág: The Story of an Artist* (Minneapolis: University of Minnesota Press, 1949), 93, 126–27, 142.

19. Transcript from an interview of G. Sidney Houston, business manager of the Minneapolis Society of Fine Arts from 1915 to 1930, by Lee Baxandall, in the Lee Baxandall estate.

20. George S. Vincent to Robert Koehler, January 3, 1916, in Carl W. Jones Papers.

21. A typed "Announcement" to be sent to the *Minneapolis Journal, Tribune*, and *Daily News*, from files of the Secretary to the Director, Minneapolis School of Art, January 1917.

22. Milliken, *A Union against Unions*, 95–97.

23. Ibid., 98–101.

24. Ibid., chap. 8, "The Minnesota Coup," 102–23.

25. Gladys M. Hamblin, "Loss Comes to Art Community through Death of Koehler," *Minneapolis Tribune*, April 29, 1917.

26. Harlow Gale, "Robert Koehler and the Art League," in the Lee Baxandall estate.

Chapter 11. Rescue, Restoration, and Return to New York City

1. "Friends Here Honor Robert Koehler by Art School Tablet," *Minneapolis Journal*, January 2, 1927. Charles S. Wells of the Art School created the relief tablet; its walnut frame was designed and carved by another friend, Mrs. A. E. Helmick.

2. Handwritten letter from Mrs. Robert Koehler to Karl W. Jones, Journal Building, Minneapolis, dated September 12, 1927. The letter was sent from Edwin Koehler's address: 2100 East 33rd Street, Kansas City, Missouri. A Xeroxed copy is in the estate of Lee Baxandall.

3. Mrs. Ellen Peterson Langguth to Lee Baxandall, February 18, 1975, in Lee Baxandall estate. Langguth refers to her recent phone conversation with Margaret Mull, retired "chief" librarian from the Central Library, who "reported that to her knowledge 'The Strike' was hanging in the old Central Library in 1932 when she worked there."

4. Frederick J. Wulling to Ruth Thompson, Minneapolis Public Library, May 30, 1946. Since Koehler's large painting was in storage at the library, Thompson must have indeed seen it. Typed transcript of originally handwritten letter is in the estate of Lee Baxandall.

5. *The World This Week*, *Montana Standard*, Sunday, June 2, 1946.

6. Melvyn Dubofsky and Foster Rhea Dulles, *Labor in America, A History*, 7th ed. (Wheeling, Ill.: Harlan Davidson, 2005), 259–61, 268–70.

7. Ibid., 285–87.

8. Ibid., 349–52.

9. Ibid., 292–93.

10. Directly beneath the outstretched arm holding back a revolver-armed cop appears Evergood's self-portrait head. His right hand comforts his forehead, seemingly struck by the billy club above it. Although not an altogether unusual way of signing a narrative painting, perhaps Evergood meant in this case to reflect his recent presidency of the Artists Union. At any rate, he was not in Chicago during the strike against Republic Steel.

11. Henry Nash Smith, ed., *Popular Culture and Industrialism, 1865–1890* (New York: New York University Press, 1967), 330–31.

12. Jim Jones, "Library, 'Overrun' with Art Works, Plans Sale," *Minneapolis Star*, April 18, 1969, 1B. The appraisal, costing $100, was to be made by the Beard Art Galleries, 1006 Nicollet Avenue. The library had moved to a new building in 1931.

13. Lee Baxandall, "New York Meets Oshkosh," in Paul Buhle, ed., *History and the New Left: Madison, Wisconsin, 1950–1970* (Philadelphia: Temple University Press, 1990), 127–28. Wrote Baxandall of the 1951 White House visit: "There I was, sixteen years old, shaking hands with Harry Truman, who didn't look me in the eyes. That bothered me." In this memoir Baxandall also mentions that through Scouting he first experienced "skinny dipping." A leader in the nudist movement later in life, he founded The Naturist Society in 1980 and published its quarterly magazine.

14. Baxandall, "New York Meets Oshkosh," 129–33.

15. Lee Baxandall, *Marxism and Aesthetics: A Selective Annotated Bibliography* (New York: Humanities Press, 1968); Lee Baxandall, ed., *Radical Perspectives in the Arts* (Harmondsworth, Eng.: Penguin Books, 1972); Lee Baxandall and Sefan Morawski, eds., *Marx & Engels on Literature & Art* (Saint Louis/Milwaukee: Telos Press, 1973).

16. Baxandall, *Radical Perspectives in the Arts*, 12.

17. Stefan Morawski, Introduction, in Baxandall and Morawski, *Marx & Engels on Literature & Art*, 6, 8, 46.

18. "Workers' Power," *The New Foundation* 2, no. 1, January–February, 1970, 16.

19. Anthony M. Clark to Lee Baxandall, June 4, 1970, in Lee Baxandall estate.

20. Samuel Sachs II to Lee Baxandall, September 3, 1970, with attached Polaroid print, in Lee Baxandall estate.

21. Another subscriber to publish the illustrated article, the *Community College Social Science Quarterly*, Grossmont College, El Cajon, California, featured it in the Summer 1971 issue dedicated to "Revolution."

22. "Robert Koehler: Painter of the People," *Milwaukee Kaleidoscope*, May 3, 1971.

23. Typed notes of Baxandall's visit to the Minneapolis Institute of Arts, May 1971, in Lee Baxandall estate.

24. Garnett McCoy to Lee Baxandall, June 9, 1971, and Lee Baxandall to Garnett McCoy, June 14, 1971, accompanied by a color snapshot of the painting, in Lee Baxandall estate.

25. Lee Baxandall to Philip Mason, undated letter, in Lee Baxandall estate.

26. Philip Mason to Lee Baxandall, July 6, 1971, in Lee Baxandall estate.

27. Joseph E. Walton to Lee Baxandall, August 16, 1971, August 24, 1971, and October, 5, 1971; Joseph E. Walton to Barrett-Dawn Moving & Storage, October 5, 1971; Lee Baxandall to Joseph E. Walton, August 21, 1971; letters in Lee Baxandall estate.

28. Invoice, Julius Lowy Frame & Restoring Company, Incorporated, 511 East 72nd Street, New York, N.Y., April 28, 1972, in Lee Baxandall estate.

29. The Rincon Post Office mural was commissioned by the Section of Fine Arts of the Public Building Administration, a New Deal program of the U.S. Treasury Department. The building, ironically, is now part of a shopping center topped by 320 luxury apartments.

30. The union's membership was 70 percent female and roughly 60 percent black, 20 to 30 percent white, and 10 to 15 percent Hispanic.

31. "Moe Foner, Labor Official and Movement's Unofficial Cultural Impresario, Dies at 86," *New York Times*, January 11, 2002. Foner was the uncle of the well-known American historian Eric Foner. The phrase "Bread and Roses" dates from the 1912 Lawrence, Massachusetts, textile strike when some female strikers, according to legend, carried signs that said: "We want bread, but we want roses, too."

32. "A Painting Long Believed Lost Is Found by Persistent Art Historian," *New York Times*, Sunday, November 12, 1972. The article inaccurately states that Koehler was raised in Minnesota and that *The Strike* "is believed to be the first painting of an industrial dispute in the United States" rather than the first of such depiction anywhere in the world.

33. *1199 News* 7, no. 11, November 1972, 15–17.

Chapter 12. Labor-Union Patronage, Museum Exhibitions, and National Fame

1. "Working Class Art—Reborn and Newborn," *The Daily World, World Magazine*, November 25, 1972, M-12.

2. *UTU News* 4, no. 48, December 16, 1972, 8.

3. Moe Foner to Lee Baxandall, December 21, 1972, in Lee Baxandall estate.

4. "City Library Lets Historic Painting Slip Away," *Minneapolis Labor Review* 39, no. 607, December 21, 1972, 16.

5. Oliver Jensen to Lee Baxandall, December 21, 1972, in Lee Baxandall estate.

6. Ralph W. Miller to Lee Baxandall, December 28, 1972, in Lee Baxandall estate.

7. Philip Mason to Lee Baxandall, January 8, 1973, in Lee Baxandall estate.

8. "Draft of Story for Soviet Mag. Ogonek," Anton Refregier, Woodstock, New York, three-and-one-half typed pages accompanying a note to Lee Baxandall, January 15, 1973, in Lee Baxandall estate. Over two years later, Refregier reported that the article had indeed appeared in *Ogonek*, but does not say in which issue. Anton Refregier to Lee Baxandall, July 14, 1975, in Lee Baxandall estate.

9. Lee Baxandall to Anton Refregier, January 24, 1973, copy of letter in Lee Baxandall estate.

10. A flyer sent out by Local 1199 in September 1973, labeled "Color reproduction of famous painting available," shows *The Strike* printed in blue above an order form. It indicates that the poster was 28 ½ inches by 20 ¼ inches and printed on "coated paper."

11. Henry Lowenstern to Moe Foner, December 7, 1972, in Lee Baxandall estate.

12. John F. Dolan to Henry Lowenstern, June 21, 1973, in Lee Baxandall estate.

13. Irving Sloan, "The Treatment of Labor," *American Teacher*, October 1973, 18.

14. Ralph Scharnau, "Elizabeth Morgan, Crusader for Labor Reform," *The New York Teacher*, magazine section, October 1973.

15. Richard N. Gregg to Lee Baxandall, October 31 and November 21, 1973, in Lee Baxandall estate.

16. Patricia Hills to Lee Baxandall, June 13, 1972, in Lee Baxandall estate.

17. Patricia Hills to Lee Baxandall, January 11, 1974, in Lee Baxandall estate.

18. Patricia Hills, *The Painter's America: Rural and Urban Life, 1810–1910* (New York: Praeger-Whitney Museum, 1974), 123. In addition to Moran's painting of slaves escaping through the wilderness, the exhibition included Eastman Johnson's *A Ride for Liberty—The Fugitive Slaves*, also from 1863, and Theodor Kaufmann's *On to Liberty*, 1867, of fugitive women and children entering a valley of freedom toward the rising sun.

19. Hilton Kramer, "Art: Social History of a Century," *New York Times*, September 21, 1974, 24.

20. Lawrence Alloway, "ART," *The Nation*, November 2, 1974, 445–46.

21. Jean B. Grillo, "Strike Painting, Socialism Comes to the Whitney," *The Village Voice*, December 2, 1974, 98.

22. Peter Ackerberg, "Library Painting Gains Recognition," *Minneapolis Star*, February 7, 1975, 1A–4A.

23. Rena N. Coen to Lee Baxandall, March 7, 1975, in Lee Baxandall estate; Rena Neumann Coen, *Painting and Sculpture in Minnesota, 1820–1914* (Minneapolis: University of Minnesota Press, 1976).

24. Lee Baxandall to Rena N. Coen, March 15, 1975, copy of letter in Lee Baxandall estate.

25. A Bicentennial Exhibition of Minnesota Art Checklist. Baxandall later presented the Philip Little portrait of Koehler to the Minnesota Art Institute.

26. Celestine Dars to Lee Baxandall, February 8, 1976, in Lee Baxandall estate.

27. Lee Baxandall to Charles Parkhurst, October 15, 1976, copy of letter in Lee Baxandall estate.

28. Earl A. Powell III to Lee Baxandall, January 3, 1977, in Lee Baxandall estate.

29. Earl A. Powell III to Lee Baxandall, February 1, 1977, in Lee Baxandall estate.

30. Lee Baxandall to Moe Foner, March 16, 1977, in Lee Baxandall estate.

31. Lee Baxandall to Earl A. Powell III, March 17, 1977, copy of letter in Lee Baxandall estate.

32. Earl A. Powell III to Lee Baxandall, June 16, 1977, in Lee Baxandall estate.

33. Earl A. Powell III to Lee Baxandall, August 16, 1977, in Lee Baxandall estate.

34. Abigail Booth Gerdts, Coordinator, "The Working American," to Moe Foner, April 25, 1979, copy of letter in Lee Baxandall estate.

35. Alloway, "ART," 600.

36. Carter Ratcliff, "Packaging the American Worker," *Art in America*, February 1980, 14–15.

37. "One Labor Union's Unique Tribute to the Working American," *American Heritage*, June/July 1980, 8, 17. Smaller black-and-white reproductions of *The Strike* accompanied innocuous accounts of the exhibition in the University of Rochester's *Gallery Notes*, the *School Arts Magazine*, and several other publications.

38. Nicolaus Mills, "The Working American, an Overlooked Vision," *Commonweal*, March 28, 1980, 184–85.

39. Michael Hopkins, "Art Show Is Not All Work," *News Tribune*, Woodbridge, New Jersey, September 19, 1980.

40. Paul Von Blum, *The Critical Vision: A History of Social and Political Art in the United States* (Boston: South End Press, 1982), 18.

41. Governor Dick Thornburgh to Lee Baxandall, May 24, 1982, in Lee Baxandall estate.

Chapter 13. Germany Reclaims a National Treasure

1. The Neue Gesellschaft für Bildende Kunst (N.G.B.K.), a nonprofit association in Berlin, was cofounded in 1969 by Katrin Sello, the daughter of a well-known art critic and a left-wing activist, with an exclusive focus on politically engaged art.

2. Lee Baxandall to Moe Foner, February 2, 1983, copy of letter in Lee Baxandall estate.

3. Arnold Bauer, "Geschichte von unten soll Mythen zerstören, Austellung in der Staatlichen Kunsthalle: 'Das andere Amerika,'" *Berliner Morgenpost*, March 12, 1983; and Thomas Doberstein, "Der Andere Ami," *Konkret* 3, March 1983, 30–35.

4. Doberstein: "Die Ausstellung präsentiert ein ziemlich unamerikanisches Amerika. Aber anti-amerikanisch ist sie gewiss nicht. Sie ist so wenig anti-amerikanisch wie die Kommunistin Angela Davis, die zur Eröffnung nach Berlin kommen wird."

5. "Budapester Strasse, Dieb in Kunsthalle: Wertvolles Gemälde unter Mantel weggetragen," *Bild*, April 2, 1983.

6. "Händler meldete sich: Ich habe das 160,000-Mark Gemälde gekauft. Gestohlener 'Sozialist wieder aufgetaucht,'" *Berliner Zeitung*, East Berlin, GDR, April 5, 1983.

7. Philip S. Foner and Reinhold Schultz, eds., *Das Andere Amerika: Geschichte, Kunst und Kultur der amerikanischen Arbeiterbewegung* (Berlin: Die Neue Gesellschaft für Bildende Kunst, 1983); abridged English translation published as *The Other America: Art and the Labour Movement in the United States* (West Nyack, N.Y.: Journeyman Press, 1985).

8. "Koehler, 1850 in Deutschland geboren, wanderte mit seiner Familie, die der socialistischen Bewegung nahestand, als Kind nach Milwaukee, Wisconsin aus. Koehler selbst schloss sich der socialistischen Bewegung in Deutschland an, nachdem er zum Studium zurückgekehrt war." Patricia Hills, "Anmerkungen zu Arbeitsdarstellungen in der bildenden Kunst seit 1800," in Foner and Schultz, *Das Andere Amerika*, 354.

9. Peter Weiss, *Die Aesthetik des Widerstands*, vol. 1 (Frankfurt am Main, 1975), 356–59, as quoted in Foner and Schultz, *Das Andere Amerika*, 355.

10. Reinhard Schultz, "Art and Labor in the United States," in *The Other America*, 17–18.

11. Ibid. Both *The Strike* and *The Socialist* are among the catalogue's three dozen color reproductions.

12. Jeff Sawtell, "*The Other America* Bears Witness to Working-class Struggle," *Morning Star*, November 23, 1984, 4. The exhibition review in a journal called *7 Days Plus* briefly mentioned *The Strike*, erroneously attributing Koehler's inspiration to the Pittsburgh "steelworkers strike of 1877" rather than to that year's railroad strike. Adam Bull, "History of American Labor and Its Art," *7 Days Plus*, December 7, 1985, 10.

13. Sheila Rowbotham, "Art and the Have-nots," *New Society*, December 20/27, 1985. Hera Cook, "Rowbotham, Sheila," in Kelly Boyd, ed., *The Encyclopedia of Historians and Historical Writing*, vol. 2 (London and Chicago: Fitzroy Dearborn, 1999), 1020–21.

14. Arthur Lipow, "The Other America," *Labour Weekly*, London, November 29, 1985.

15. A half-page, black-and-white reproduction of *The Strike*, with a brief description, appears on page 37 of *Haymarket Scrapbook*, edited by David Roediger and Franklin Rosemont (Chicago: Charles H. Kerr, 1986), a rich assortment of essays, documents, letters, photographs, prints, and illustrations having to do with various aspects of the Haymarket tragedy.

16. Lee Baxandall to Reinhard Schultz, August 11, 1986, copy of letter in Lee Baxandall estate.

17. Letter of offer from Vance Jordan, the Jordan-Volpe Gallery, New York City, February 11, 1987, and a copy of Baxandall's *The Strike* sale agreement, February 17, 1987, in Lee Baxandall estate.

18. Lee Baxandall to Matthias Eberle, Deutsches Historisches Museum, Berlin, April 12, 1989, copy of *The Socialist* sale agreement letter in Lee Baxandall estate.

19. Lee Baxandall to Timothy Kuene, Timothy Kuene Fine Arts, Milwaukee, Wisconsin, September 21, 1989, copy of letter in Lee Baxandall estate. Manoogian's acquisition of *The Strike* may already have been a prospect when the Jordan-Volpe Gallery purchased the painting from Baxandall.

20. Lee Baxandall to Dr. Agnete von Specht, Deutsches Historisches Museum, Berlin, Germany, April 26, 1990, copy of letter in Lee Baxandall estate.

21. Lee Baxandall to Reinhard Schultz, November 17, 1987, copy of letter in Lee Baxandall estate.

22. Baxandall to von Specht, April 26, 1990.

23. Agnete von Specht to Lee Baxandall, December 11, 1990, in Lee Baxandall estate. "Dank Ihres Hinweises ist es dem Deutschen Historischen Museum auch gelungen, den 'Streik' zu erwerben. Wir hoffen sehr, ihn bald im Rahmen einer Ausstellung zeigen zu können."

24. Agnete von Specht to Lee Baxandall, March 11, 1991, in Lee Baxandall estate.

25. Agnete von Specht, "Einleitung" (Introduction), *Streik: Realität und Mythos* (Berlin: Deutsches Historisches Museum, 1982), 9–12. Jola Merten, "Es gilt auch heute noch als Inkunabel der Arbeiterbewegung: Ausstellung zur Geschichte des Streiks," *Berliner Morgenpost*, May 22, 1992. Von Specht's "incunabulum" comment is quoted in this article.

26. Agnete von Specht, "Robert Koehler's Gemälde Der Streik als Historienbild," in *Streik: Realität und Mythos*, 157.

27. "Wenn Koehler seinen Lebensunterhalt aus Gemälden dieses Sujets allein hätte bestreiten müssen, er wirklich im Armenhaus hätte enden können." Ibid., 162.

28. "Sorgen auf beiden Seiten; in der Hofwohnung, vier Treppen hoch . . . aber auch in der Villa des Arbeitergebers klopft sie an." Klaus-D. Pohl, "Zur künstlerischen Wahrnehmung des Streiks," in *Streik: Realität und Mythos*, 167.

29. Ibid., 168.

30. As part of a partial recreation of the 1893 World's Columbian Exposition art exhibition in Chicago, organized by the Smithsonian Institution's National Museum of American Art and the National Portrait Gallery, *The Strike* briefly returned one more time to the United States in 1993.

Index

Studies in American Thought and Culture

Series Editor
PAUL S. BOYER

Advisory Board
CHARLES M. CAPPER

MARY KUPIEC CAYTON

LIZABETH COHEN

NAN ENSTAD

JAMES B. GILBERT

KAREN HALTTUNEN

MICHAEL KAMMEN

JAMES T. KLOPPENBERG

COLLEEN MCDANNELL

JOAN S. RUBIN

P. STERLING STUCKEY

ROBERT B. WESTBROOK

Back to the Land: The Enduring Dream of Self-Sufficiency in Modern America
DONA BROWN

Margaret Fuller: Transatlantic Crossings in a Revolutionary Age
Edited by CHARLES CAPPER and CRISTINA GIORCELLI

Creating the College Man: American Mass Magazines and Middle-Class Manhood, 1890–1915
DANIEL A. CLARK